TRANSPARENT
WATERCOLOR WHEEL

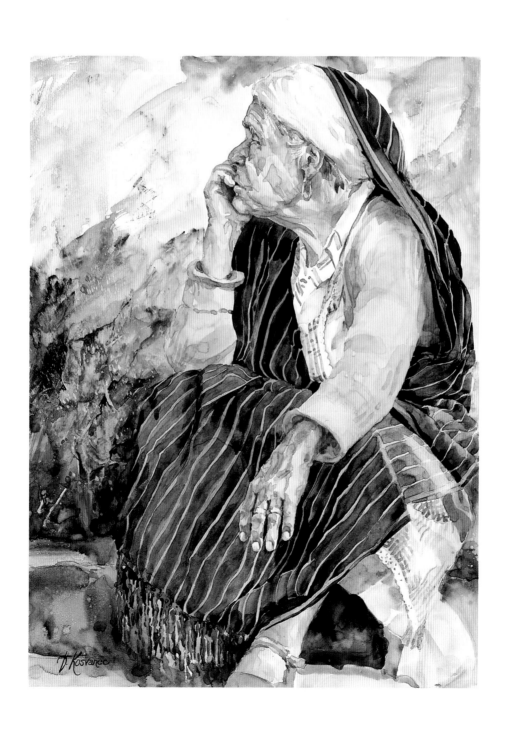

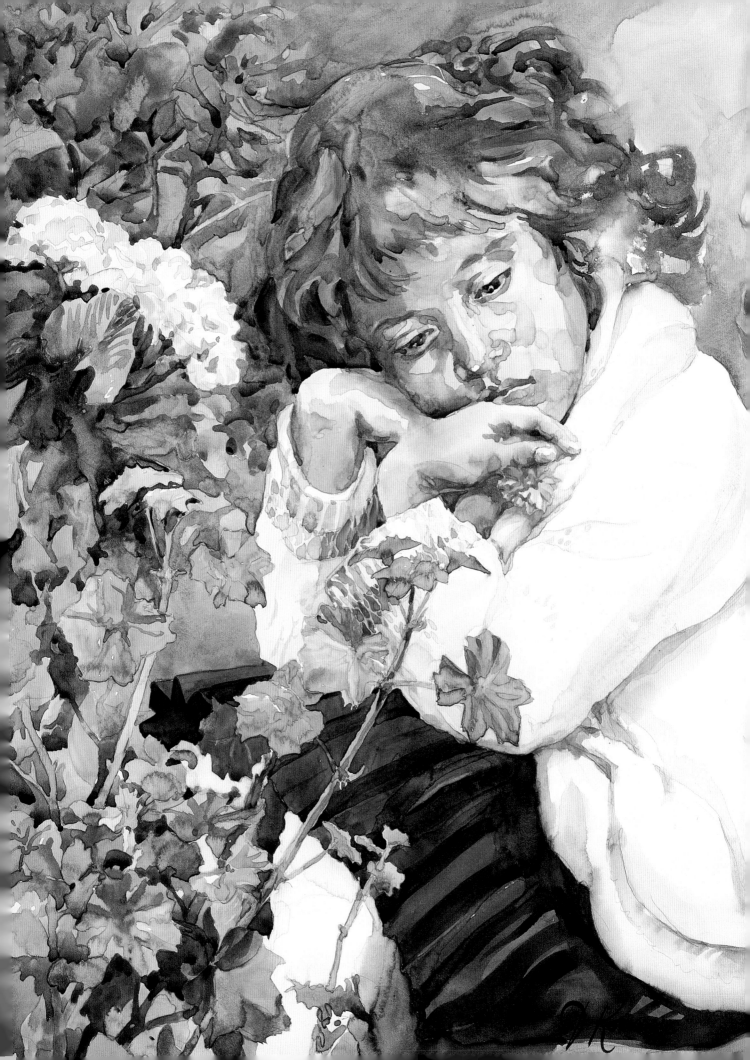

TRANSPARENT WATERCOLOR WHEEL

JIM KOSVANEC

WATSON-GUPTILL PUBLICATIONS
1515 Broadway, New York, NY 10036

This book is dedicated
in memory of my grandfather,
who unselfishly forged who I am;
and, to my wife, Billie,
who anneals his groundwork.

Half-title page:
TIMELESS, 19 1/2 x 14 1/2" (49.5 x 36.8 cm),
Crescent 115 hot-pressed board, collection of Doug Dowling

Title page:
DAYDREAM BELIEVER, 19 1/2 x 14 1/2" (49.5 x 36.8 cm),
Crescent 115 hot-pressed board, collection of the artist

Contents page:
IN THE EYE OF THE BEHOLDER, 29 1/4 x 21 3/4" (74.3 x 55.3 cm),
Winsor & Newton 140-lb. hot-pressed paper,
collection of Mr. and Mrs. Donald Davis

Page 142:
ANCESTRAL COVENANT, 19 1/2 x 14 1/2" (49.5 x 36.8 cm),
Winsor & Newton 140-lb. hot-pressed paper,
collection of Kelly and Martha Leeman

Text set in 11 pt. Minion
Designed by Bob Fillie, Graphiti Graphics
Graphic production by Ellen Greene

Copyright © 1994 Jim Kosvanec

First published in 1994 in the United States by Watson-Guptill Publications,
a division of BPI Communications, Inc., 1515 Broadway, New York, N.Y. 10036

ISBN 0-8230-5436-5

Library of Congress Cataloging-in-Publication Data

Cataloging data for this book is available from the Library of Congress.

Manufactured in Singapore

First printing, 1994

3 4 5 / 98 97 96 95

ACKNOWLEDGMENTS

During the book's four years of development, I've asked for the assistance of many people. Frankly, without their generous guidance and expertise, this book would lack significance. Before the first two dozen pages were written, I was fortunate to have the critique of two perceptive, sage writers who encouraged me to go forward with my project. I'm grateful to Cecil Smith and especially to Joseph Persico, who took time from his demanding writing schedule to fully edit my brief maiden text. But if any one person deserves my ardent gratitude for exhaustively polishing the text and ensuring its coherency, this person would certainly be my wife, Billie. If it reads well, it is largely due to her efforts.

Many manufacturers generously gave of their expertise and products for review. They all promptly replied to follow-up questions, assuring me that my assumptions were accurate or in need of revision. My thanks go to the following companies and people:

To Winsor & Newton for its generous supply of research and art materials; and specifically, to Lynn Pearl for her gracious, long-standing assistance, as well as to Wendell Upchurch and P. J. Staples.

To the people of Grumbacher, particularly Jack Newton for his brush expertise and help in opening doors leading to the publication of this book, and Donna Chastain for her invaluable assistance and patience in sharing her comprehensive expertise in the field of color and pigments.

To H/K Holbein and, expressly, Peter and Andrew Hopper for their watercolor samples and forthright information.

To Special Papers Inc., Myra Beverly, Peter Cowie, and Bruno Navarre, the product manager in Paris for Arches paper, for answering a plethora of questions and supplying a large amount of research material.

To Crescent Paper and Hal Metzger for providing unreserved information about their paper and processes.

A very special thanks to Katherine and Howard Clark of Twinrocker Handmade Paper, not only for their hospitality and expertise, but also for their generous contribution of superb handmade paper.

Thanks and kudos go to Michael Walter and staff of Perfect Image Inc. photo processing lab of Des Plaines, Illinois, for providing the most professional and exacting photographic services I've ever received.

To Andrew Daler of Daler-Rowney for his generous contribution of research material and watercolor samples.

To Sally Drew of Daniel Smith for her enthusiastic, knowledgeable assistance, and extraordinarily generous set of Daniel Smith watercolor samples.

To Susan Anderson of Sylvania for sharing her vast, expert knowledge about bulbs and lighting.

My appreciation to M. Stephen Doherty, Editor-in-Chief of *American Artist* magazine, for tracking down artists' addresses and for other invaluable support. Likewise, thanks go to Candace Raney of Watson-Guptill for patiently helping me grasp the myriad technical requirements behind writing a book for publication. Deepest appreciation to my editor at Watson-Guptill, Marian Appellof, who expertly refined and arranged my words for the betterment of the book. Her sensitivity, willingness to collaborate, and professional manner during the editorial task made what could possibly have become an arduous operation quite pleasurable.

To Helen Coffee, a respected art teacher at the Belles Artes in San Miguel de Allende, for use of her National Library-like collection of art books.

To Jo Brenzo, an esteemed educator of photography at the Belles Artes, without whose loan of professional photographic lighting equipment certain photographs within this book might never have been possible.

My thanks go to Wanda Reindorf, a professional artist and former student, for developing the initial structure of the matrix for the Kosvanec Transparent Watercolor Wheel.

To Bob Barnum for his enthusiastic phone calls and amiable assistance in helping me track down artists' addresses.

To Brianne Bremer, my stepdaughter, for her editing efforts that went awry when the mail burro missed San Miguel and headed south to Panama, never to be seen again.

To Isidro Cassero, our caretaker, who patiently helped in many ways, always sprinkling his kindhearted assistance with quick-witted humor.

Living in central Mexico, without a truly efficient postal department or an affordable parcel delivery service, makes writing a book a bit tedious. To compensate for the lack of these conveniences requires the entreatment of many friends and acquaintances. So, many thanks to those individuals who ferried packages and mail to and from the border: Richard Sacks, Joanie Barcal, Sallie Cardno, Bert and Sally Fayne, Dan and Hope Wolf, and Andrea Braun Byrne.

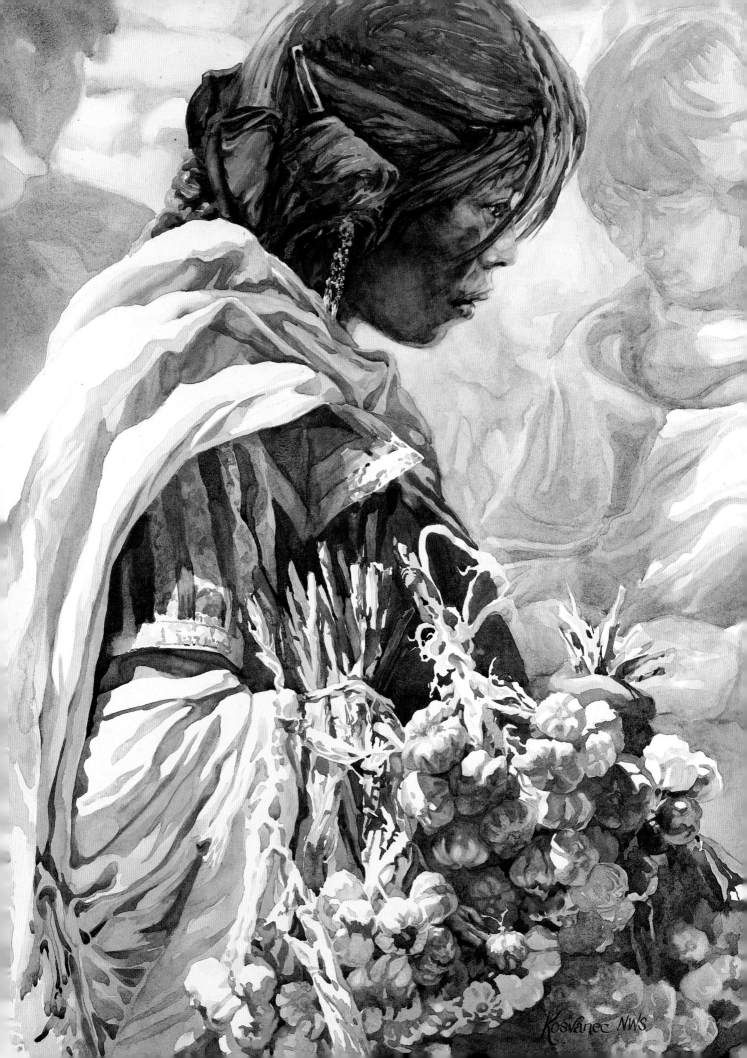

Kosvanec NWS

CONTENTS

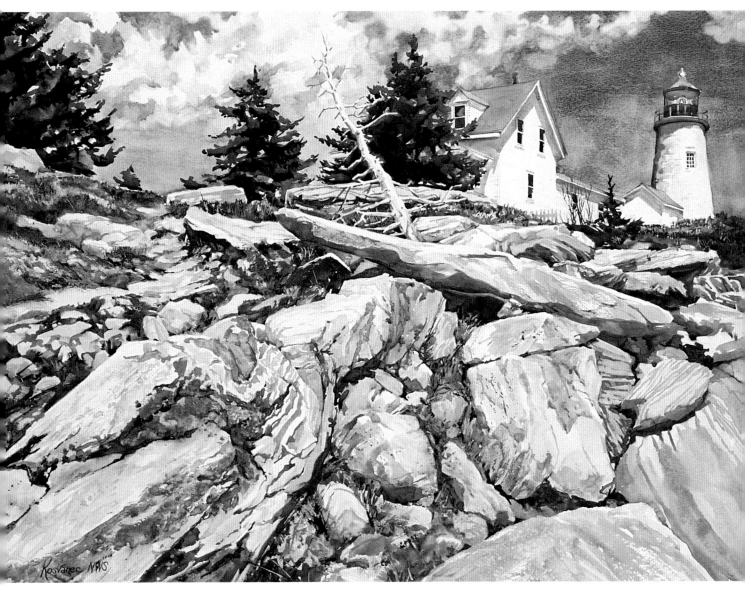

LIGHT AT PEMAQUID POINT, 21 1/2 x 29 1/2" (54.6 x 74.9 cm), Strathmore Imperial
500 hot-pressed paper, collection of Mr. and Mrs. Paul Edwards

As a teenager I drove up the Maine coastline from my home in Kennebunk to explore the villages and ports. Art was part of my adventures. I tried sketching and painting scenes such as this grand lighthouse and discovered that although my ambition was unbound, my skills were limited. Later in life, after study and practice, I returned to tackle these same subjects. Perhaps they are somewhat romantic, but they serve a vital purpose in fulfilling my life. The wait and the study were worth it.

INTRODUCTION

A wise writer once said something to this effect: "The most intimidating factor in writing is staring at a blank sheet of paper." How true for the painter as well. The question for the amateur and professional alike is, "How and where do I start?" Usually, a thorough and thoughtful conceptualization process is good preparation. Think of it as a chess game. You may not know the result, but you can often visualize the possible moves and at least orchestrate the direction. However, without complete knowledge of the mechanics of the medium involved, the result will seldom match what you see in your mind's eye.

It seems ironic to me that the medium of transparent watercolor is so often the choice of beginning artists. True, it is a portable medium; you can pack everything into a small carrier and take it with you; yes, it dries quickly and the support doesn't take much space. Despite these positives, however, transparent watercolor has one overriding disadvantage for the untutored: the degree of difficulty involved in controlling it. Eager to start painting, the beginner often doesn't study the mechanics and stumbles along with poor results. But only disciplined study will give you the knowledge that frees the soul to express itself. Transparent watercolor is not an easy medium to master; even experienced watercolorists humbly admit they can do little more than try to understand and control a respectable percentage of its characteristics. Ultimately, the medium cannot be mastered—only handled masterfully. So, you may be asking yourself, "Why bother? I'll try another medium." Let me encourage you to continue. I know of no other medium that offers such stimulating challenges or is as visually rewarding. This book provides information that will remove many, if not all, of the frustrating roadblocks in your path to creativity.

The attribute that distinguishes a well-executed transparent watercolor painting from one using an opaque medium is *luminosity*. Think of transparent watercolors as being similar to stained glass windows, which are most resplendent when light passes through them from behind. The same is true with transparent watercolors. Light passes and refracts through the pigments and then bounces back from the paper through the crystalline pigment particles, simulating a stained glass effect. This is something to keep in mind as you delve into the medium. You should always be cognizant of what it will take to achieve the "glow." Simultaneously, you'll need to know what will destroy the effect.

Transparent watercolor requires more forethought and conviction than most other mediums. There are methods to lift color and "start over," but frankly, these are very detectable even when done well. You don't need to become a purist of transparent watercolor technique; rather, you should strive toward producing the best work you can by competently utilizing the advantages of the medium.

In studying the mechanics you'll learn what you can and cannot do with transparent watercolors, and most importantly, will discover which color mixtures will predictably give you the results you desire. You'll learn what other elements can affect luminosity—the physical properties of various paints, the paper you select and how you prepare it, the brushes you choose, and how you liquefy paint, charge a brush, and deliver a wash to your painting surface. Generally you'll come to better understand the watercolor painter's hardware. All you really lack is useful information—knowledge that supports the craft of painting. Read and practice until you feel more in "harmony" with your equipment. Using the Kosvanec Transparent Watercolor Wheel will improve your painting, but without full knowledge of your materials, without the ability to properly execute a wash, and without the knowledge of how all this affects luminosity, you'll be driving a Porsche with tractor tires. Learning the craft of transparent watercolor first will enable you to paint spontaneously with crisp results and to express your concepts adroitly.

Kosvanec NWS

THE TRANSPARENT WATERCOLOR WHEEL

W hen I began painting in water-color, I was captivated by the works of the masters, studying volume after volume of repro-ductions of their art. Their achievements appeared effortless. I was certain I could develop my own masterly works by diligently attending to techniques, observing the elements of design, and developing a strong concept. Yet despite some early success, there was always a criti-cal element missing.

After becoming a member of the Art Institute of Chicago, I was allowed access to the Print and Drawing Room to pore through the museum's fine collection of early watercolors. Imagine how I felt as the curator set in front of me a box containing more than twenty works by Winslow Homer. After my initial disbelief that anyone would let me leaf through these unprotected works at such close range, I began to analyze them, as well as other paintings by Maurice Prendergast, J. M. W. Turner, and John Singer Sargent with intense curiosity.

Certainly, all the basic elements were there: strong composition, good drawing, resolute brushwork, sen-sitive handling of subject lighting, as well as illusions of dimension and mass. These artists' handling of the medium was forthright. They weren't afraid of tack-ling difficult subjects; indeed, they seemed to thrive on them. Interpretations were fresh and engrossing because their vision of the various subjects was imagi-native and not at all academic. They risked failure and consistently won, giving something of themselves with each brushstroke.

There was something else that made these works special. I noticed a richness and luminosity in the dark passages that wasn't apparent in reproductions. The light sections were painted so decisively, the tints gleamed. My own paintings by comparison were life-less. I could always envision these luminous colors before painting, but my actual color combinations were often muddy and fell short of my expectations.

Why did their paintings radiate with color? Was it the paint they used? Were the formulas different? After learning that most contemporary formulas are pre-cisely the same, I concluded their clarity of color resulted from, yes, a touch of genius, but also from a sincere dedication to their medium. They were patient enough to experiment and formulate effective color combinations—colors that beamed from the paper.

Although several artists had published color combi-nations that were dependably clean and luminous, they were selected from a narrow field of colors. These

Left: CYCLES OF HOPE, 19¹/₂ x 14¹/₂" (49.5 x 36.8 cm), Winsor & Newton 140-lb. hot-pressed paper, collection of Mr. and Mrs. Thomas VanderMolen.

Above: INNER THOUGHTS, 14¹/₂ x 19¹/₂", (36.8 x 49.5 cm), Winsor & Newton 140-lb. hot-pressed paper, collection of the artist

were helpful, but what I envisioned was a system for predicting clean color combinations that would apply to any color I might choose. I felt that by understanding and charting the characteristics of the most popular colors, a pattern would emerge. I wanted to determine the degree of success of any mixture without running a million or more color tests. I'm a painter, not a lab technician.

Surprisingly, all the information I needed existed in technical bulletins published by paint manufacturers. Testing more than one hundred tube colors and sorting them into identifiable groups was just the beginning. The difficult task was analyzing the relationships among the groups, identifying a pattern, and then finding a method to display the results.

After two years the Kosvanec Transparent Watercolor Wheel evolved, offering the transparent watercolorist logical choices that consistently lead to predictable color combinations. Essentially, the wheel sorts watercolor pigments into five groups according to their physical and behavioral characteristics: transparent nonstaining colors; semitransparent nonstaining colors; transparent staining colors; semiopaque and opaque colors; and whitened and blackened colors. Each group occupies a separate ring on the wheel. The colors interrelate, ring to ring, with specific mixing results. Once you understand the characteristics of the colors in each of the basic groups, you can explore how they work together. Accompanying the Transparent Watercolor Wheel are guidelines, as well as a simple chart called the Color Matrix, which are designed to help you not only avoid muddy combinations but, more importantly, to consistently choose luminous color combinations. There are, of course, times when a muted color is precisely what you need in a painting. Muddy mixtures can be beautiful if laid down with a good suspension of water and left to dry undisturbed. The guidelines can help you select these muted combinations if that's what you seek.

What you are about to learn will greatly improve your painting ability. With practice you will feel comfortable with the concepts of the Kosvanec Transparent Watercolor Wheel, and will become proficient at selecting logical color combinations. You will be liberated from vexing color choices and be more confident in expressing your artistic ideas.

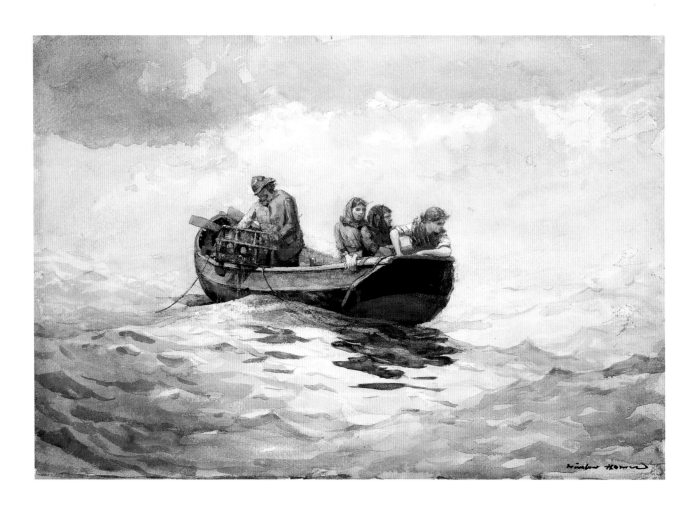

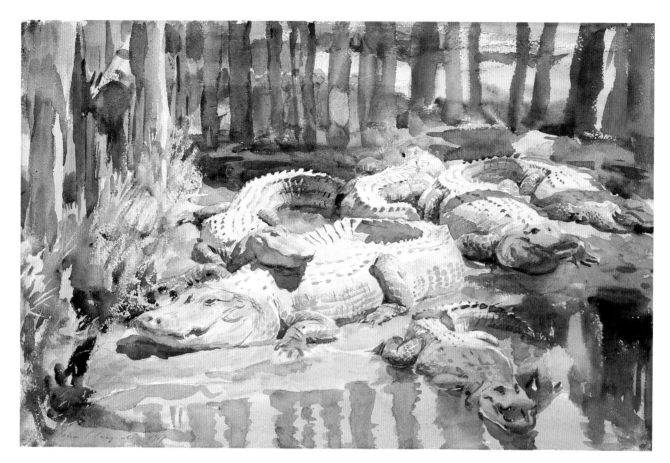

Opposite page: *Winslow Homer,* CRAB FISHING,
14⁹/₁₆ x 21³/₄" (37.0 x 55.2 cm), 1883, courtesy
Worcester Art Museum, Worcester, Massachusetts

*This painting is one of a series Homer executed
after he had been living in a North Sea fishing
village for nearly two years. His intent in trav-
eling to England was largely to study watercol-
or, since there it was respected as a serious
medium while in the United States it was
considered less noble.*

Above and detail, right: *John Singer Sargent,*
MUDDY ALLIGATORS, 13²/₃ x 21¹/₄" (34.7 x 53.4 cm),
1917, courtesy Worcester Art Museum,
Worcester, Massachusetts

*Sargent's complete understanding of water-
colors allowed him to express his extraordinary
artistic response to these alligators despite writ-
ing that they "don't make very interesting pic-
tures." In the closeup detail you can see how he
used lifting, scraping, blotting, and other sur-
face effects. A list of the watercolor paints Sar-
gent used indicates his concern for luminosity.
Notice the transparent washes of violets on the
lighted side of the largest alligator's head, and
the complementary warmer color mixture
under the jaw. Although Sargent used cadmi-
ums, he relied mostly on transparent and semi-
opaque colors. The dark passages are clean and
crisp. Photo courtesy Worcester Art Museum,
Worcester, Massachusetts.*

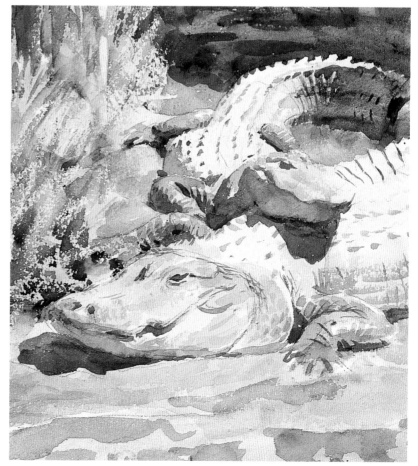

TRANSPARENT NONSTAINING COLORS

The most useful colors for the transparent watercolorist are transparent nonstaining colors, which occupy the innermost ring on the Kosvanec Transparent Watercolor Wheel (see foldout page). These colors allow light to pass through their pigment particles to the paper and reflect back to the eye. This dazzling effect, called luminosity, is similar to the visual sensation that occurs with stained glass. When you observe light shining through stained glass, the effect is stunning. But when light falls only on the surface of the glass, the effect is muted. So, as long as you work with transparent nonstaining colors (and don't lay the paint on with a trowel), you will experience beautiful, luminous results.

Transparent nonstaining colors have another advantage: They can be lifted from dampened paper without leaving a strong stain behind. You can nearly return to the paper's natural white state.

For some artists, the colors in the transparent nonstaining category are adequate for a complete palette. Unfortunately, though, these colors lack density or deep value—in other words, guts. There circulates a baseless notion that properly executed watercolors should be composed of thin, misty glazes. Using a palette that excludes all but the transparent nonstaining colors tends to support this misconception. To this day, some people continue to believe that for a watercolor to be valid, it must be vaporous! I advocate using all the transparent nonstaining colors available and relying on them for most—but not all—of your painting.

AUREOLIN

ROSE MADDER GENUINE

PERMANENT ROSE

COBALT BLUE

VIRIDIAN

HOOKER'S GREEN

GUIDELINES

You may confidently glaze one transparent nonstaining color over another without fear of tarnishing the colors beneath. Just be certain the layers are dry between applications, and connect brushstrokes as quickly as possible to avoid lifting the previous glaze.

Within reason, you may mix transparent nonstaining colors with any number of other transparent nonstaining colors without causing them to become muddy.

By mixing a transparent nonstaining color with a semiopaque or opaque color, you will create a combination that is cleaner and more transparent than if you had used an opaque color alone.

Be cautious when mixing a transparent nonstaining color with a staining color, which may "dye" the nonstaining pigment and change its character. Generally, this combination is successful if the staining color is added sparingly.

Don't depend on transparent nonstaining colors to make dark values, as these pigments are inherently light in value. Measured against a gray scale where zero is white and ten is black, the darkest value you could achieve with transparent nonstaining colors would be about a seven or eight.

Transparent nonstaining colors are easily removed, revealing nearly white paper. These colors are among the most versatile and reliable we can choose.

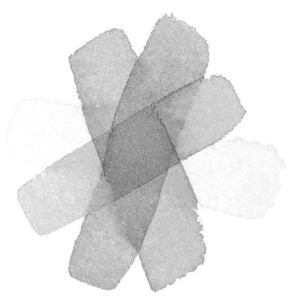

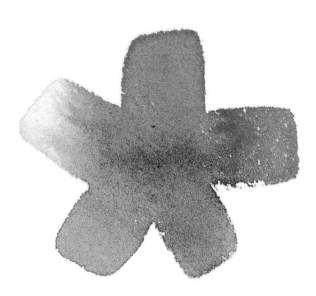

Four overlapping glazes of rose madder genuine, cobalt blue, viridian, and aureolin attest to their capacity to remain luminous.

Even when you mix five transparent nonstaining colors together—here, rose madder genuine, cobalt blue, viridian, Hooker's green, and aureolin—they continue to glow.

The square at upper right is burnt umber, a blackened semiopaque color; combining it with rose madder genuine (the square at left), a transparent nonstaining color, results in a mixture (the bottom square) that is more luminous than the burnt umber alone. The transparent rose madder genuine imparts some of its qualities to the blend.

Mixing a transparent staining color (here, phthalo blue) into a transparent nonstaining color (such as aureolin) must be done cautiously so that it does not overpower the weaker nonstaining color.

The darkest value you can achieve by mixing the three transparent nonstaining colors viridian, rose madder genuine, and cobalt blue is no more than perhaps 80 percent black on a ten-value gray scale, since the colors themselves aren't inherently deep in value.

| 10% | 20% | 30% | 40% | 50% | 60% | 70% | 80% | 90% | 100% |

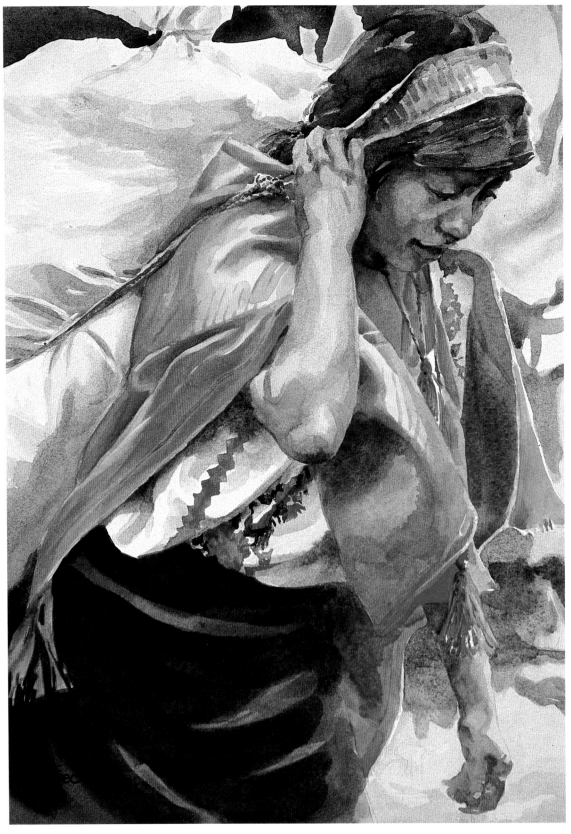

DAYBREAK DEPARTURE, 19¹/₂ x 14¹/₂" (49.5 x 36.8 cm), Winsor & Newton 140-lb. hot-pressed paper, collection of Sharon and John Garside

In this painting I used permanent rose, a stable quinacridone pigment, in the bright pink band that rims the shawl. This color is very transparent and won't stain other colors, although it will slightly stain the paper.

COLOR MATRIX

	Transparent and Semitransparent Nonstaining Colors	Transparent Staining Colors	Semiopaque and Opaque Colors	Whitened and Blackened Colors
Transparent and Semitransparent Nonstaining Colors	Transparent and luminous.	Semisuccessful mixtures. Transparents slightly dulled by stains. Add stainers slowly.	Okay; best to use 1, maximum 2, semiopaques or 1 opaque with transparents. The more the muddier.	Okay; best to use 1, maximum 2, semiopaques or 1 opaque with transparents. The more the muddier.
Transparent Staining Colors	Semisuccessful mixtures. Transparents slightly dulled by stains. Add stainers slowly.	Excellent, unless applied too thickly.	Very dull, especially cadmiums and the more opaque colors.	Dull and gray.
Semiopaque and Opaque Colors	Okay; best to use 1, maximum 2, semiopaques or 1 opaque with transparents. The more the muddier.	Very dull, especially cadmiums and the more opaque colors.	2 okay; 3 or more are muddy.	2 okay; 3 or more are gray and murky.
Whitened and Blackened Colors	Okay; best to use 1, maximum 2, semiopaques or 1 opaque with transparents. The more the muddier.	Dull and gray.	2 okay; 3 or more are gray and murky.	2 okay; 3 or more are muddy. Chalky and gray.

SIMPLIFIED GUIDELINES
(See text for fuller explanations.)

RING 1:
TRANSPARENT NONSTAINING COLORS

1. Transparents mix or glaze with other transparents without restrictions.

2. Transparents mix well with all other pigments except staining colors, which can "dye" them.

RING 2:
SEMITRANSPARENT NONSTAINING COLORS

1. Semitransparents may be used like transparents but with more restraint. They are not as versatile as fully transparent colors.

RING 3:
TRANSPARENT STAINING COLORS

1. Staining colors mix well with other staining colors.

2. Some mixtures of staining colors with other categories are strong and successful, while others are dulled by the stain. Mix cautiously, slowly adding staining colors last.

RING 4:
SEMIOPAQUE AND OPAQUE COLORS

1. Two semiopaques or opaques usually mix well together.

2. Three semiopaques or opaques mixed generally turn muddy.

3. Semiopaques and opaques mix well with transparents.

4. Some semiopaques and opaques mix well with staining colors, but most are adversely affected. Generally, the more opaque a color is (e.g., the cadmiums), the less likely it is to mix cleanly with a staining color.

RING 5:
WHITENED AND BLACKENED COLORS

1. These are also semiopaque or opaque, and should be handled according to the guidelines for that color category.

2. Avoid selecting a whitened or blackened color as a "clean" complement, or do so with the understanding that it is a neutralized color.

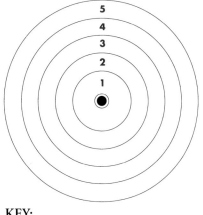

KEY:
RING 1: TRANSPARENT NONSTAINING COLORS
RING 2: SEMITRANSPARENT NONSTAINING COLORS
RING 3: TRANSPARENT STAINING COLORS
RING 4: SEMIOPAQUE AND OPAQUE COLORS
RING 5: WHITENED AND BLACKENED COLORS

THE KOSVANEC TRANSPARENT WATERCOLOR WHEEL

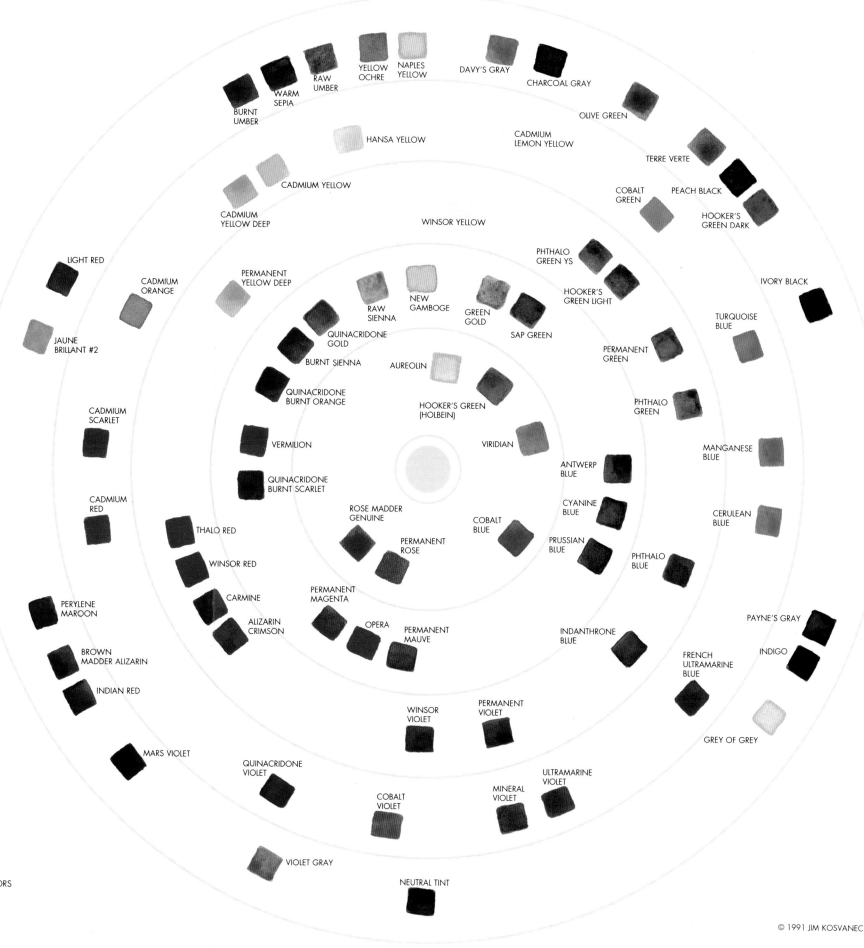

© 1991 JIM KOSVANEC

SEMITRANSPARENT NONSTAINING COLORS

Occupying the second ring on the Kosvanec Transparent Watercolor Wheel are the semitransparent nonstaining colors. I almost feel guilty separating these pigments from their relatives in the fully transparent nonstaining color category, since in varying degrees, they call for nearly the same handling under the guidelines. But because semitransparent nonstaining colors are characterized by a touch of opacity, using them requires some restraint. Although some of these colors are not as permanent as I would prefer, there are enough that are sufficiently durable to help fill the voids in the ring of transparent nonstaining colors.

GUIDELINES
You may glaze several semitransparent nonstaining colors over one another without concern for muddiness, as long as you allow each layer of paint before applying the next. Connect your brushstrokes as quickly as possible to avoid lifting the previous glaze.

By mixing a semitransparent nonstaining color with a semiopaque or opaque you will create a combination that is cleaner and more transparent than if you had used the opaque color alone.

Be cautious when mixing a semitransparent nonstaining color with a staining color. The staining color may "dye" the nonstaining pigment, changing its character.

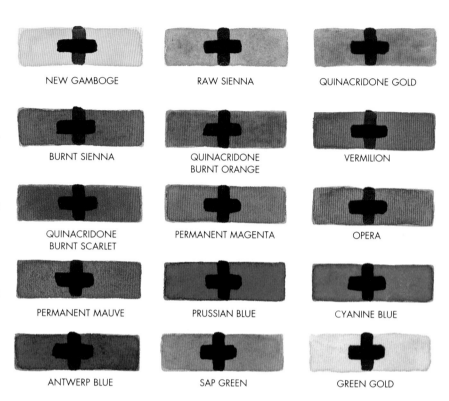

NEW GAMBOGE　　RAW SIENNA　　QUINACRIDONE GOLD

BURNT SIENNA　　QUINACRIDONE BURNT ORANGE　　VERMILION

QUINACRIDONE BURNT SCARLET　　PERMANENT MAGENTA　　OPERA

PERMANENT MAUVE　　PRUSSIAN BLUE　　CYANINE BLUE

ANTWERP BLUE　　SAP GREEN　　GREEN GOLD

These semitransparent nonstaining colors are slightly more opaque than the fully transparent colors on the inner wheel. To illustrate this property, I first painted each color over a vertical black line of India ink; then, when the color was dry, I painted a horizontal black line over each color, revealing the contrast. As you can see, only a few of these colors exhibit some opacity. Use them as you would the transparent nonstaining colors, but with more restraint.

Three overlapping glazes of sap green, new gamboge, and burnt sienna yield color that remains luminous.

Mixing cobalt blue, a transparent nonstaining color, with vermilion results in a violet that is slightly more luminous than the vermilion is alone.

Here, vermilion has been mixed with phthalo blue, a transparent staining color. The combination is sullied by the phthalo blue's strong staining properties.

TRANSPARENT STAINING COLORS

I would characterize staining colors as saturated, intense, and unforgiving. These are colors you wouldn't want to splash on good clothing or have your cat race through and carry off to carpets and upholstery. They occupy the third ring on the Transparent Watercolor Wheel. Among them are colors with "permanent" or "phthalocyanine" ("phthalo" for short) in their names; included, too, are Grumbacher's "Thalo" colors and Winsor & Newton's "Winsor" colors. Although often opaque or semiopaque, these pigments are so supersaturated and fine that they are essentially transparent. Thus, it would serve no real purpose to use them in other than a diluted, transparent state.

Transparent staining colors will stain the fibers of the paper you apply them to. You can lift the darkest portion of a staining color, but forget about removing the remainder—you'll annihilate the paper's surface before you expunge the evidence! When mixed with other color categories, they stain those colors and sap their vigor. This can be calamitous depending on the color you select. Yet the advantage of having colors that can narrate intensity and dark values quickly and effectively, without becoming muddy, overrides any possible complications. The simple list of guidelines for this category will help you control the transparent staining colors.

When using these pigments for glazes, you can apply layers of rich color one over another (wet over bone dry) without worrying about creating a muddy effect as long as you use reasonable restraint in the numbers and densities of layers.

Explore further. Lay down an underglaze of a transparent staining color and let it dry; then paint over it with an opaque color that can be lifted. Using various lifting methods, you can create textured, mottled effects by allowing some staining color to peek through. These sparkling effects offer the viewer visual variety.

Other colors, such as sap green, burnt sienna, and manganese blue, also stain the paper, but they can be mixed with other pigments without the dulling results that staining colors impart on their less compatible neighbors. For example, mixing a staining color such as phthalo green with cadmium red produces a dull result, whereas mixing sap green with cadmium red does not. For this reason these colors are grouped in other categories more appropriate to their specific behavior.

GUIDELINES
When glazing or underpainting, use transparent staining colors first. If you choose to apply a transparent staining color over a color from another category, don't forget that it will often stain the underlying pigment, dulling its luminosity.

When mixing transparent staining colors, remember that the most successful combinations occur with other transparent staining colors. The least successful combinations are with semiopaque and opaque colors, which are composed of coarser pigments that are readily stained and discolored.

When mixing transparent staining colors with colors in other categories, remember that the staining color should be added to the mixture last—a little at a time. Transparent staining colors are potent and will overwhelm other colors if used in equal proportions.

When creating mixtures of staining transparent colors, start with the color that is lighter in value, then add the darker colors. For example, use yellow first, slowly adding red, then blue or green. This is sound advice when painting with any category of colors, but is more important with the staining colors.

Use transparent staining colors for vivid, rich, dark passages that will remain luminous, but don't forget they can also be diluted to create subtle tones as well.

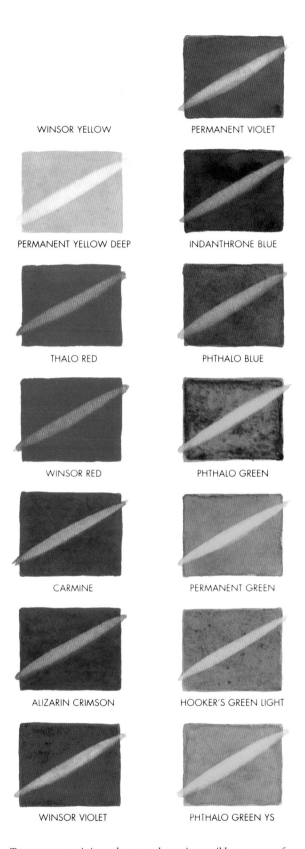

WINSOR YELLOW

PERMANENT VIOLET

PERMANENT YELLOW DEEP

INDANTHRONE BLUE

THALO RED

PHTHALO BLUE

WINSOR RED

PHTHALO GREEN

CARMINE

PERMANENT GREEN

ALIZARIN CRIMSON

HOOKER'S GREEN LIGHT

WINSOR VIOLET

PHTHALO GREEN YS

Transparent staining colors are almost impossible to remove from your paper. They are, however, saturated, intense colors that have great potential when handled properly.

Notice how the staining power of phthalo green so deeply saturated the fibers of the paper that even after repeated scrubbings it was impossible to return the paper to white. The paper's condition is pathetically pilled, and painting over a surface such as this leads to unsatisfactory results.

Here are five glazes of transparent staining colors. You can see that even where all five overlap, the color is still luminous. The order of the glazes is Winsor yellow, carmine, phthalo blue, carmine (horizontally), and Winsor green.

First I painted a background with the staining color Winsor red. After it dried, I overpainted it with burnt umber and olive green. When this stage was dry, I speckled it with water drops and, with a brush, drew a line with clear water. I then removed the dampened paint with a tissue, revealing the underlying background stained with Winsor red.

Over a base of French ultramarine blue, a semiopaque color, I painted carmine, a staining color. This darkened and dulled the semiopaque.

Here carmine is the base color, with French ultramarine blue painted over it. The result is luminous in comparison with the previous example.

Mixing these four transparent staining colors—Winsor yellow, carmine, phthalo blue, and Winsor green—yields a luminous gray.

Here, three opaques—cadmium lemon yellow, cadmium red, and French ultramarine blue—were "attacked" by the staining properties of Winsor green, resulting in a lifeless gray.

The example at left demonstrates how just a small amount of the transparent staining color Winsor green sufficiently tints aureolin. The example at right shows how aureolin is overwhelmed by the tinting strength of as little as 50 percent Winsor green.

For this example I used Winsor yellow as the base color, adding carmine and phthalo blue to it in proportions governed by each color's inherent value. Thus, because the yellow is the lightest of the three, I used more of it, mixing in a much smaller quantity of the mid-value red and an even smaller amount of the dark blue.

Notice the subtle tints transparent staining colors can render when diluted with sufficient water. Don't overlook mixtures as well.

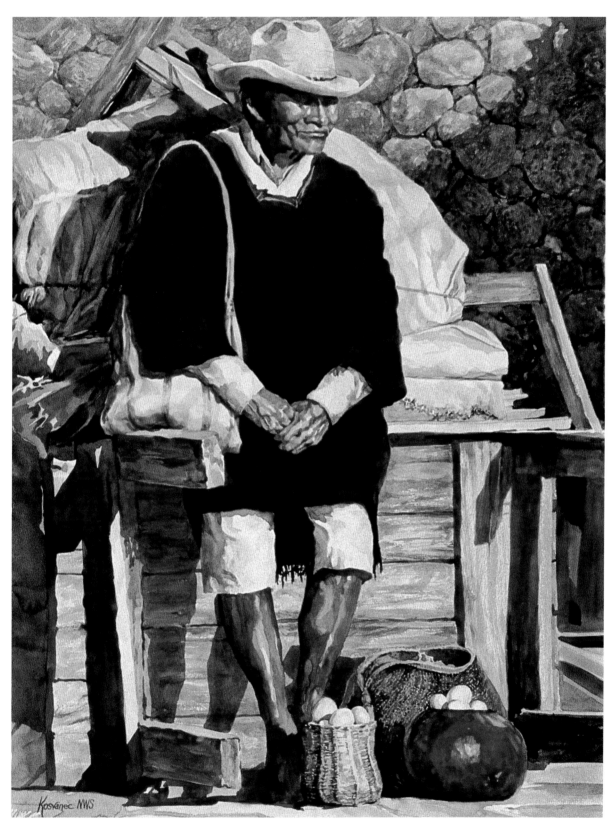

BLIND FAITH, 29¼ x 21¾" (74.3 x 55.3 cm), Strathmore Imperial 500 140-lb. hot-pressed paper, collection of Linda and Gary Baumgardner

I like this painting, but have no idea why I painted it so tightly. It supports the dictum that suggests you let the painting tell you where it wants to go. The red gourd pot utilizes as many as eight colors and countless glazes. The man's wool jacket comprises many glazes of Winsor yellow, carmine, Winsor blue, and Winsor green, plus shadow accents of those colors.

SEMIOPAQUE AND OPAQUE COLORS

For our purposes, semiopaque and opaque colors, occupying the fourth ring of the Kosvanec Transparent Watercolor Wheel, can be lumped together in terms of their advantages and disadvantages. Opacity varies greatly from color to color and from brand to brand, so you'll need to judge it for yourself by experimenting with specific colors. With some opaques, you can feel and hear the gritty consistency as your brush mixes pigment and water together on a mixing tray.

Semiopaques and opaques are used transparently, not opaquely! They fulfill a range of visual possibilities by contributing a certain weightiness or earthiness, anchoring your work. They also permit a range of techniques such as negative spattering, direct lifting, and plastic wrap texturing. Semiopaque and opaque colors are not essential to a transparent watercolorist's palette, but I wouldn't be without certain ones.

Cadmiums, ranging from yellow through red, are some of our most opaque colors. Despite this less desirable property, to disregard them would be a mistake. To mix them together doesn't cause additional opacity because they all have cadmium as their common denominator, making them compatible. Also, they are so close to one another on the color wheel that when you mix them, you are merely concocting a variation on a color theme. Consider any combination of cadmiums as a distinct new cadmium color.

Cadmiums make superb color notes for paintings. When used transparently—that is, mixed with enough water to create a thin wash rather than applied in a thick layer—the colors yodel from the paper, especially when it is white and untouched. On the other hand, cadmiums are miserable for overpainting, and mixing them with other opaques usually produces an undesirable result.

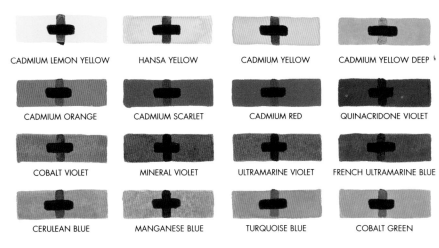

CADMIUM LEMON YELLOW HANSA YELLOW CADMIUM YELLOW CADMIUM YELLOW DEEP

CADMIUM ORANGE CADMIUM SCARLET CADMIUM RED QUINACRIDONE VIOLET

COBALT VIOLET MINERAL VIOLET ULTRAMARINE VIOLET FRENCH ULTRAMARINE BLUE

CERULEAN BLUE MANGANESE BLUE TURQUOISE BLUE COBALT GREEN

This chart of semiopaque and opaque colors demonstrates the range of their opacity, which varies greatly with each color and brand. You can run your own test by painting a stripe of waterproof India ink, letting it dry, then painting your colors over it.

Cadmium yellow, cadmium red, cadmium orange, and cadmium lemon yellow all blend together to create a combination that is as clean and luminous as any one of these colors used alone.

At left are four cadmium colors used straight from the tube. Notice how vibrant the colors are. At right is a mixture using those same cadmiums plus other opaques. Not only is the base color muddy, but the overglaze of cadmium red compounds the muddiness.

WHITENED AND BLACKENED COLORS

These are semiopaque and opaque colors that contain some white or black in their composition. They are handled according to the same guidelines used for semiopaques and opaques, and in fact could just as easily have been placed on that ring of the color wheel, but I've separated them so that we might have an additional reference. Thus, they are located on the fifth, or outermost, ring on the color wheel. I'm not suggesting you avoid a color because it has white or black in it, because there are times when using one of these can successfully tone down an otherwise strident combination. I simply want you to be aware (not beware) of specific color properties and choose purposefully.

Most semiopaques and opaques are nonstaining, but more than a few have staining properties. To determine these characteristics, apply a swatch of a given color to your paper, wait for it to dry thoroughly, and then try lifting it. If you find that the color stains, follow the guidelines for staining colors as well as the advice for opaque colors.

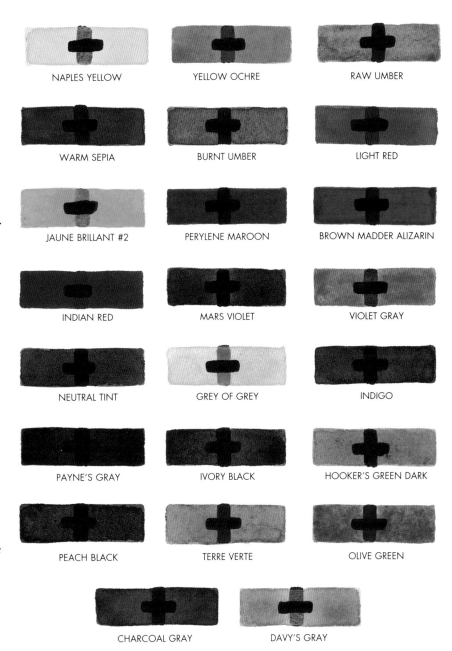

NAPLES YELLOW YELLOW OCHRE RAW UMBER

WARM SEPIA BURNT UMBER LIGHT RED

JAUNE BRILLANT #2 PERYLENE MAROON BROWN MADDER ALIZARIN

INDIAN RED MARS VIOLET VIOLET GRAY

NEUTRAL TINT GREY OF GREY INDIGO

PAYNE'S GRAY IVORY BLACK HOOKER'S GREEN DARK

PEACH BLACK TERRE VERTE OLIVE GREEN

CHARCOAL GRAY DAVY'S GRAY

These whitened or blackened colors vary in opacity. Although most belong with the semiopaques and opaques, a few belong with semitransparent or staining colors. I have, however, placed them in their own category because the white or black in their composition has a noticeable effect on color combinations.

GUIDELINES

(These apply to semiopaque and opaque colors as well as to whitened and blackened colors.)

Mix two opaques cautiously. The mixture should be well suspended in water and, once applied, allowed to dry undisturbed. Avoid reworking the passage. If you decide to restate it, use a transparent non-staining glaze and apply the wash in a way that will not lift or disturb the dry wash. Don't overglaze with a staining color, or you will further dull the opaque mixture.

Don't mix three or more opaques unless you intend to create a mud puddle! One exception: Cadmiums mixed with one another give opaque but not muddy results.

Combining a staining color with an opaque or a semiopaque color yields a dull (but possibly acceptable) likeness of the wet mixture. This union sometimes works well for painting subdued shadows. Semiopaques are in general affected less adversely than opaques by the staining colors.

Staining colors "dye" the coarser particles of opaques most radically. Generally, the more opaque a color is, the less likely it is to mix cleanly with a staining color. For example, cadmiums are not good mixing candidates with staining colors. Also, a color containing white appears lifeless when a staining color is added.

Although a few semiopaques and opaques can be used successfully as glazes, most should not. The result is usually a cloudy or chalky effect.

Use opaques to overpaint when you intend to use lifting techniques. Use transparent staining colors for the underpainting.

Although some manufacturers list their phthalo or permanent colors (including Grumbacher's Thalo and Winsor & Newton's Winsor colors) as opaque or semiopaque, don't think of them as such; regard them as transparent staining colors. They are so concentrated that they are vigorous even when used well diluted. It's counterproductive to use them in any manner other than transparently.

I'd evaluate these combinations of opaques as marginally transparent. Used more thinly, they would exhibit more luminosity. The combinations are, from left to right, olive green with cadmium red, burnt umber with cadmium lemon yellow, and French ultramarine blue with cadmium orange.

These three colors from the semiopaque and opaque category—French ultramarine blue, yellow ochre, and olive green—convene to create a mud puddle. It's unlikely that even a thinned application of this mixture would be at all luminous.

Staining colors (on the top) "dye" the coarser pigments of opaque colors (bottom), dulling the particles. Shown here are, left to right, Winsor red applied over cerulean blue; phthalo blue over light red; and phthalo blue over yellow ochre.

Here, the opaque color turquoise blue is painted over a base composed of the staining colors Winsor yellow, carmine, and phthalo blue. The opaque pigment appears chalky and conspicuously incompatible with the other colors.

Mixing the transparent staining color Winsor red and the opaque French ultramarine blue gives dull but acceptable results.

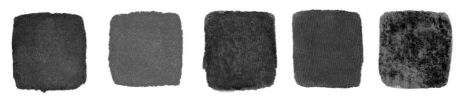

The transparent staining colors Winsor yellow, carmine, Winsor red, phthalo blue, Winsor violet, and phthalo green are shown here at an intensity that keeps them just short of being termed opaque. When diluted, they remain vibrant.

EXPLORING COLOR COMBINATIONS

Painting sample swatches will help you understand the ideas discussed in the guidelines. If you don't have every color I mention, try a similar one on the same ring on the Transparent Watercolor Wheel. Refer to the guidelines and the Color Matrix (below) to see how the examples apply. (What follows assumes you already know how to suspend your paint in the right amount of water, deliver it properly to the paper, and let it dry undisturbed. For advice on this, see chapter five.)

To use the Color Matrix, choose one category from the left-hand vertical row (say, Transparent Staining Colors) and another from the top horizontal row (say, Whitened and Blackened Colors). Then find the text block where your vertical and horizontal choices intersect, which tells you the results you can expect when you mix colors from your chosen categories (in this case, "Dull and gray").

If you mix rose madder genuine, aureolin, cobalt blue, and viridian together, you can be fairly certain the result will be luminous despite how strange a combination this may seem. These are fully transparent nonstaining colors that mix well without restrictions, within reason.

If you again choose rose madder genuine, but select cadmium lemon yellow in place of aureolin, French ultramarine instead of cobalt blue, and phthalo green instead of viridian, the result, once dry, will be quite a bit less luminous. With two opaque colors (the cadmium lemon yellow and French ultramarine blue), the mixture teeters on becoming less desirable. The knockout blow is delivered by phthalo green, which stains the opaques.

COLOR MATRIX	Transparent and Semitransparent Nonstaining Colors	Transparent Staining Colors	Semiopaque and Opaque Colors	Whitened and Blackened Colors
Transparent and Semitransparent Nonstaining Colors	Transparent and luminous.	Semisuccessful mixtures. Transparents slightly dulled by stains. Add stainers slowly.	Okay; best to use 1, maximum 2, semiopaques or 1 opaque with transparents. The more the muddier.	Okay; best to use 1, maximum 2, semiopaques or 1 opaque with transparents. The more the muddier.
Transparent Staining Colors	Semisuccessful mixtures. Transparents slightly dulled by stains. Add stainers slowly.	Excellent, unless applied too thickly.	Very dull, especially cadmiums and the more opaque colors.	Dull and gray.
Semiopaque and Opaque Colors	Okay; best to use 1, maximum 2, semiopaques or 1 opaque with transparents. The more the muddier.	Very dull, especially cadmiums and the more opaque colors.	2 okay; 3 or more are muddy.	2 okay; 3 or more are gray and murky.
Whitened and Blackened Colors	Okay; best to use 1, maximum 2, semiopaques or 1 opaque with transparents. The more the muddier.	Dull and gray.	2 okay; 3 or more are gray and murky.	2 okay; 3 or more are muddy. Chalky and gray.

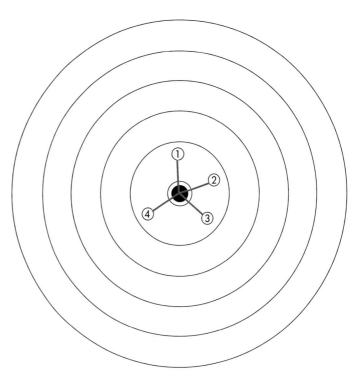

This example shows luminosity at its finest, despite the outlandish selection of colors—aureolin, viridian, cobalt blue, and rose madder genuine, all transparent nonstaining colors on the Transparent Watercolor Wheel and thus compatible according to the guidelines.

1. AUREOLIN
2. VIRIDIAN
3. COBALT BLUE
4. ROSE MADDER GENUINE

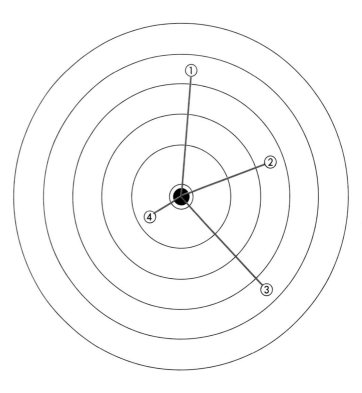

This example shows how mixing visually similar but physically different colors can give less desirable results. Combining a transparent nonstaining color (rose madder genuine) with two opaques (cadmium lemon yellow and French ultramarine) is marginally acceptable. Introducing a stainer (phthalo green) destroys compatibility.

1. CADMIUM LEMON YELLOW
2. PHTHALO GREEN
3. FRENCH ULTRAMARINE
4. ROSE MADDER GENUINE

Let's explore another combination. This time, use Winsor yellow, phthalo blue, and Winsor violet. This works fine, since they are all staining colors. Now, select cadmium lemon yellow, French ultramarine blue, and mineral violet instead, and you'll have a relatively dull mixture. Check the Color Matrix or the guidelines, and you'll find that mixing three or more opaques creates a muddy result.

Substitute phthalo blue for the French ultramarine blue in this last mixture, and matters go from bad to worse, again owing to the phthalo blue's staining properties.

What might work in this situation? Probably the best compromise is a combination of aureolin, cobalt blue, and mineral violet. According to the guidelines, this should do the job because semi-opaques and opaques are compatible with transparent nonstaining colors, as long as there aren't more than just two opaques in the mixture.

You also could drop the mineral violet, substitute rose madder genuine, and increase the blue in the mixture to come up with a similar, more transparent color result, but you'd be losing the beautiful settling qualities of the mineral violet. Got the idea?

The most successful mixtures are those composed of three staining colors—here, Winsor yellow, phthalo blue, and Winsor violet.

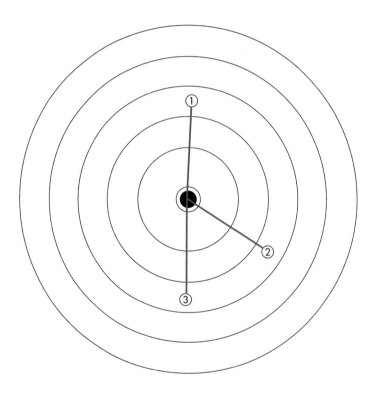

1. WINSOR YELLOW
2. PHTHALO BLUE
3. WINSOR VIOLET

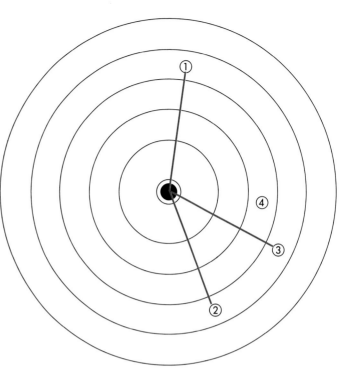

As you can see in the example at left, the mixture of three opaques—here, cadmium lemon yellow, mineral violet, and French ultramarine blue—is muddy, but the combination shown at right of two opaques (cadmium lemon yellow and mineral violet) with a staining color (phthalo blue) is sludge!

1. CADMIUM LEMON YELLOW
2. MINERAL VIOLET
3. FRENCH ULTRAMARINE BLUE
4. PHTHALO BLUE

The best scenario is to choose two transparent nonstaining colors and a semiopaque. The guidelines state that we may mix transparent nonstaining colors at will. In this example the two transparent nonstaining colors aureolin and cobalt blue are combined with mineral violet, a semiopaque nonstaining color with granular settling qualities. The resulting mixture is a clean, lustrous color that is more transparent than mineral violet alone. Look at the center of this swatch, where the colors have melded. The color is luminous and interesting.

1. AUREOLIN
2. MINERAL VIOLET
3. COBALT BLUE

CREATING LUMINOUS GRAYS

Interestingly, the most successful traditional paintings are composed by more than three-quarters of grayed colors created generally by mixing complements rather than by adding black. (Complements are colors that lie opposite each other on the color wheel—for example, red and green.) You can think of graying or "toning down" a color with its complement as a way of neutralizing or naturalizing it.

Mixing a pair of exact complements gives you a completely neutral gray. To vary the results and thus achieve more visual interest, try choosing not your given color's exact complement but one that lies to either side of it on the color wheel. Using a near-complement from the warm side of the wheel lets you create a gray that advances. Choosing a near-complement from the cool side results in a receding gray. Use the guidelines for the Transparent Watercolor Wheel to select the most suitable colors for mixing compatibility. What may be the most obvious choice may not always be the most compatible. A neighboring color from another ring might be a superb alternative.

If your objective is to create a dark gray, you must start with a color that is inherently dark in value. Thus, it is useless to select a yellow for the base color of a dark neutral, since yellow is simply too light. Remember, *value* describes a color's lightness or darkness relative to a gray scale. You must develop a good appreciation for color value. I've found that squinting helps me easily determine a color's value. Squint at the yellow swatch shown here. Notice how close it is to the light end of the gray scale.

Judi Betts, KALEIDOSCOPE, 15 x 22" (38.1 x 55.9 cm), collection of the artist

Judi Betts's painting Kaleidoscope *shows how effective grayed colors can be. By selecting transparent and semitransparent colors in complementary or triad schemes, she has created radiant variations that help to bring more emphasis to the purer color statements. More than 75 percent of the color in this successful painting is neutralized.*

Value is the term used to describe the relative lightness or darkness of a color. Here, notice that even at maximum strength this yellow is located at the light end of the gray scale. You can't make a dark from a light-value color. Value awareness is an important element of color choice.

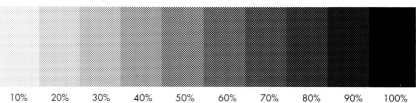

10% 20% 30% 40% 50% 60% 70% 80% 90% 100%

DARK GRAYS

There are hundreds of possibilities for creating dark grays. Let's slip around the wheel clockwise and begin with Hooker's green, a transparent nonstaining color. Across from it in the same category lie rose madder genuine and permanent rose, colors that are compatible mixers with Hooker's green but that aren't deep in value. According to the guidelines, the transparent staining colors Winsor violet and alizarin crimson or carmine could cause problems because of their staining qualities. Moving one step further outward to the semiopaque and opaque ring, we alight on cobalt violet and quinacridone violet. Cobalt violet is too light in value, but quinacridone violet is dark, and also compatible!

Next, look at your reds. The darkest among them is carmine or alizarin crimson. Choosing carmine, and knowing that the best mixer for a transparent staining color is another one in the same category, we note that permanent green and phthalo green are perched opposite the reds on the same ring of the Transparent Watercolor Wheel. Phthalo green is darker, so when mixed with the carmine it yields a very dark, effective neutral.

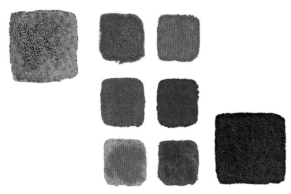

To create a gray, here are the choices to combine with Hooker's green, shown at top left. Rose madder genuine and permanent rose (top pair) are too light in value to create a dark. Alizarin crimson and Winsor violet (center pair) are staining colors that might work. From the semiopaque and opaque ring, the possibilities are cobalt violet and quinacridone violet (bottom pair). Cobalt violet is too light in value, but quinacridone violet is physically compatible and deep in value. Mixing it with Hooker's green results in the gray shown at bottom right. Not only is the mixture dark; it is, despite its deep value, luminous.

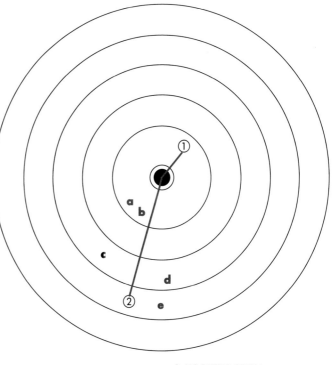

1. HOOKER'S GREEN
2. QUINACRIDONE VIOLET
(a. rose madder genuine)
(b. permanent rose)
(c. alizarin crimson)
(d. Winsor violet)
(e. cobalt violet)

Carmine and phthalo green are shown at left. The first mixture to the right of this pair is very close to a complete neutral. The second is slanted to the warm side with more red, and the last to the cool side with more green. Subtle color selections such as these allow you to make objects advance or recede in space, and can make a painting significantly better.

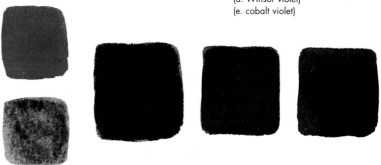

MIDDLE-VALUE GRAYS

When you need middle-value grays, the possibilities broaden. There are more mid-value colors to choose from, as well as a variety of pigment characteristics that can make for more expressive mixtures. For instance, manganese blue will contribute a lovely settled texture. French ultramarine blue, raw umber, and cobalt violet are examples of other sedimentary colors that, as they dry, settle to produce a beautiful granular effect. Let's explore a few interesting color swatch combinations.

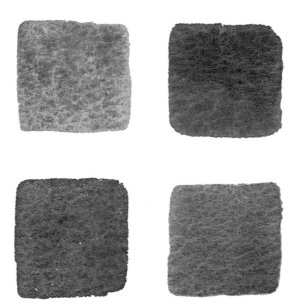

Mid-value grays are plentiful. Shown at upper left is a mixture of manganese blue and vermilion. To its right is a mix of French ultramarine blue and burnt sienna. At bottom left is a combination of cerulean blue, rose madder genuine, and aureolin. At bottom right is a gray made of raw umber, mineral violet, and French ultramarine blue.

Here are a few more grays. When they are sitting next to one another, you can see that one is more red, green, blue, or whatever. But when they are used within a painting, only gray is perceived. The eye seeks to neutralize the color. You are tricking human vision. Use grays like these to your advantage to create a mood, a feeling of depth, form, or space. Reading from left to right, the color samples in the upper row are mixtures of cobalt violet and olive green; cobalt blue and burnt sienna; and rose madder genuine and viridian. In the bottom row they are, from left to right, mineral violet, sap green, and raw sienna; viridian, cobalt blue, and vermilion; and permanent rose with Hooker's green.

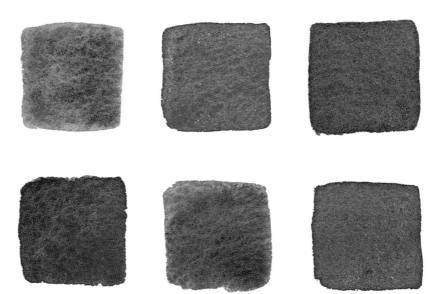

LIGHT GRAYS

When it comes to light grays, nearly any combination will work. It is best to stick to the guidelines for the most pleasing results, although wandering outside those parameters will be hardly noticeable. There isn't enough pigment introduced in a light gray to make an obvious visible difference. If you opt for a slightly muddy mixture to begin with, know that should you wish to restate it later, your options are limited. A slightly muddy mixture glazed over another slightly muddy mixture produces . . . mud! With that advice in mind, look at the grays shown here and you'll notice that even poor color combination choices seem effective in a single application.

If you spend two or three hours working on your own color samples, you'll be well on your way to glowing results. I practice what I preach. Being familiar with the guidelines, I don't refer to them any longer, but the Transparent Watercolor Wheel is posted next to my painting table, where I refer to it often. Whenever I find myself wandering from it, little problems inevitably arise.

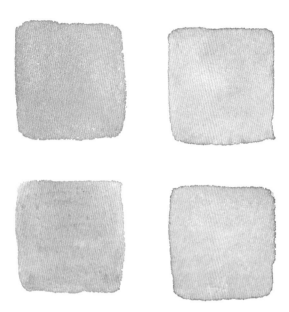

The colors used to create these grays are a little out of the ordinary, and if used more heavily, they would be dull. Used lightly, however, they are acceptably bright. The square at top left is a mixture of cadmium red and phthalo green; the square at top right is cadmium lemon yellow, turquoise blue, and alizarin crimson, which is generally a miserable combination. The square at lower left is violet gray plus olive green; the one at lower right is jaune brillant #2 mixed with indigo.

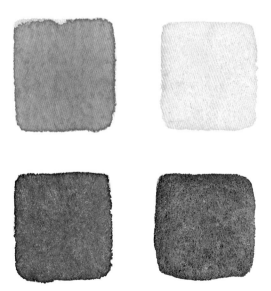

Prepared grays, to my eye, seem flat and opaque. Mixing grays yields more provocative colors. Here are four tube colors used straight. The top two are Davy's gray and grey of grey, respectively; the bottom two are, respectively, Payne's gray and peach black thinned to a middle value.

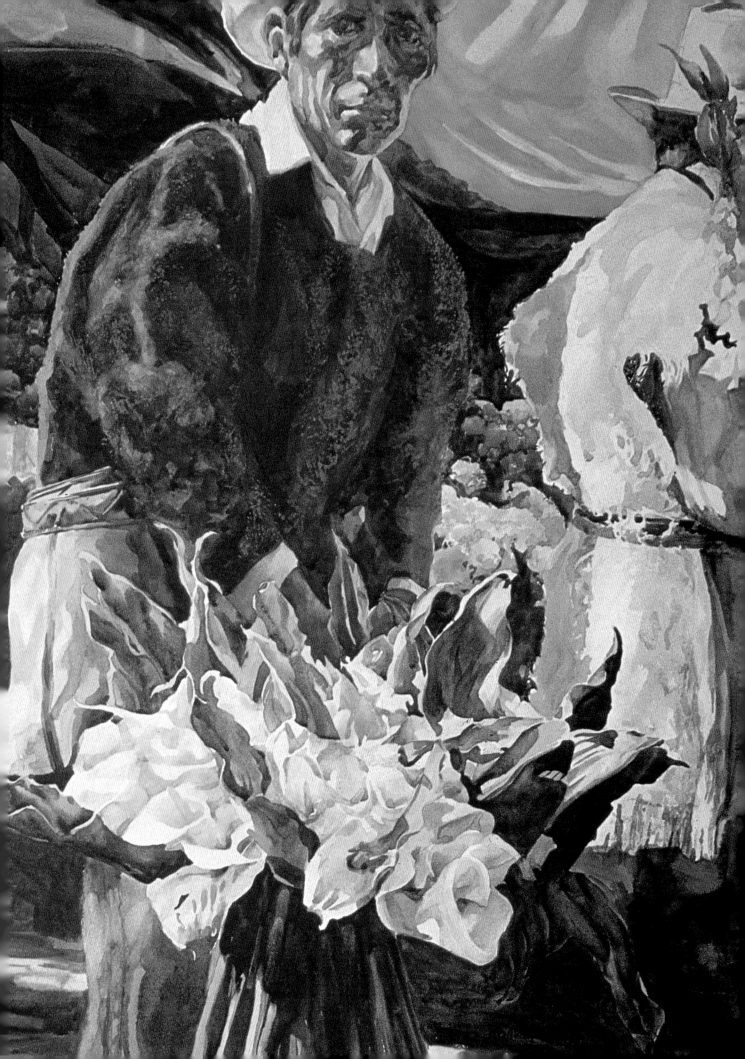

CHOOSING WATERCOLORS

Many artists choose watercolors by simply looking at a color chart and selecting those that are most appealing—like culling out their favorite jellybeans. Others adopt a palette of colors suggested by an admired artist. An experienced watercolorist might experiment with many different colors and brands, which can be tedious, time consuming, and expensive.

Although there is no "magic bullet" for finding the right paints to match your expectations, this chapter will supply the information you need to make intelligent decisions. Selecting individual watercolor paints involves not only color choice, but such considerations as permanency, lightfastness, and the variations in quality and performance that exist from brand to brand. By applying the information outlined here, you'll assemble a palette that is better tailored to your style and more archivally sound.

Few amateur watercolorists understand the differences between student-grade and professional-grade paints. I imagine that, unwittingly, a majority believes the student grade will be adequate and more economical during the learning process. The fact is, they offer false economy and will cause frustrating results. I'll demonstrate why.

Most watercolorists ignore permanency and lightfastness because the terms and standards seem confus-

ing. They really aren't, and the information offered here should help clear up any mystery. Also, discoveries in paint development indicate that some recent paints might be more permanent than we thought. On the other hand, some tests reveal that a few long-cherished colors aren't as durable as was previously believed. In my frank review of different brands of professional paints, you'll learn what to anticipate, good or bad.

Once you've absorbed this information, you can explore the specific color descriptions, which contain useful facts and some important precautions. I've chosen the most popular colors produced by the most popular manufacturers, giving attention to lesser-known ones where deserved. I may suggest color combinations or techniques that work well with a particular color.

Look up your palette colors, and rate their usefulness according to the guidelines. Are there some that overlap in characteristics and hue? Are there problematic colors? Check the color descriptions; you might find something more appropriate.

Palettes are very personal, and I've suggested a starter kit with some reluctance. If you are advanced, you might consider the advantages of this palette and how it might integrate with yours. Whatever you skill level, I urge you to explore color intelligently—continually.

Left: BLACK MAGIC, WHITE MAGIC, 29¼ x 21¾" (74.3 x 55.3 cm), Strathmore Imperial 500 140-lb. hot-pressed paper, collection of R. Crosby Kemper
Above: RIVETED, 20 x 28" (50.8 x 71.1 cm), Lanaquarelle hot-pressed paper, collection of Philip and Edith Hamerslough

SELECTING PAINTS:
PROFESSIONAL VS. STUDENT GRADE

Watercolor paints are composed of powdered pigments suspended in gum arabic and, most commonly, glycerin. Glycerin keeps the paint from drying, while gum arabic binds the pigment particles and makes the colors brilliant when applied to the paper; it is the watercolorist's varnish medium.

When it comes to selecting watercolors, I advocate professional-grade tube paints—period. It's understandable that a beginner might be hesitant to invest in professional-grade paints over the more economical alternative. However, to keep costs down, student-grade paints are extended with chalky fillers that hamper luminosity by blocking light that would otherwise pass through the pigments and reflect back. If you use student-grade paints, you can expect chalky results no matter how well you choose your color combinations. To illustrate the qualitative differences between the two grades of paint, I made two paintings (shown opposite) of the same subject on the same kind of paper, using professional-grade paints for one and student-grade paints for the other.

First, with the student-grade paints, the colors immediately turned muddy when I mixed the darks, especially the dark washes of the sculpture. Even floating in colors was futile. Middle tones are less than vibrant, since the chalkiness is still evident. The light passages of unmixed colors, such as the pure reds, yellows, and blues, are nearly the same visually as their professional-grade counterparts; because they are opaque colors, they will appear vibrant as long as they aren't mixed with other opaques. However, all student-grade paints are more opaque than those of professional quality, making it difficult to use them with the Transparent Watercolor Wheel.

The professional paints yielded rich, varied darks. It was easy to float in colors and keep washes workable over an extended period, whereas the student paints dried too fast to consider manipulating them. It wouldn't have done any good anyway, since the colors would only have become muddier.

Another problem with student-grade paints, and one that is seldom mentioned, is that when you charge your brush with a mixture on your palette, the brush hairs tend to splay and separate; to get the brush to point, you have to overcharge it with paint. In contrast, professional paints are so tactile that you can actually feel their creamy consistency, making it easy to charge your brush properly and know how it will react when you're laying down a wash.

Professional-grade pan paints— watercolors in dry cake form suspended in more glycerin than tube paints to keep them from cracking or powdering—are superb, but unfortunately just can't be relied upon to deliver a heavy charge of pigment without the effort of lathering the cake with your brush. The difference between pan and tube paints is like that between a bar of soap and liquid soap.

Yes, tube paints are expensive. Despite this, you'll find that the pigments are so concentrated that you'll use less paint to achieve better results. But before you buy, you need to know which brands are superior, and which colors are preferred.

POPULAR BRANDS
My recommendations stem from personal experience and colleague advice. The four brands I rely on most are Winsor & Newton Artists' Water Colours, Holbein Extra Fine Artists' Water Colors, Grumbacher Finest Watercolors, and Daniel Smith Finest Watercolors.

Winsor & Newton is the most widely used brand of watercolor paint in the world. The integrity of the pigments and their mixture is consistent and dependable, though to me some colors seem so concentrated that they are too thick to use without first diluting them on a mixing tray. When you want a charge of color, you don't necessarily want a heavy glob. Generally, though, you could use this one brand and never need another.

Holbein, a Japanese manufacturer, offers an excellent line of transparent watercolors. The tubes have a nozzle opening that's wider than most other brands (Winsor & Newton has followed suit), which allows an easier flow from the tube, and the tube material itself is light, which allows you to squeeze, fold, and roll the tube without cramping your finger muscles. The caps are relatively large, so you won't need pliers to loosen them. Last, Holbein's watercolor paint is like toothpaste in consistency. You can pick it up with your brush and use it immediately. This is because Holbein uses no wetting agent, such as ox gall liquid, in the

Student-grade paints as used in the example at left appear muddy and flat, as if mixed with chalk. Washes dry too quickly to allow for advanced techniques. Professional-grade paints as used at right glow with color and permit lengthy periods of manipulation. Because they have a higher tinting strength and last longer, they are a good value when compared to feeble student-grade paints.

manufacture of these paints. The result is a creamier paint that doesn't spread unpredictably when used in wet applications. In addition, it responds very well in dry-brush applications.

Certain of Holbein's exotic colors are more opaque than I find acceptable. Some of these are not entirely permanent and will fade relatively fast. You must refer to a permanency chart when buying any color of any brand of paint. I've also found that Holbein's phthalocyanine equivalents—colors with "permanent" as part of their name—have a color standard all their own. This means you can't simply substitute, say, Winsor & Newton's Winsor yellow with Holbein's permanent yellow, because they are oceans apart in appearance. A few colors are surprisingly transparent, such as raw umber

and raw sienna. Overall, Holbein watercolors are excellent, but I can't recommend basing an entire palette on them alone.

Although I use Grumbacher Finest Watercolors less often, I admire this maker's attention to quality and highly recommend these paints. The tubes are a little larger than other brands, which makes them economical by comparison. Also, the caps are larger and thus easier to handle. Grumbacher Academy watercolors are the firm's student-grade line.

Recent arrivals on the market are Daniel Smith watercolor paints, which are superior to many others available and rate very high on the permanency scale. For example, their sap green is rated extremely permanent, whereas most other brands of this color are rated two categories below. This mail-order

firm offers an exciting line of clean, vibrant, highly saturated colors—including many beautiful hues that I've never seen before. Daniel Smith's watercolors have a smooth consistency and readily mix into luminous washes. On a scale of one to ten, I'd have to rate most of them a twelve. I'm also pleased that many colors usually considered opaque or semiopaque in other brands are considerably less opaque in the Daniel Smith line. Still, there are a few colors that are quite disappointing—viridian, raw umber, and burnt sienna, for example, are dull and opaque by comparison to the competition.

Some of the other brands I recommend are: Rowney Artists' Water Colours, Schmincke, Sennelier, Le Franc & Bourgeois, and Talens Rembrandt Artists' Water Colours.

PERMANENCY AND LIGHTFASTNESS

Most of us would rather get down to the business of painting than worry about how long our works will last. But if you respect your art, you owe it to yourself to heed the issue of permanency and do what you can to ensure it. In large part, this means getting into the habit of simply checking the paint colors you choose against the manufacturer's durability classification chart. Since there are nearly six times as many desirable permanent colors as there are dubious ones, I believe it's actually easier to choose a permanent or durable color than it is a moderately durable or fugitive hue.

The major manufacturers, notably Winsor & Newton, publish technical bulletins that offer a wealth of information about their paints, including facts about chemical composition, behavior under various lighting conditions, performance in certain painting techniques (such as lifting), and durability in any number of situations. These technical bulletins may seem dry, but they contain lots of cogent information that can be put to good use.

We've all heard the assertion that watercolors are not durable, that they fade rapidly. This ridiculous claim has misled many people to think of watercolor as a secondary medium, one meant to be used in preparatory studies for serious works of art—paintings executed in oil. Several years ago I visited a museum in Maine that had on display a collection of watercolor paintings by Winslow Homer. The paintings were draped with black cloth, which the viewer

had to raise to look at the works. Considering the value of the paintings, this was not an unreasonable precaution. However, the lights were so dim I couldn't see the nuances of color and technique. I asked the curator if the lights could be raised but was told no, because it was felt that the light would fade the paintings! This is unfortunately a typical response and represents the general misconception about watercolor's durability.

Assuredly, many factors can cause the slow demise of watercolors, or for that matter, of any pigment-based paint. Classifying colors according to durability is helpful; still, measuring durability is not an exact science. In any case, we're artists, not scientists.

With few exceptions, the pigments used in the manufacture of oils, alkyds, acrylics, pastels, and many other mediums are all from the same mortar. Opaque mediums usually involve a thicker application of pigment, so there are more molecules backing up the surface molecules. It's the surface molecules that fade first, so unless you remove the surface layer of color and alter the painting, the concerns for fading are similar. Varnishes with ultraviolet filters protect the surface of canvas paintings. Similarly, a watercolorist who feels preservation is paramount should frame his or her paintings with UV-absorbing glass or acrylic.

Opaque mediums suffer their own durability problems, such as surface cracking or crazing that occurs over time. Works on canvas are in direct contact with surrounding atmospheric conditions

and are thus vulnerable in ways that are not concerns for watercolor paintings properly framed behind glass with a sealed back.

Transparent watercolorists don't mix white with their paints, whereas painters who work in opaque mediums do. Adding white to a color causes its durability rating to drop, sometimes dramatically. Thus, the durability of a very thin watercolor wash and an application of opaque paint mixed with enough white to approximate the watercolor statement is about equal. Beware—some of the colors you'll find on the Transparent Watercolor Wheel, such as grey of grey and jaune brillant, contain titanium white, which causes the permanency rating of the colors it's mixed with to plummet.

Colors fade in dissimilar ways, no matter what the medium. For instance, some colors fade slightly early on, then remain stable for a long period. Some hues eventually fade to white, while others darken with exposure to light. Most commonly, as pigments age, they suffer a loss of chroma and value.

The terms *lightfastness, durability,* and *permanency* are often confused with one another. Since watercolorists aren't concerned with how weather-resistant a color may be, permanency and durability may be considered virtually synonymous. *Lightfastness* refers to the effect of light upon a pigment. *Permanency* encompasses lightfastness, as well as the factors that can alter a pigment's physical state. For instance, in rating the permanency of ultramarine blue, it is duly noted that this color is instantly

bleached by acids; it is also noted that ultramarine blue is highly resistant to fading.

It's interesting to note that the permanency rating of alizarin crimson, a color long favored by many watercolorists, has been downgraded of late, presumably because it is not durable in thin washes or when mixed with white. Still, it remains an invaluable color and need not be banished from your palette, as long as you understand and accept its shortcomings and apply it correctly. A sensible alternative to alizarin crimson is Holbein's carmine, which visually is almost identical and which Holbein rates as absolutely permanent.

Phthalocyanine and quinacridone colors (such as permanent rose) are relatively young pigments, having been around for only fifty years or less. Tests indicate that they may be soon be rated absolutely permanent.

Paint tube labels contain more information than ever before, including ASTM standards (American Society for Testing and Materials), which indicate a paint's chemical composition and warn of any hazards. ASTM also establishes testing levels for pigments to determine permanency.

Colors such as the quinacridones and the more recent perylenes come from the automotive industry, where they were developed for use as car paints—which are expected to endure under extreme conditions. It appears that colors made from these synthetic bases will eventually be rated absolutely permanent—encouraging news, since most of these hues are bright, transparent, and handle exceptionally well.

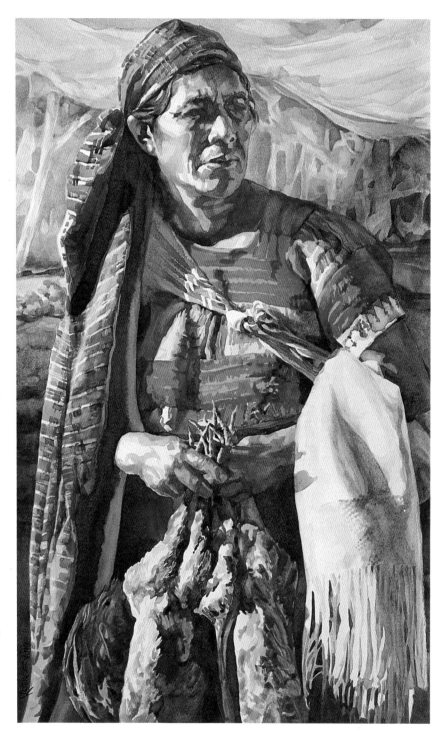

Silent Auction, 28 1/2 x 18" (72.4 x 45.7 cm), Strathmore Imperial 500 140-lb. hot-pressed paper, collection of Jack and Georgia Olsen

There is a plethora of reds in this painting. In the long scarf and the other dark reds of the clothing, I used Holbein's carmine rather than alizarin crimson, because it is visually indistinguishable, and is categorized as more permanent. In use, I prefer its characteristics over those of alizarin crimson.

COLORS ON THE WHEEL AND THEIR CHARACTERISTICS

In the next several pages I describe all the colors that appear on the Kosvanec Transparent Watercolor Wheel as well as a few that do not, presenting them here more or less in hue order starting with the yellows and progressing toward black and white. By no means do you need all of the colors on the wheel; I myself use quite a few in my work, but may select only ten or fifteen for any given painting. In fact, some of the colors described here are ones I've tried and put aside, or that I caution you to avoid in certain situations. Because a given color can vary from manufacturer to manufacturer in both look and handling, I've tried to indicate cases where this is a notable factor in choosing between one brand and another.

Winsor yellow (Winsor & Newton). This is a cool, semitransparent staining yellow that mixes readily with other colors, yielding especially clear, clean passages when you combine it with other transparent colors.

Permanent yellow deep. I use Holbein. This yellow is so warm, I'd consider using it in place of my semiopaque cadmium orange if it were in the same color category. It is a clear, staining pigment that may have a future on my permanent palette.

New gamboge. I use the Winsor & Newton and Daniel Smith brands.

THE FRENZY OF SPRING, 22 x 29" (55.9 x 73.7 cm), Winsor & Newton 140-lb. hot-pressed paper, collection of Mr. and Mrs. Thomas VanderMolen

The yellow-green of the grass reeds was created using cadmium lemon yellow and peach black. This unusual combination can make a rather convincing spring green. It takes no more than a touch of black to turn the yellow into a green.

CARVING A NICHE, 14¹/₂ x 21¹/₂" (36.8 x 54.6 cm), Strathmore Imperial 500 140-lb. hot-pressed paper, collection of Elizabeth A. Davison

By using raw sienna straight or in combination with other colors in the mid-value shadows of the rocks, I was able to make the passages glow as if reflected light was bouncing in. Also, notice how the juxtaposition of greens in the shadows helps the blues and violets become more vibrant.

This cheerful, semitransparent yellow is very versatile. It mixes well with other colors and is a good choice for glazing techniques. New gamboge is, to my eye, a "generic" yellow, not warm, not cool by comparison to other yellows.

Aureolin. From my analysis, the Holbein, Daniel Smith, and Winsor & Newton brands of this color are similar. I often use this moderately transparent, cool cobalt yellow for glazes. As a general rule, you must apply a yellow glaze before other colored glazes. Aureolin does not overpaint with the same clarity it seems to have as a first wash. In a paint well and when mixed, aureolin appears grayed, but the grayish effect disappears when the paint touches paper.

Cadmium lemon yellow. I use Holbein, Winsor & Newton, and Grumbacher. Very cool and almost indistinguishable from Winsor yellow, this semiopaque color must be used cautiously if it is to stay bright. I most often resort to cadmium lemon for flesh tones in fair-skinned subjects. It works well in combination with transparent colors for sunlit highlights, and is effective when used alone on untouched white spaces to create the illusion of rounded or receding surfaces. Cadmium lemon is also sensational to mix with black for believable spring greens.

Hansa yellow. This bright primary yellow is a nonstaining semiopaque color whose great potential is often overlooked. Daniel Smith's Hansa

yellow is a shade between new gamboge and cadmium yellow, which makes it worth consideration. It is also rated extremely permanent.

Cadmium yellow; cadmium yellow deep. I prefer Winsor & Newton's cadmium yellow for its hue and semitransparency, though find it a bit thick in consistency. Holbein's is nearly as semitransparent, with a better consistency. Cadmium yellow is a cheery color you'd likely see in a kindergarten room, so it should be used with some prudence. I use it in flesh-tone mixtures and where I need an appropriate color accent. Some brands offer a light, medium, and deep tint; I prefer the deep because it can be thinned with water to bring

it up to the value of the light tint yet retain intensity. Also, I find it slightly more transparent than the medium and light tints. The cadmium yellow light seems to be lightened with a chalky white filler that saps the energy from this otherwise vibrant yellow. All cadmium yellows have an idiosyncrasy to be aware of: If this otherwise stable pigment is exposed to high humidity and light, its permanency drops significantly.

Jaune brillant. Holbein makes this color in two values, #1 being the lighter; #2 is darker and more lightfast. Both are opaque, and should be used thinly to tone a light area. You can mix transparents with jaune brillant, but to avoid overpowering this delicate color, you should add any color cautiously. Don't use it for flesh tones; it is too predictable as such, and cannot be darkened without becoming chalky and dull. Using it thinly for highlights on fair-skinned subjects, however, is appropriate.

Naples yellow. This very opaque whitened yellow is a pleasing color, but its opacity and high proportion of white makes it difficult to mix and coordinate with clear colors. The chalky appearance of Naples yellow seems to draw attention to itself. It is rated as a durable color, but can be somewhat difficult to lift.

Yellow ochre. This is an opaque, nonstaining whitened color, although some brands are semiopaque and contain less white; there is much variation from brand to brand. I have several different tubes in my paint box but prefer to thin the more transparent raw sienna to get nearly the same hue. Yellow ochre will quickly muddy when mixed with anything except a transparent color.

Raw sienna. I've tried several brands and have settled on Holbein, which I find less opaque than others—I'd categorize it as semitransparent, while a few brands resemble sludge. I often use this earth color to suggest shadows filled by reflected light on rocks, trees, masonry walls, and the like. When used directly from the paint well and decisively scrubbed across a chosen area of the paper, raw sienna can add strength, direction, and variety to streaks of light. Although it does not mix well with most colors on the palette, it floats into moist washes with exquisite results. It lifts well but can leave a slight glow of "mellow yellow" behind.

Quinacridone gold. This Daniel Smith color is a semitransparent, moderately staining color that serves as a vibrant link between raw sienna and burnt sienna. Like all quinacridones, it leaves a trace of color behind when lifted. Unlike the phthalos, however, which stain other colors, quinacridones harmonize very well with other pigments. Quinacridone gold is rated extremely permanent.

Raw umber. I use Winsor & Newton, Holbein, and Grumbacher. This semiopaque nonstaining pigment is an earth color in the yellow family. In general, yellows applied over a previous wash appear dead, but raw umber can be an exception. It doesn't work well over all colors or over dark passages but, used discreetly, can save an otherwise yellow-starved part of a painting. I enjoy mixing raw umber with subtle colors like cobalt blue, cobalt violet, olive green, or burnt sienna and applying the paint in a pastelike consistency, leaving behind visible brushmarks and creating an effect that is more dramatic than what you'd get with a single flat wash using the same colors.

Burnt umber. This is a dark, semiopaque to opaque blackened brown that, when used alone, I find lifeless. The danger in using it to create a dark brown passage is applying it too thickly. However, I've found that by mixing in some alizarin crimson (or Holbein's carmine), peach black, Winsor red, or Hooker's green, I can subtly enliven burnt umber and swing the color temperature of the resulting dark brown toward cool or warm, depending on whether I want the color to advance or recede. It is important that the mixture be well suspended in water and allowed to pool on the paper, then left to dry undisturbed; otherwise it will appear dull. If you don't get the value right the first time, cautiously overpaint with a transparent staining color wash, taking care not to lift and mix the paint underneath. Burnt umber is easily lifted from most smooth surfaces, especially hot-pressed paper.

Warm sepia. This moderately nonstaining, semiopaque black-brown is a color I feel it's better to create from other colors than to give full berth on a palette, unless your subject matter includes a lot of weathered barn doors. Warm sepia contains a high proportion of black and is a good choice for painters who like to use black, because it is a natural-looking color. It also will mix well with yellows and greens to tone down deep forest colors.

Vandyke brown. I have a tube of Winsor & Newton's Vandyke brown and don't use it. A dark, semitransparent black-brown, this

TORTILLERAS, 27 x 37" (68.6 x 94.0 cm), Crescent 115 board, collection of JoAnn Heumann

I used raw umber liberally in the walls behind the women. The creamy consistency and transparent nature of this blackened hue allowed me to drag broken color over the surface to create a textural appearance. What's more, it glazes over light-value washes to impart a yellowish glow without becoming muddy like most yellows. Also, notice how light red can be an effective color for mid-value flesh tones of darker-complexioned people. However, since it can become muddy in a wink, it needs to be used with deliberation and not reworked once dried.

color is one you could easily do without if you don't mind mixing. It would fall between warm sepia and burnt umber on the outer ring of the Transparent Watercolor Wheel. If you decide to investigate Vandyke brown, be aware that it is fugitive, meaning that it changes hue over time.

Burnt sienna. I admire Holbein's burnt sienna, a beautiful, semi-transparent red-brown with a consistency similar to that of raw umber. This earth color is always on my palette, though you could do without it by mixing alizarin crimson, new gamboge, and olive green; viable substitutes for these colors are carmine, aureolin, and sap green. Approximating burnt sienna requires staining colors in the formula, which means you won't be able to lift your mixture from the paper. Also, the last color

to lift will be the green, which is probably just the opposite effect from what you wanted. Burnt sienna itself will leave a light sienna tone behind after lifting.

Quinacridone burnt orange and **quinacridone burnt scarlet** (Daniel Smith). More radiant than burnt sienna, these two semitransparent, slightly staining colors are rated extremely permanent. Both quinacridones are visually similar in a saturated wash, but when thinned appear very different. These colors have great potential for flesh tones and in landscape palettes.

Light red. I prefer Winsor & Newton. This color is thought to be opaque, but is semiopaque in my estimation. It is not very different from burnt sienna in color but is more powerful when used as an

overglaze for dark flesh tones. Try mixing light red with transparent yellows, blues, and greens to produce unusual dark greens. Light red isn't the most versatile color, and thus shouldn't be part of a limited palette.

Cadmium orange. I've settled with Winsor & Newton and Grumbacher's cadmium orange, an opaque color that, like other cadmium-based paints, can be thinned to a relatively transparent state and will still come through with a dynamic statement. Cadmium orange works well alone or in combination with other very light washes. Don't paint this color over a dark wash or you'll end up with a veil of gray. Instead, lift as much as you can of the previous wash, then lay down a saturated wash of cadmium orange. If transparency means anything to you, use cadmium

orange thinned with enough water to avoid a poster-paint application. Otherwise, it will surely be orange, but it will look flat and chalky. This color can readily be mixed from cadmium scarlet or cadmium red and cadmium yellow. There is no problem mixing any of the cadmium colors together; the results are no more opaque than the individual colors themselves.

Vermilion. I use Holbein. This nonstaining semitransparent red deserves to be more popular. The beauty of vermilion is its ability to mix with nearly any color for interesting warm tones. You can even create a golden color by mixing vermilion, new gamboge, and olive green. Variations of this combination using other yellows, greens, and blues work well for flesh tones. Also, I've found vermilion excellent for glazing flesh tones that need restating. Sadly, vermilion recently dropped from many charts. Manufacturers point to rising costs, scarcity of the mineral, and potential health risks. However, Holbein's vermilion is readily available, and I find little difference between it and the last of my Winsor & Newton.

Cadmium scarlet. An opaque orange-red, cadmium scarlet could be used in place of cadmium orange and cadmium red but is often overlooked. Cadmium scarlet stains the paper slightly when you lift it. Close in hue to vermilion, it can be substituted for that more expensive color but is much more opaque and less versatile.

Cadmium red. I prefer Winsor & Newton. Visually this opaque red is so robust it could be used on Christmas ornaments. Thus, it is best used for carefully planned "punctuations" within a painting, as it can become irritating in large amounts. Mixed with most other colors, cadmium red easily becomes muddy. Some combinations of mud, however, especially those made with this color, can result in a sensitive, smoky effect if they are applied with adequate suspension in water, are not oversaturated, and are not overpainted. Cadmium red is a special-use color you might not choose for a limited palette, but when you need its strength, it's difficult to replace. I use cadmium red *light* for flesh tones of fair-skinned individuals,

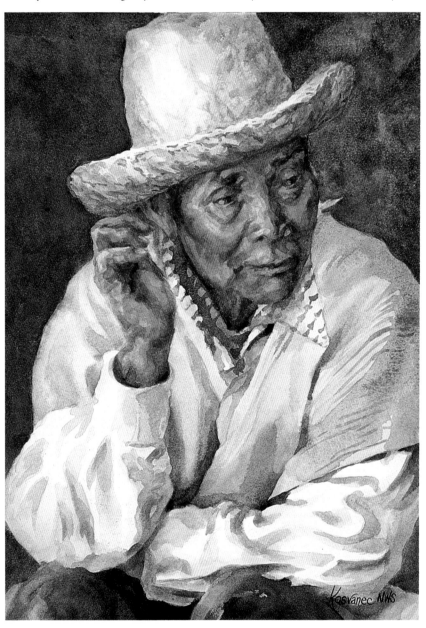

IDLE MOMENT, 19¹/₂ x 14¹/₂" (49.5 x 36.8 cm), Winsor & Newton 140-lb. hot-pressed paper, collection of Mr. and Mrs. Sherwood Boudeman

The whites and darks are of interest in this painting of a Mayan merchant. The whites were developed using thin washes of mineral violet, French ultramarine blue, raw sienna, raw umber, and manganese blue. The mineral violet base helps create soft, granulated shadows that appear back-filled by reflected light. The dark background was developed from blotches of phthalo colors, mainly red, blue and green, that were washed on and then partially lifted. The multiple layering and repeated staining caused a pebbled effect.

mixing it with Winsor yellow, new gamboge, cerulean blue, Hooker's green, or viridian.

Winsor red (Winsor & Newton); **Thalo red** (Grumbacher). Near equivalents of these colors are permanent red and Daniel Smith's perylene scarlet. These semiopaque staining primary reds lean a little toward the cool side of the color wheel, which you should keep in mind when formulating mixtures. The various reds mentioned here differ slightly from one another in hue and transparency. Winsor red is so saturated and intense that it's unnecessary to use it in anything but a transparent manner. You'll notice that in mixtures its red intensity disappears, and about half of its strength is lost when it dries, so plan accordingly and add more red than appears correct. Daniel Smith's perylene scarlet isn't as fickle after drying. I often use Winsor red as an underglaze for an area I intend to make very dark. The red is not apparent when overglazed, but quietly adds life and warmth to shadows. If you don't like the effect, start a new painting, because you're not going to remove this staining color without a battle.

Alizarin crimson. Winsor & Newton's alizarin crimson is excellent except for its less than desirable permanency rating. This transparent staining color is a blue-red I would be lost without. You can mix a plethora of other colors with it, such as an olive green, a burnt umber, a Payne's gray, and a burnt sienna, just to name a few. Alizarin crimson is also a useful color for creating dark flesh tones. Although it seems to be compatible with nearly every color, it is an intense staining color that should be added slowly and cautiously to mixtures.

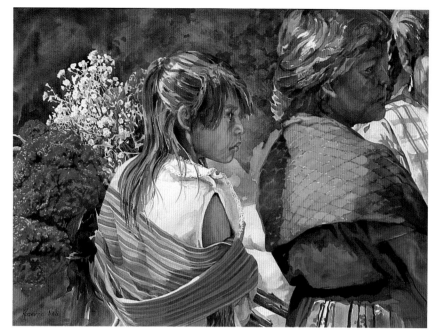

MOMENTARY DISTRACTION, 25 x 34" (63.5 x 86.4 cm), Arches 140-lb. cold-pressed paper, collection of Thomas and Rosemarie Morgan

French ultramarine is a beautiful, warm blue with an ability to settle and granulate in washes. It mixes well with transparent and semitransparent colors, but muddies when combined with opaques. The woman's dress is largely ultramarine blue and is mixed with rose madder genuine and viridian for shadow statements. I also mixed French ultramarine in the shadow of the woman's red shawl. Notice how the dark lines of the shawl in light are reversed to light lines in the shadow.

One unfortunate attribute is that when it is used in thin washes, alizarin crimson's durability rating drops. But in this situation you can substitute rose madder genuine. Alizarin crimson should be applied only in a saturated wash. Rowney's crimson alizarin is a brighter red with less blue than Winsor & Newton's. A good alternative to alizarin crimson is Holbein's carmine.

Carmine (Holbein). Holbein's carmine is rated absolutely permanent and is a good substitute for Winsor & Newton's less durable alizarin crimson. (Don't confuse matters and choose Winsor & Newton's carmine, which is rated low for permanency.)

Perylene maroon (Daniel Smith); **brown madder alizarin** (Winsor & Newton). These are blackened, staining semiopaque brown-reds

that are similar to each other in appearance. Perylene maroon is rated higher for permanency and is slightly more transparent than brown madder alizarin.

Indian red. I don't use this brown-red any longer; I can approximate its hue but get more pizzazz and certainly more transparency by combining other colors. For me, the major drawback of Indian red is that it has the quality of house paint, covering in one coat.

Opera (Holbein). I fell in love with this popular, intense pink, but then I noticed its permanency rating was in the lowest category. It is a fantastic color to use in flesh-tone mixtures, but I have replaced it with Winsor & Newton's permanent rose, which is rated as being more permanent. I am pleased with the similarity of results.

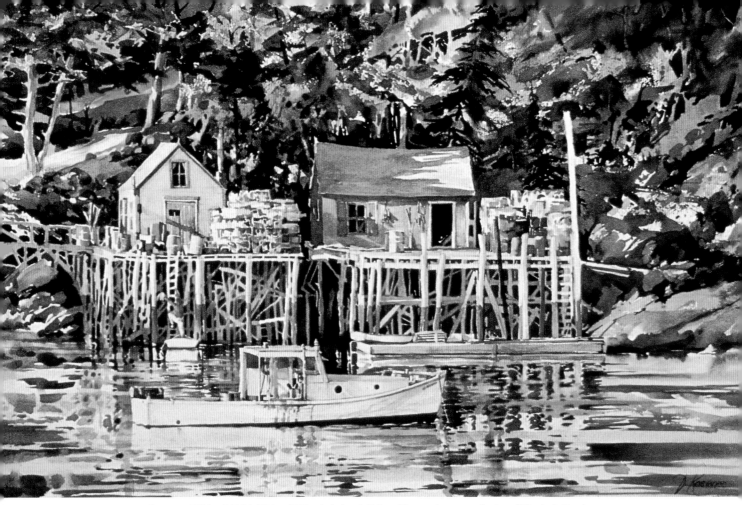

NEW HARBOR MORNING, 20¹/₂ x 30¹/₂" (52.1 x 77.5 cm), Arches 140-lb. cold-pressed paper, collection of Elizabeth Moody

It was fun developing the negative space between the pilings as well as their reflections. Once the darks and mid-values were established, I painted bolder, less conventional colors such as cerulean blue in the preserved whites of the light-struck pilings, and in various spots along the docks and in the wooded background. In the wooded area behind the shacks, I played value and color contrasts against one another. The greens of the groundcover and trees are played against oranges and siennas. Notice how the colors on the front of the building at right meld from rose madder genuine through cobalt blue and raw sienna. I selected cadmium red for the jacket of the man descending the ladder into the dinghy in order to draw attention to him. Without that bold color, he would be lost.

Permanent rose. I use Winsor & Newton. Daniel Smith's quinacridone rose is a near equivalent. This sensational transparent, slightly staining pink can be mixed with blues to create sensitive violets. I use it mostly in flesh tones when working with an extended palette. If working with a limited palette you could substitute it with thinned rose madder genuine.

Rose madder genuine. I use Winsor & Newton. This transparent color is very similar to alizarin crimson in appearance, just less intense. I prefer it for brighter, light-value washes; alizarin crimson is better suited to dark, saturated statements. A major difference between the two is that rose madder is nonstaining, while alizarin crimson is a very strong staining pigment. This alone could justify having both of these colors on your palette. Overall, rose madder genuine is more permanent than alizarin crimson and when used in thin washes is more stable. So, turn to it whenever possible.

Crimson lake. This beautiful semitransparent crimson (which does not appear on the Transparent Watercolor Wheel) could be quite useful if it weren't for its impermanent nature.

Quinacridone violet (Daniel Smith). A semiopaque, moderately staining color situated between crimsons and violets, quinacridone violet is rated extremely permanent.

Permanent magenta. I use Winsor & Newton. This semitransparent, slightly staining color is similar to quinacridone violet in many respects. It, too, is a quinacridone and is generally rated permanent.

Mineral violet (Holbein). This semiopaque nonstaining color could easily be renamed ultramarine violet. In handling characteristics it is similar to ultramarine blue, but mixes more easily with

other colors. Mineral violet combined with yellows and browns lets you create soft shadows that appear filled with reflected light. Mixing it with greens gives you delicate browns. This color is not essential, but you may find it useful on an extended palette. A combination of cobalt blue and rose madder genuine is a good substitute. Don't use an acid-based additive such as Winsor & Newton's Water Colour Medium with mineral violet or any other ultramarine-based pigment, as the acid will bleach the color.

Ultramarine violet. This color is just a little bluer than mineral violet; otherwise, its characteristics and the guidelines for handling it are the same. Two excellent brands are Daniel Smith and Schmincke.

Permanent mauve. Winsor & Newton offers this color only in dry half-pan form. A beautiful, semitransparent nonstaining color that is rated durable, permanent mauve is somewhat similar to cobalt violet in appearance but has softer handling qualities and, when dry, settles like an ultramarine.

Cobalt violet. I use Winsor & Newton. If you are on a budget, this color's cost will haunt you each time you squeeze the tube. It is a beautifully subtle semiopaque pigment with an interesting manner of granulating as it dries. It also mixes well with yellows, including raw sienna, to create a gorgeous glowing shadow effect. Cobalt violet can go muddy quickly if mishandled, and does not overpaint well. I've tried a few other brands and found them to be more opaque by comparison.

Winsor violet (Winsor & Newton). Holbein and Schmincke offer their equivalent, permanent violet. A

sensational hue, this semitransparent staining violet can be approximated by mixing alizarin crimson or Holbein's carmine with a little phthalo blue. Because Winsor (or permanent) violet is a staining pigment, you should approach mixtures with other color categories cautiously.

Mars violet. A dark, opaque brown-violet, this is a specialty color that doesn't lend itself especially well to transparent watercolor painting. However, mixed with a transparent yellow, it can produce a sensitive, muted warm gray.

Violet gray. This is another specialty color, which I have used carefully, knowing that its opacity might get me into trouble. Inherently light in value, it can be persuaded to change subtly with the addition of just one other color. Don't try adding two other colors, and don't lay it down heavily. Keep it thin and as transparent as possible.

French ultramarine blue. This color comes in light to deep variations. I use Winsor & Newton, Holbein, and Grumbacher. French ultramarine blue is a color with many frustrations and rewards. It is nearly opaque, mixes poorly with most semiopaques, and dries considerably lighter than expected. It has an attractive granular effect when allowed to flow and settle on fresh paper. Because it is a dark, warm blue, it is often called upon to strengthen foreground shadows in warm-toned mixtures. It is nonstaining and easily lifted if applied alone or in combination with other nonstaining colors. This is good to know, since overpainting is calamitous and leads to instantaneous mud. But mix French ultramarine with transparent pigments and you'll enjoy an endless variety of

energetic, luminous colors. All ultramarines are acid-sensitive. Don't use an acid-based watercolor medium with them, as the acid will bleach the color. Also, it's not advisable to use glazes mixed with watercolor medium over or under washes of an ultramarine.

Indanthrone blue (Daniel Smith). A fantastic primary blue, this color wets, mixes, stains, and dries like a phthalo blue. What I like about it is that it isn't as cool as most blues; it falls in line with cobalt and French ultramarine blue to form an important triumvirate of transparent nonstaining, transparent staining, and semiopaque primary blues.

Cobalt blue. I like Holbein. Depending on the brand, cobalt blue can be transparent to semiopaque; it is a nonstaining color that lifts well. Though seldom used by itself because of its very distinctive hue, it can be used to subtly tone down other colors that alone might otherwise be too strident. Considered a neutral blue—one that's neither warm nor cool— cobalt blue is easy to work with and is essential to either a traditionalist's or a purist's palette. Don't depend on it as a primary blue, in place of phthalo blue, as it is not intense enough to use in mixing deep, saturated colors.

Cerulean blue. I use Winsor & Newton. This opaque, nonstaining cool blue belongs on an extended palette. It is useful when mixing flesh tones of fair-skinned individuals or for articulating form on receding planes. It can be dropped into a painting to create transparent "jewels" of light. To avoid mud, mix cerulean blue only with transparent colors and avoid restating a passage you've already laid down. Inherently light in value, it will

look chalky and dead if called upon to create a dark mixture.

Phthalo blue. Equivalents are Winsor & Newton's Winsor blue and Grumbacher's Thalo blue. This transparent, strongly staining color is an indispensable near-primary blue. Although too cool to be considered a true primary, phthalo blue can be adjusted for temperature. Almost any color will mix with phthalo blue, but it stains some pigments in such a way as to reduce their luminosity. Some interesting results can be derived by mixing phthalo blue with different proportions of the other primaries, such as Winsor yellow and Winsor red, or new gamboge or aureolin plus alizarin crimson or Holbein's carmine. To add variety to a shadow area, float in some phthalo blue while the wash is still moist and watch it disperse and mingle with the color already on the paper, creating many interesting effects. The consistency of the color floated in should be fluid, but not waterlogged.

Prussian blue. I find the difference in hue between Prussian blue and phthalo blue very slight. Of the two, phthalo blue is not only more transparent but also more reliably permanent, whereas Prussian blue is said to fade in light and recover in darkness.

Cyanine blue (Winsor & Newton). This color has a strong likeness to phthalo blue in hue but is essentially a nonstaining semitransparent color, meaning it can be lifted. But, like Prussian blue, it fades in light and recovers in darkness.

Antwerp blue. A beautiful, semitransparent nonstaining blue-green, this color has a sensational granular texture. Diluted, Antwerp blue loses much of its strength. This could be compensated for, but unfortunately it is another of the mysterious disappearing/reappearing pigments.

Manganese blue. I use Winsor & Newton and Holbein, preferring the latter slightly for its consistency. Manganese blue is a semiopaque nonstaining turquoise whose most distinctive quality is its ability to produce a granulated effect. Like ultramarine blue, it breaks into minute rivers and valleys of color as it dries. If you mix another nonstaining semiopaque with it, the colors settle together, creating an interesting textural lacework. Manganese blue is too light to be useful for dark mixtures, but because of its cool temperature, it is more often used as a background color. Manganese blue deserves a place on an extended palette. Experiment by mixing it with raw umber, raw sienna, burnt sienna, or cobalt violet for some interesting effects. In recent years manganese blue, like vermilion, has dropped from several manufacturers' color charts. Its demise would be unfortunate, as it's a color with no equivalent.

Turquoise blue. This is one of those colors you probably wouldn't buy unless you like painting water scenes of the Bahamas. I have used Holbein's a few times to discover a flat and dull result. Daniel Smith's cobalt teal, a near equivalent, isn't as opaque or as Bahamian. If you need a decent mid-value gray, try combining either of these two colors with cadmium red, scarlet, or orange, but take care not to let the mixture become heavy and opaque.

Indigo. I use Holbein. This is a semiopaque, moderately staining blue-black that can easily jump the fence and run away with your painting. If you use it straight, with the intention of laying down a dark passage, its metallic quality will usually distinguish itself unflatteringly. It does not overpaint well and seems to deaden glazes, but it can modify colors if used subtly. It makes varied greens when mixed with yellows, oranges, umbers, or siennas, but I don't believe this is enough reason to use it.

Phthalo green. Various makers have their own names for this color, including permanent green, Winsor green (Winsor & Newton), Thalo green (Grumbacher), and monestial green (Rowney). I'm hooked on Winsor green and Daniel Smith's phthalo green BS ("blue shade"), although Rowney's monestial green runs a close third. This semitransparent staining green is almost indispensable. Its tinting strength is so great that the small amount needed in mixtures must be considered transparent in application. Phthalo green is used in hundreds of important mixtures, including browns, greens, grays, luminous blacks, and beautiful clear glazes. This cool, deep color is particularly useful for creating receding planes. Though you might be able to approximate it by mixing other colors, you'd fall short of its rich, dark intensity when you add yellow. For a relatively nonstaining green, try Holbein's Hooker's green or the less intense viridian.

Phthalo green YS ("yellow shade") (Daniel Smith). I've separated this color from the other phthalo greens because it is much warmer. Almost a pure, "primary" green, it is bright yet capable of very dark statements. In all, it is one of the most beautiful greens I've seen or worked with. It's also rated extremely permanent.

Viridian. Holbein and Winsor & Newton are two brands I can depend on; Schmincke is also excellent. Viridian is a transparent, relatively nonstaining metallic blue-green of moderate intensity. Its bluish quality sometimes makes mixing a bit tricky if you're looking for a warm green. Unlike phthalo green, however, you may add viridian to other colors without having to use microscopic amounts. Viridian alone is not a natural-looking color, except perhaps in backlit ocean waves. Try combining it with yellows, oranges, reds, and earth colors to create creamy mixtures you can maneuver with your brush for special foliage effects.

Hooker's green. I use Winsor & Newton, Grumbacher, and Holbein. A warm, natural green, Hooker's is transparent and nonstaining to moderately staining, depending on manufacturer. It's surprising how much this color also differs in hue from one brand to another. Holbein's has a warm, yellow summer green appearance, and although it stains the paper slightly, I've included it among the transparent nonstaining colors. Winsor & Newton's Hooker's green light, on the other hand, belongs with the staining colors. Winsor & Newton's Hooker's green dark (and Grumbacher's Hooker's green deep) are cooler, blacker colors that stain the paper and appear dull and lifeless. They don't mix as well with other colors as Holbein's Hooker's green, which has a compatible intensity and doesn't overwhelm subtle mixtures. Its transparency and range will generally keep you out of trouble. I often use this green in flesh-tone mixtures and when expressing receding planes and form. It's also useful in formulating greens of all sorts. If you were to limit yourself to just one

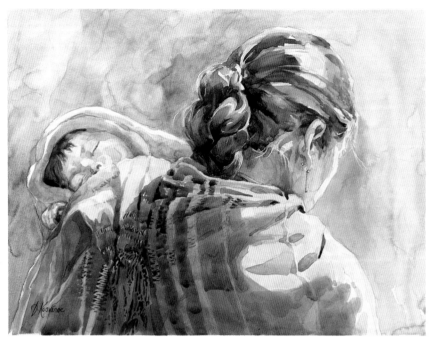

CRADLED IN SLUMBER, 14¹/₂ x 19¹/₂" (36.8 x 49.5 cm), Crescent 115 board, collection of Betty and James Drenning

In this tender painting I wanted a light background that wouldn't interfere with the figures. Manganese blue, which is most evident next to the child's face, was cool enough to make the background plane recede without distraction. On the mother's right, I mixed manganese blue with raw sienna and rose madder genuine to create the delicate granulated green wash.

green for your palette, choose Holbein's Hooker's green.

Terre verte. This is a nonstaining, semiopaque blackened green. To me this color looks like nothing in nature except swamp algae; I'd like to hear from painters who have found a use for it.

Sap green. I have used Winsor & Newton, Holbein, and Daniel Smith. This gorgeous, semitransparent yellow-green stains the paper somewhat but not other colors it's mixed with. It has a beautiful consistency and combines well with many colors. I depend on sap green for creating interesting effects, texturally lifting nonstaining pigments applied over it to reveal the staining remains of green. Some brands of this color are less durable than others, and in the past, because I could find no substitute that worked as well in

dark mixtures, I would use it very cautiously—only in a deeply saturated state whose density I hoped would compensate for this color's tendency to fade. Fortunately, Daniel Smith now makes a sensational sap green that is better than any I've used and is rated extremely permanent. Try mixing it with other transparents such as alizarin crimson (or Holbein's carmine), aureolin, or quinacridone colors, and with earth colors such as siennas and umbers for interesting greens or glowing reds.

Cobalt green. Currently I'm using Holbein. This opaque nonstaining color (it will stain the paper a little, but not other colors) should be used cautiously to avoid mud. Alone, applied to fresh paper, it has a superlative, luminous green quality much like reflected light. I've used cobalt green in combination with nonstaining complementary

THE GIFT, 19¹/₂ x 14¹/₂" (49.5 x 36.8 cm), Winsor & Newton 140-lb. hot-pressed paper, collection of the artist

Hooker's green, the most important green on my palette, is used here to make the eye sockets recede by the bridge of the nose. I also used it to model the form of the woman's forearm. The greenery incorporates sap green, olive green, and viridian, straight or mixed with yellows for highlights or with reds for dark areas.

colors such as vermilion, cadmium red, and burnt sienna to devise an array of soft, warm to cool mid-value grays. Don't mix it with staining colors, which will dull it.

Olive green. I use Winsor & Newton and Holbein. This is a semi-transparent, nonstaining, natural-looking green that can be used straight from the tube. It mixes well with rose madder genuine and

alizarin crimson (or carmine) for rich, warm, luminous browns. I also find it useful for flesh-tone mixtures. Olive green is not an essential palette color; you can easily mix it from aureolin or new gamboge and viridian or Hooker's green, plus burnt sienna, burnt umber, or light red.

Green gold (Daniel Smith). If you like glowing spring greens, you'll

love green gold, a semitransparent nonstaining color that is extremely permanent. To achieve a similar color, I previously had to mix a touch of black with yellow, but the result was never as transparent or as vibrant as this tube color.

Davy's gray. Opaque and nonstaining, Davy's gray is a warm, atmospheric color, almost the glowing gray you see engulfing a lighthouse along the Maine coast. It is subtle and tones well with light semiopaque colors, but use it thinly or it will dry bland and dull. I consider it a special-use color. A word of advice: Left on the palette overnight, Davy's gray sets as hard as a chunk of mortar that's not worth salvaging. Just pry it out of the well and put down a fresh blob.

Grey of grey (Holbein). This alabaster gray contains a high proportion of opaque white. It can be used as a neutralizer; when I want a light section of a painting to lie still and not draw attention, I introduce a smidgen of grey of grey to tone it down. Occasionally I have used this gray for sunny highlights on flesh instead of leaving the paper white. But these are weak reasons to use this color; Davy's gray would be a better choice.

Payne's gray. A distinctive, unnatural-looking metallic blue-gray, this color is a transparent staining pigment that can work in dark passages but will often dry 50 percent lighter than it appears wet. So, typically it is restated, and turns muddy or dull. When used thinly for light passages, its durability rating falls.

Neutral tint. This semiopaque paint is supposed to neutralize a color without changing its inherent qualities and hue. But in my

opinion, neutral tint doesn't work; it is too violet not to affect complementary colors. It also fades very fast when applied in thin washes.

Ivory black. This is a warm, semiopaque black; lamp black is its cool counterpart. Neither is a natural color to use in transparent watercolor techniques. The only justification for having them is for mixing with yellows to create greens, or to sign your name audaciously.

Peach black (Holbein). A warm, semiopaque nonstaining black, this is a popular color I use infrequently. If there is any peach in this black, it's well hidden. It can be mixed with yellows to create some especially convincing greens that give the sense of light shining through leaves. I've also used it with burnt umber to generate a dark brown similar to warm sepia or Vandyke brown, and it will darken transparent colors nicely. Be careful to allow whatever color you use with peach black to dominate; otherwise the combination will appear as unnatural as a poster paint black.

Charcoal gray. Winsor & Newton's charcoal gray is one of the most neutral blacks I've ever used. When diluted it lacks the greenish quality found in other blacks. Although I seldom use black, I'd highly recommend this one to any painter needing a stable black capable of spanning the value range without changing color.

Chinese white. I'm not sure I should even mention this semiopaque white, which is not useful for covering up mistakes; for that, you need white gouache. Chinese white can be added to colors to cut their brilliance. If you do this with one color, you need to follow suit and add it to most or all others or the painting will lack harmony.

LOW TIDE, 21 1/2 x 29 1/2" (54.6 x 74.9 cm), Arches 140-lb. cold-pressed paper, collection of Allan Davis

Although I used a full palette for this painting, the colors were nearly all grayed with their complements to achieve the silvery atmospheric appearance. The point is, I never resorted to a tube gray or black, finding the mixed grays more captivating. Subtle grays in the water suggest gentle motion. Darker grays from the pilings' and dinghy's reflections tie the foreground and middleground planes together. The texture in the foreground rocks was accomplished by dipping a sponge in slightly diluted paint and "stamping" it onto the surface. The finer lines that seem to wiggle around as small fissures were painted with a rigger brush.

A PAINT STARTER KIT

Color choice is a very personal matter, but without some initial guidance a neophyte artist might omit certain valuable colors. For that reason I'd like to suggest a "starter kit" that includes colors from each of the five categories on the wheel:

Transparent Nonstaining Colors
aureolin
rose madder genuine
cobalt blue
viridian
Hooker's green (Holbein)

Semitransparent Nonstaining Colors
raw sienna
burnt sienna or quinacridone
 burnt orange
sap green (Daniel Smith)

Transparent Staining Colors
Winsor or permanent yellow
carmine (Holbein) or Winsor,
 permanent, or Thalo red
phthalo blue
phthalo green

Semiopaque and Opaque Colors
cadmium yellow
cadmium red
mineral violet
French ultramarine blue
cerulean blue and/or manganese blue

Whitened and Blackened Colors
raw umber
peach black
olive green

The total number of colors is twenty, more or less. If you want to reduce the numbers, drop olive green, Winsor (or permanent) yellow, mineral violet, manganese blue, and peach black.

AUREOLIN			WINSOR YELLOW
CADMIUM YELLOW			ROSE MADDER GENUINE
CADMIUM RED			CARMINE
RAW SIENNA			BURNT SIENNA
RAW UMBER			MINERAL VIOLET
CERULEAN BLUE			FRENCH ULTRAMARINE BLUE
COBALT BLUE			PHTHALO BLUE
HOOKER'S GREEN			PHTHALO GREEN
SAP GREEN			VIRIDIAN
OLIVE GREEN			PEACH BLACK

MY PERSONAL PALETTE

I use more colors than most water-colorists, including on my palette certain hues that are visually similar but physically different, allowing me to choose compatible pairings. The more you understand about the complexities of color selection, the more you'll want to stretch out beyond the basic colors. But don't complicate the situation. Some colors are so similar in hue and characteristics that assigning a well on your palette to each of them serves no purpose. Refer back to the descriptions of specific colors that begins on page 40. Before you make your selections, read the description of each you're considering. When you've narrowed the field, and are more familiar with the ways specific colors interact, the choices will be obvious.

I generally have about thirty colors laid out in my paint wells. An additional five to six are specialty colors, or colors I'm considering for replacement or permanent addition to my armament. I never use all thirty in a single painting. Since my paintings always have a bias toward one color family, when I begin work on a given composition I find myself choosing colors from one-third of the color wheel, selecting just a few complements from the opposite side of the wheel. The next painting may have an entirely different quality of expression, and I'll find myself almost led by the nose toward another third of the color wheel.

Here are the colors I use, ordered according to the way I lay them out on my palette: aureolin, Winsor yellow, cadmium lemon yellow, cadmium yellow, new gamboge, cadmium orange, raw umber, raw sienna, burnt umber, burnt sienna or quinacridone burnt orange, light red, vermilion, permanent rose, Winsor red, rose madder genuine, Holbein's carmine (or alizarin crimson), cobalt violet, mineral violet, cobalt blue, manganese blue, cerulean blue, French ultramarine blue, phthalo blue, indigo, phthalo green, viridian, Holbein's Hooker's green, olive green, sap green, and peach black. In my temporary paint wells I have jaune brillant #2, Winsor violet, cadmium orange/red, and turquoise blue. Another tray holds a selection of the Daniel Smith colors I'm considering. I'm certain many of these will augment my standard palette or else replace the same color produced by another manufacturer.

Check the color wheel, and you'll see that my colors are arranged in a counterclockwise direction around it. I start at the top with yellow, move through the reds, then to the blues, and back up to the top again. I position phthalo green next to phthalo blue on my palette because if I inadvertently splash a drop of one of them into the other, the result is inconsequential. However, both colors are such strong strainers that one stray trickle into the well of a weaker color could contaminate it. I try to avoid placing an opaque color, especially a cadmium, next to a staining color, because if I accidentally trail some staining color into the opaque color's well, the attack is brutal and sometimes fatal.

THE PAINTING PROCESS

My workshop students invariably value painting demonstrations. Following along step by step is an effective way to experience the considerations a watercolorist makes before and during the painting process. For a demonstration to be most beneficial, it should be interactive—with the artist answering questions and explaining thought processes as he or she proceeds. I've tried to simulate this situation by stopping between important stages to share my decisions, and hope to have anticipated and answered the questions you might have asked. Once I begin to paint, many decisions are made unconsciously. By taking copious notes as I went along, I've tried to capture all my thoughts on paper.

I begin each of the four demonstrations by explaining what motivated me to select the subject. I seldom paint something I'm not familiar with and believe the most successful paintings are the result of a profound affinity with the subject matter. Thus, a painting is often a narrative of your life's experience or fantasy.

Aside from the main theme of color choices, I define my reasons for paper and surface selection based on how their characteristics can contribute to

the success of a painting. Interestingly, you will see how this important preplanning sometimes can change the course of the painting's development. I explain how I consider composition and various elements of design before sketching, searching for color themes to unify the painting's mood and weighing how light and dark shapes might create engaging patterns. I also recount the changes I consider before committing the elements of my resource photograph to paper. Finally, I describe my brush selection and a few textural techniques I employ as I paint, and my concerns before embarking on the next stage.

Although we haven't yet covered some of the topics I'll touch upon, such as paper and brushes, I'm sure you are familiar enough with these tools to find my comments constructive, and perhaps returning to them after covering the other materials will be beneficial.

Following the four step-by-step demonstrations, we'll take a closer look at four more of my paintings. Color choice is the emphasis of these studies, with comments explaining my reasons for selecting certain colors or color combinations.

Every painting is like a journey for me. Some expeditions are better than others, but all are worth taking. Let's enjoy the journey and discovery process together!

Above and left, detail: BEASTS OF BURDEN, 25 x 34" (63.5 x 86.4 cm), Arches 140-lb. cold-pressed paper, collection of Mr. and Mrs. Edward Crockett

EXPRESSING THE QUALITY OF LIGHT

I grew up in Maine. I remember long drives along the coastline, where I was enchanted with the ageless struggle between earth and water. I was aware of a light that appeared to be filtered through gauze, diffusing highlights and the full, colorful shadows. It seemed to me, too, that an ochre aura pervaded this boundary between sea and rock. This sense of light and the accompanying smells beckoned my senses. I'll never forget it.

I painted *Returning to Port* in my studio in San Miguel de Allende, Mexico. At an altitude of nearly 7,000 feet, the air is crisp and the light is sharp. Colors vibrate here; shadows are distinct. In contrast, my memories returned to the diffused light and atmosphere of Maine.

As I began, my first decision concerned paper. I selected Winsor & Newton rough, a surface I felt would allow me to create interesting textures in the rocks. With that resolved, I thought about design, how color choice might describe a mood, and how I might diverge from the photograph I was using as my visual resource to achieve a more interesting painting. I decided on a bright blue sky with high, wispy clouds set against the bright white of the lighthouse and the darker trees and rocks. I felt a need to move the trees in front of the house to expose more of the structure, add a window with shutters, drop in a fence where there was none, change the flare of the lighthouse tower slightly, and take several other artistic liberties.

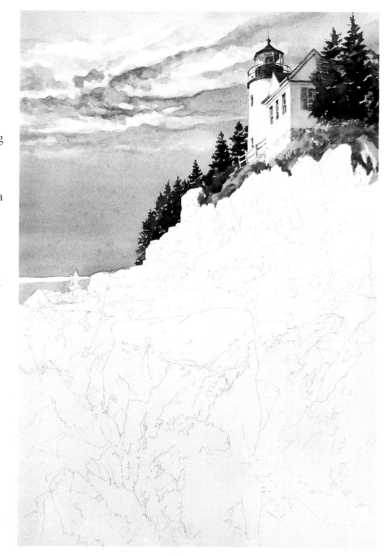

STEP ONE

As with most of my paintings, I began by applying aureolin in the mid-highlights. This time I modified the yellow with cobalt blue, rose madder genuine, and Hooker's green—all transparent nonstaining colors. The next step was to develop a more dramatic sense of light than existed in my rather dull resource photograph. I decided to paint the sky first, since this would set the timbre for what would follow. On a few painting occasions, when I've left the sky until last, I find it can lose compatibility with other elements. The painting found its own direction as I developed clouds and the tones within the sky. The colors I applied were deeper in value and more grayed than I had originally planned. The painting was taking me for a ride. I didn't resist; I followed obediently. Half of the sky was painted right side up and the other half, upside down. Doing this meant I didn't need to reach as far to work on the clouds; also, the pooling of colors from this position allowed the paint to create the darker sections of the clouds' undersides, which are naturally more dense. I used cobalt blue, rose madder genuine, raw sienna, and vermilion, painting these colors through the tree lines and down to the earth. In one glaze, I ran the color into the shaded side of the lightkeeper's house to create unity, although it was later modified with other colors.

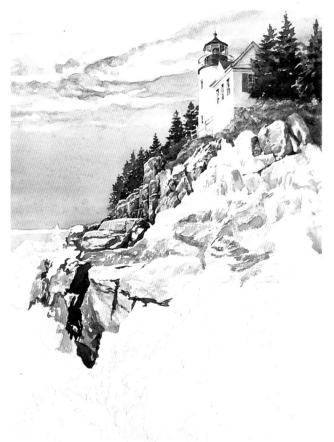

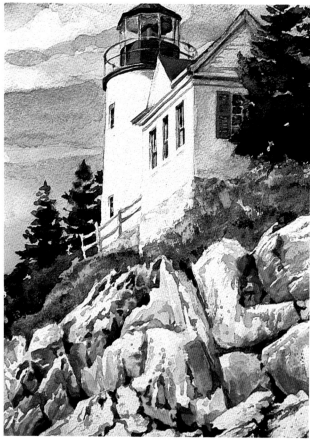

STEP TWO

Having finished the sky, I decided to tackle the center of interest, the lighthouse and adjoining building. Without my realizing it, they developed with greater detail than I had first envisioned. If I'd wanted detail, I would have opted for hot-pressed paper, not rough. Nonetheless, I couldn't ignore where the painting was leading me. I began these details using transparent nonstaining colors first, following them with transparent staining colors for the darker areas. The whites are light glazes of new gamboge, vermilion, turquoise, and jaune brillant #2. It may seem that these are a lot of colors to use to achieve white, but they help show form and light in a very subtle way.

I painted the trees using various combinations of reds and greens. The first glazes were very fluid, generally paint-ed wet into damp. The following glazes were more concentrated with color and were applied with a drier brush, which I pushed into the paper to splay the hairs, thus creating the visual effect of pine needles. I rendered the trees in the near distance with more detail as well as darker values to make them appear closer to the viewer. The darker values also had more chroma—meaning they were purer in color and less grayed. The more distant trees are lighter in value and less detailed, making them recede in space.

STEP THREE

My next step was to develop the grass and some of the sienna-colored rocks. I did this by applying loose, well-suspended, light washes of siennas and greens, and while the washes glistened I floated in cobalt blue, Hooker's green, and rose madder genuine to create darks. Once these areas were dry, I used an oil painter's hog-bristle brush to render spiny patches of modified greens using a drybrush technique, splaying the bristles to apply fairly dry, rather opaque paint.

The rocks already had a light glaze of yellow and raw sienna on them from the early stage of the painting. They shouldn't be as white as the house unless they are reflecting light from a water-soaked surface; since they weren't, I felt comfortable knocking them down one step in value. The first colors, raw sienna and burnt sienna, were applied in varying degrees of water suspension from wet to dry. The dry creates texture, while the wet develops form and mass. My next step was to mix raw umber and indigo to create crevices and darker shapes among the rocks, giving the impression of mass. Last, I reduced the importance of a few highlights to create more realistic lighting effects and to draw attention to the highlights that remained.

STEP FOUR

The foreground rocks contain large masses of shadows. In painting them, I wanted to give the impression of shape and keep some interest in the dark color. This is where fully liquefied suspensions, painted color into color on the paper, can be most interesting. If all the colors used were mixed on the palette and then applied to the paper, the effect would be boring and probably muddy by comparison—assuming the values were equal. The base colors were raw umber, burnt umber, and indigo. I floated in burnt sienna, cobalt blue, French ultramarine, carmine, Hooker's green, and mineral violet. If thoroughly mixed, these colors can quickly lead to mud, but allowed to mingle on the paper, they are stimulating.

STEP FIVE

With a light value of raw umber and a touch of cobalt blue, I established the underwater shapes of the reflecting pools. I then painted around each shape with a very fluid yet concentrated wash of burnt sienna, maintaining the wetness if an early section began to dry too quickly. I immediately followed up by floating in French ultramarine to darken the brown. Rather than cover it homogeneously, I continued to create the impression of the underwater shapes. Once the wash was dry, I ran a damp brush through the dark color, selectively dragging some through the lighter shapes of the raw umber. The dark section of water is not complete, but we'll come back to it in a moment.

The color that reflects the sky is cobalt blue and a smidgen of raw umber. The first wash was very light. The second wash, which had a higher concentration of cobalt blue, defines the shapes that extend from the shadowed water. Then a little raw umber painted through some of the highlighted areas helped to further unify the underwater objects, making them more convincing.

About this time the pools were well developed but lacked the refinements needed to mellow highlights that were hooting for attention. I mixed a glaze of Winsor blue and Winsor green and laid it very lightly over some of the more strident highlights. You can see some of the color in a more concentrated state to the left of the lower, center rock.

FINISH

Now I was ready to have fun punctuating the painting by strengthening shadows and accenting highlights. I often darken shadows with staining colors, and where I'd preserved a few whites within the shadow—which obviously shouldn't remain white—I applied this wash, tying together the shaded structure. When I began work on the highlights, I lightly glazed them selectively with color notes of vermilion, cadmium yellow and cadmium orange, Winsor yellow, and cobalt violet.

By dragging a damp brush on its edge, I took advantage of the rough paper surface to develop textures in the rocks. Note that the direction of the texture needs to follow the grain of the rocks to be credible. Another textural technique I used was spattering colors in selective areas. Where they seemed overly important, these spatters were partially blotted or lifted off completely. This is called negative spattering. (You can also do this by spattering clear water over a painted passage, then lift the color with a tissue.)

RETURNING TO PORT, 30 x 22" (76.2 x 55.9 cm), Winsor & Newton 140-lb. rough paper, collection of Mr. and Mrs. Thomas VanderMolen

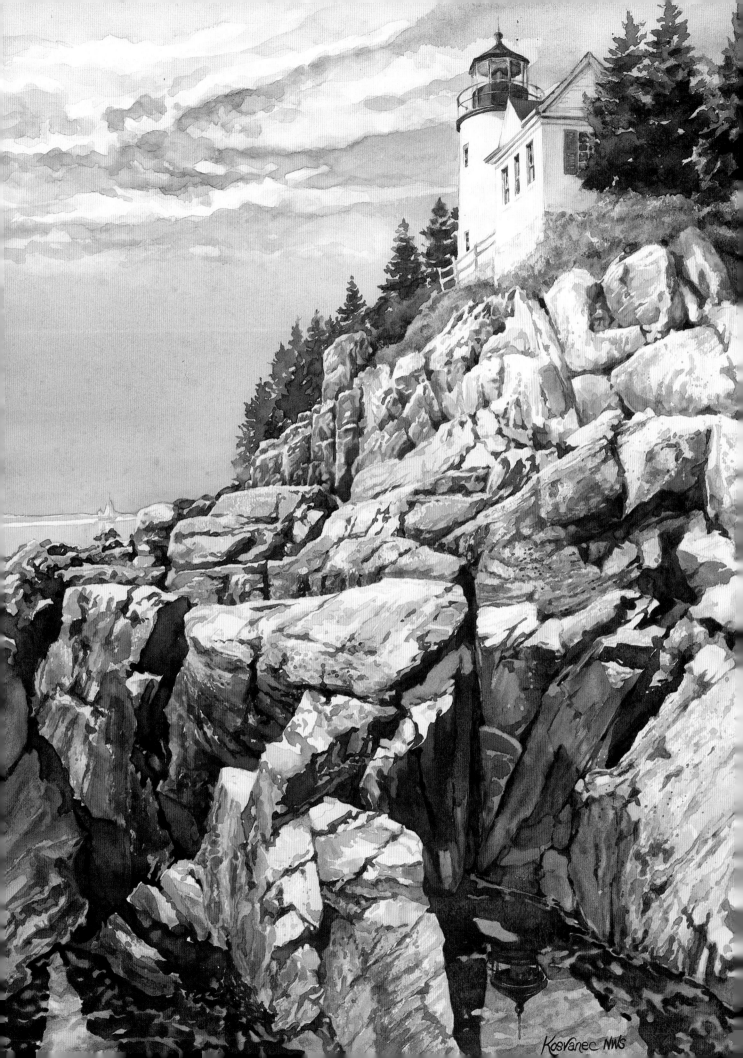

Kosvanec NWS

CAPTURING AN INTIMATE LANDSCAPE

I have passionate memories of early spring walks through national forests in New Mexico and Colorado. At times, my footsteps were the first to imprint the snow-covered trails. The solitude of this environment heightens my primal senses. I love the relationship between the self and nature, and having often absorbed the bond I strive to infuse it into my art at will.

This particular scene captures the essence of what transpires between water and rock during a spring thaw. When I first started photographing, I wanted to capture a landscape, mistakenly believing that a panorama would best symbolize the substance of my experience. But I discovered that for me, it didn't work. I realized that my focus was more intimate. Encapsulated scenes such as this one better reveal my relationship to nature's force, determination, and balance. In fact, I often prefer to crop my subjects tightly and capture an intimate moment regardless of whether I am painting human beings or inanimate objects. As I recall, this scene wasn't much larger than the painting's actual size of 20 × 15."

STEP ONE

As usual, I began with a wash of aureolin throughout the areas of the composition that contain yellow. I broke away from painting solely with the transparent nonstaining colors and used raw sienna and burnt sienna in various mixtures, applying them in mid-value to lighter washes. Using the same colors and introducing cobalt blue, Hooker's green, olive green, and raw umber, I mixed a wide range of hues and made lines in the rocks using the edge of my mop brush. Nearly all of the textures were created using the

mop after discharging excess liquid into a sponge. Sometimes I scuffed the edge of brush in the direction of the rock's grain; other times I pushed the bristles ahead of the handle.

The highest wedge of dark color representing the rock darkened by water on the right is rose madder genuine, olive green, Hooker's green, and cobalt blue. Further down the same rock, I used five to seven layers of washes to build the impression of the rock's texture and strengthen the shadow. I tried to be clear in my mind

about the direction of the rock's fissures and grain so as not to contradict my first statements by changing part way through. Here I relied on rose madder genuine, new gamboge, Hooker's green, and cobalt blue. At the lowest point of the rock, I reduced detail and floated burnt sienna into cobalt blue, raw sienna, and Hooker's green.

The shadow under the right-hand rock was painted over a glaze of raw sienna and rose madder genuine. The dark color is carmine, sap green, and Hooker's green. To ensure a dark shadow, I used a very fluid, heavy charge of color and floated in additional paint as the wash evaporated. When the wash was barely damp, I pressed a tissue into it to lift a few areas, giving the impression of reflected light. The small white droplets of water within this dark area were painted around rather than masked off with frisket. I find this method to be more expedient and to give more natural-looking results.

The upper left rock is shown here in the first few stages of wash development. Essentially, the same light-colored washes were used to begin this area. However, the darker color that will become the shadowed area should have a warmer glow than its neighbor, so I glazed raw umber and olive green in this section early on. Although these two colors are semiopaque, I've tried to keep them fluid and light enough in value not to hinder luminosity once other colors are applied over them. The risk is that the passage could go muddy if not thoughtfully handled in the next stage.

STEP TWO

To achieve the effect of light sparkling over the lower rock's glistening surface, I began by identifying the character of the rock and of the rushing water. The two elements weave through each other and are a challenge to paint convincingly. The smooth, hot-pressed paper precludes using surface texture to any advantage, so brushwork is needed to produce the effect.

Here, the painting is essentially complete. The most difficult part is remembering all the color combinations I used to create grays in the water. A few combinations are: vermilion with cobalt green or olive green; cobalt violet with aureolin; mineral violet or Winsor violet with raw umber or raw sienna; burnt sienna with cobalt blue or French ultramarine blue; rose madder genuine with

viridian or Hooker's green; and cerulean blue with burnt sienna or burnt umber used lightly. Since I mainly needed light-value grays, I could even have reached for semiopaques and opaques without undue concern.

Once the lightest values and subtlest colors of the water were complete, I continued building the rest of the values working light to dark. In some cases, I had a second color mixed and ready to drop in using a second brush. A third brush was handy to lay in a clear, damp wash of water, blending out wet washes to soften an edge. I was eager to lay down the darks, as they would give punch to the painting. It may seem that the swirls of grays were laboriously painted, but they were actually fun and not time

consuming. I developed their patterns in several stages; my thought was to create a sense of motion and form.

The lower rock that's awash was indeed a challenge. The layers of activity in its underlying form, coupled with the water and the various reflections, offered me a true chess game. Again, rather than using masking fluid or an opaque white to achieve the whites, I painted around the spots using fine-pointed #6 and #8 rounds and a #6 liner. The #6 round gave me more control, and the liner developed character. This was painted very quickly and not belabored. Normally while painting in this fashion, I hold the brush much more upright and closer to the end of the handle to avoid getting too caught up in details.

FINISH

Finally I was ready to dive into the darks. The warm dark combination I find most sensational is carmine (or alizarin crimson) with sap green or Holbein's Hooker's green. You can see areas where the red or the green base color is dominant, but none where the two create a neutral gray. When I need to neutralize this mixture, I often add cobalt blue. Within these darks, especially noticeable in the upper section of the fall, are some dark and mid-value yellow-based colors. They are raw sienna and raw umber, painted onto white paper while the dark color was still damp. To varying degrees, one blended into the other, but the impression is that of light shining through from the rocks below the falling water.

By restraining myself from overusing opaque colors, I produced a clean painting. As a reward, I was going to allow myself to let loose, within reason, with those little scamps. Finally I could place color notes throughout the painting. In effect, the cadmiums and other very opaque colors could do what they do best, which is to stand alone as vibrant color statements. I dipped into well-diluted cadmium lemon yellow for highlights, jaune brillant #2 to render an illusory warm glow to the water, and turquoise and mineral violet for interesting twists of unexpected color where they might lie next to their complements.

It's wonderful to be transported back to these cold streams in the Rockies without having to pay the fare.

DOWNHILL RUSH, 20 x 15" (50.8 x 38.1 cm), Winsor & Newton 140-lb. hot-pressed paper, collection of Mr. and Mrs. George Kunz

Kosvanec NWS

ADJUSTING TO CHANGES IN PAINTING STRATEGY

On the first of November people throughout Mexico, such as this young mother who has lost an infant, celebrate All Saints' Day, when souls of the *angelitos* are beckoned back for a visit. Latin Americans find this a solemn yet festive occasion. Saintliness is bestowed on infants because they die without sin and are unquestionably carried straight to heaven. To lure the young souls back to their terrestrial homes, loved ones line pathways and altars with colorful flowers, mindful of how youngsters are fascinated and attracted to them. Since flowers alone can't reliably accomplish this task, they also tempt the spirits with treats and candies while music and firecrackers round out this less than ambiguous solicitation. This celebration affirms that life and death are inexorably linked, and that the living and the dead can be spiritually one.

STEP ONE

In beginning a figure painting, I start with aureolin and permanent rose, both transparent nonstaining colors, to infuse the glow and tone of flesh. Normally during this stage, I also apply this light wash to any objects that have yellow or rose as part of their color base. This luminous underglaze helps them glow as the painting progresses. In this painting I give the hair this flesh-tone glaze as well to suggest a warm light source from the left.

STEP TWO

I usually start with the face and other exposed parts of the figure. That way if I blunder, I won't have wasted time on less demanding elements. Keeping values in mind, I added Hooker's green to the right eye socket next to the bridge of the nose, and applied cobalt blue along the transition line between sunlight and shadow. Once the forms were established, I introduced the semitransparent nonstaining colors to broaden color appeal. Where I might ordinarily choose burnt sienna, I substituted quinacridone burnt orange; likewise, I substituted quinacridone gold for raw umber. As the flesh tones and form quickly developed, I expanded my color selection to include additional semitransparent colors such as vermilion, new gamboge, and sap green. I sparingly used semiopaques and opaques such as mineral violet, French ultramarine, manganese blue, and indigo.

I don't leave hair until the face is completed; instead, I initially contribute some of the flesh-tone colors to it. To ignore the hair until later usually alienates it from the head like a cut-rate wig. Occasionally, as the colors deepen, I scrape moist (but not wet) paint with a fingernail to reveal a light strand of hair.

I'm not certain how or why I wavered from my original intent of keeping this painting soft and muted, but contrasts and color intensity rose sharply. Mindful of my departure, I compensated for the shift as I began to suggest shapes and color in the back-

ground. Was I was pleased enough with the painting's progress to continue? I saw potential and revised my approach. I now envisioned bright reds in the background.

I continued with the leaves, using combinations of Hooker's green, sap green, cobalt blue, aureolin, and quinacridone burnt orange. Then I began the shawl. Since many local colors reflect into its muted violet shadows, describing what I used might become very confusing, so here I mention just the simplest combinations.

The base color is cobalt blue and permanent rose with a touch of aureolin. To this I added quinacridone gold, quinacridone burnt orange, or mineral violet.

Up to this point I've stayed away from staining colors for the sake of this demonstration. That's not to say that I wouldn't ordinarily use them. But until you can confidently choose appropriate color combinations, they should be avoided until the figure is well established, since you may need to lift color and revise.

JUANITA'S MEMORIES, 15 x 20" (38.1 x 50.8 cm), Crescent #115 hot-pressed board, collection of the artist

FINISH

During this last stage, I painted the ribbon and dress with vermilion and glazed cobalt blue and vermilion to create form and value. The shadow areas were defined with this last combination plus quinacridone burnt orange. The shadows of the shawl were further developed with various mixtures of rose madder genuine, cobalt blue, and quinacridone burnt orange. With a stiff half-inch synthetic bright brush I lifted highlights in the hair, ribbon, and shawl.

For the sake of simplicity, I described finishing the figure first, but I actually painted no more than the first wash of vermilion on the mother's dress and ribbon and then slipped over to the bougainvillea. The first washes were the lighter, cooler color of permanent rose. While squinting, which I do a lot, I loosely developed the patterns of positive and negative shapes of the foliage at the right side of the composition. I restated the bougainvillea, again using permanent rose mixed with mineral violet. The last stage in developing the petals was to apply carmine; in some places I applied a transparent layer of it over the greens to enliven them. The dark green stalks and leaves in the lower right were combinations of Winsor violet with Hooker's green, sap green, or Winsor green brewed with occasional dashes of quinacridone gold and quinacridone burnt orange. With the painting nearly complete and the outline of the lilies well defined by a strong background, I went back into the lilies with jaune brillant #2, cadmium lemon yellow, and manganese blue. I felt the cool staining colors of phthalo blue and green would illuminate some sections of the bougainvillea leaves, so I rewet areas with water and selectively floated in these colors. Using the same philosophy, only with less color intensity, I glazed phthalo blue along the rim light of the young woman's face. After stepping back to analyze the work, I accentuated the background value behind the shawl on both sides of the woman to set the two planes farther apart.

As an afterthought, I realized I was using a tool that is seldom discussed in watercolor painting—my finger. Whenever I need to reduce or maneuver a wash, I unhesitatingly adjust it by smearing it with my finger. If you employ this sophisticated method, don't forget to wash your hands afterward to avoid ingesting potentially harmful paint compounds.

DESCRIBING THE PLAY OF SHADOWS AND LIGHT

Around the turn of the century the town fathers of San Miguel de Allende built a "laundromat" for public use below the picturesque waterworks, erecting concrete tubs and scrub boards. Even before these "modern" improvements came about, women would wash their clothes at the site, pounding them on rocks bathed by a natural spring. These days, water still streams in abundance free of charge for anyone to use. The tubs, lined by trees and foliage, are awash in dappled light, and the reflection of local color furnishes a painter with a multitude of opportunities. The atmosphere here thrums on those days when chatty women gather to gossip under the pretense of laundering clothes!

STEP ONE

I started this painting with a full complement of transparent nonstaining colors rather than my usual aureolin and rose madder genuine or permanent rose. My intent was to explore light and emphasize color in shadows, and to concern myself with shapes and design. Through this first stage, I concentrated mostly on the figure and the wall behind her. From this, I can begin keying the values and coloration of other elements as I proceed.

STEP TWO

I intensified the shadows on the tubs and walls with quinacridone burnt orange, quinacridone gold, Hooker's green, and cobalt blue. The woman's apron was rendered with mixtures of quinacridone gold, cobalt blue, and aureolin. At times I would float in color while also lifting some of it from the shadows to create the illusion of reflected light. The green blouse was aureolin and Hooker's green, intensified with a subsequent glaze of cobalt blue. Later, I defined the dark shadow folds with a dense green made of Hooker's green and rose madder genuine.

I looked forward to painting the foliage as a maze of shapes. To develop the negative shapes, I used an orange base color of aureolin and rose madder genuine; you can see this in the background at right. Once I completed the pattern of leaves and branches, I applied weak glazes of viridian and Hooker's green in wide bands to several areas at left.

Next, I created additional shapes, expanding the labyrinth of leaves with different mid-value combinations of Hooker's green or sap green with quinacridone burnt orange or cobalt blue. This reduced the orange base color to an "underglow" that related better to the colors in the foreground. In the middle of the background, note how I tracked the line of small tree trunks and branches behind the foreground leaves. I also placed a few glazes of Hooker's green and manganese blue over the lighter leaves. On the left, the darker values were developed with glazes of carmine. At this point, I felt the foliage on the left was too busy. But rather than tone it down at this early stage, I chose to wait until more elements evolved, when I could better coordinate this area with the rest.

Unconsciously, I chose a lettering brush to paint the foliage, which seemed suitable at the time. I fancied the way it cut from a fine chisel, then opened to a broader line.

I wanted to tackle fabrics next, since the shapes are an essential element of the design. The sheet hanging over the edge of the tub was painted with vermilion and turquoise blue to create the gray; the green-blue is a diluted turquoise blue. Near the bottom of the sheet, I floated in raw sienna to give the impression of reflected light filling the shadow. The light yellow towel is cadmium lemon yellow with mineral violet in the shadows. Choosing a color's complement is often the most expedient and conventional way to paint its shadow. I raised the chroma in the mid-values by slipping in some quinacridone gold.

The first glazes of color on the shadowed back wall and the tubs created a good foundation for exploring descriptive texture and balancing values. To do this I painted many glazes of greens over the dark orange, avoiding the staining phthalos. After one glaze dried, I grabbed a coarse damp sponge and selectively stamped its texture into the dried paint. After fifteen seconds or so, I gently blotted the areas with a tissue. More glazes followed; finally, with a #6 round, I spattered some clear water on shadows and again partially lifted color with a tissue.

I loosened some of the shadows along the lighter back wall using a #8 round and clear water. I scooped up excess water and pigment with a thirsty brush and, while floating in French ultramarine blue, restated the shadows with a lighter value. Next, I painted light red along the sunlit side of the tubs, using a little indigo with olive green and quinacridone burnt orange to suggest cast shadows. Then I accented a few of the whites with a thin glaze of jaune brillant #2.

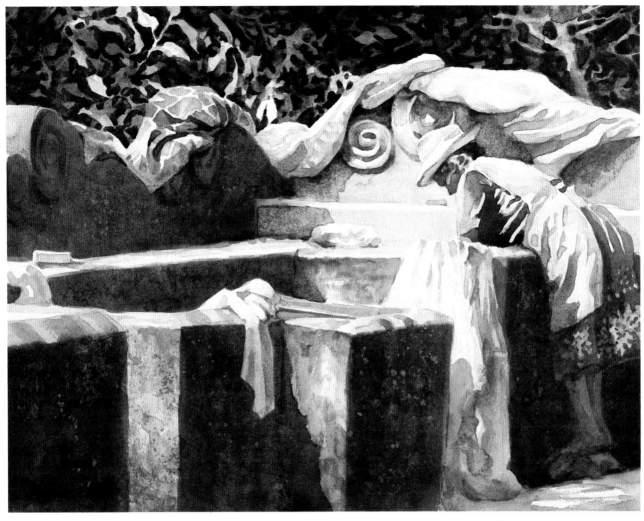

BELOW THE WATERWORKS, 15 x 20" (38.1 x 50.8 cm), Twinrocker cold-pressed paper, collection of the artist

FINISH

My last effort was to complete the foliage. Once the entire background was well developed, I made a mix of quinacridone burnt orange and Hooker's green to darken particular sections more. Because I had inattentively chosen a lettering brush to paint the foliage, it was too distinct, busy, and stylized. So, to subdue it and tie together disparate elements, I elected to lay in broken glazes of carmine and phthalo blue. This was followed by carmine and sap green to create another transparent dark that could further reduce the importance of distracting areas.

ANALYZING PAINTINGS

Having followed the process of creating four paintings, let's examine another four, scrutinizing color choices more closely. Each is figurative, but even if you don't paint figures, you'll find useful information regarding color selection and combinations that will work with any subject. Here, some colors are selected according to their temperature or for their compatibility in combinations, while others are chosen for their tactile quality. Surely, there are many more reasons for choosing colors, and listing them would be a lifetime's work, but this section should give you a glimpse of the analytic process used in color selection. You'll even find muddy combinations chosen for a purpose!

After studying the information in the callouts that border these paintings, try using the same approach in your work. With some practice, choosing colors according to their effectiveness in a passage should become second nature. You'll be painting more thoughtfully, and your paintings will be more luminous and engaging.

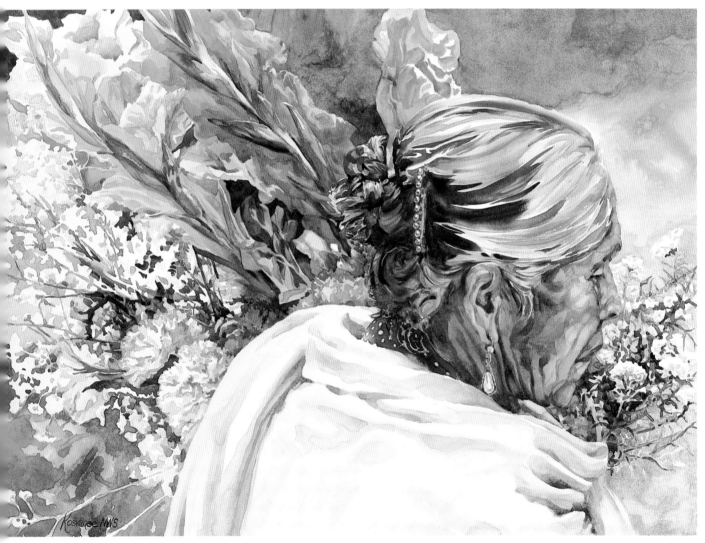

REMEMBRANCE, 21³/4 x 29¹/4" (55.3 x 74.3 cm), Winsor & Newton 140-lb. hot-pressed paper, collection of Mr. and Mrs. Thomas VanderMolen

Aureolin with cadmium red and/or cadmium orange; darks contain burnt sienna and olive green.

I paint hair spontaneously, sometimes applying the colors so thickly that they are opaque. In this case, the burnt umber is too heavy in a few spots but the combinations of raw sienna with olive green and raw sienna with mineral violet, plus highlights of staining colors such as Winsor blue and violet, seem to compensate for the opacity. The deepest darks are burnt umber, alizarin crimson, and Hooker's green.

Working wet into wet, I mixed Winsor blue and alizarin crimson on the paper with random strokes of sedimentary earth colors such as raw umber, burnt sienna, and raw sienna. When this was nearly dry, I lifted sections of color with a tissue. The staining colors remained, but dulled sections were left where the tissue didn't remove paint. The result is a glowing atmospheric effect from the staining colors, surrounded by muted random shapes of the stained earth tones.

Vermilion and cobalt violet with a little permanent rose.

Here you can see a range of hues created with rose madder genuine as a base color. Hooker's green dominates the deep shadow. Olive green and aureolin are under the front of the cheek, with rose madder darkening it below.

Mineral violet and manganese blue, modified with raw sienna.

Alizarin crimson, Winsor blue, and olive green create a muted, nonluminous background color. Just to the right, raw umber and French ultramarine blue mixed with these staining colors create a similar effect.

Aureolin filters through mineral violet, raw sienna, and finally cadmium orange, suggesting reflected light.

After an initial glaze of aureolin as a base color, I used mixtures of aureolin and rose madder genuine or permanent rose, sometimes modified with cobalt blue, Hooker's green, or olive green. For lighter flesh tones I generally use cobalt blue, cerulean blue, and cobalt violet with rose madder genuine and aureolin. Avoid trying to state dark values with this latter combination or you will produce mud, since none of these colors is inherently dark in value. Highlights used to model form are cool colors, such as Winsor blue, Winsor green, cobalt blue, Hooker's green, or manganese blue.

A Single Figure, 20 x 15" (50.8 x 38.1 cm), Winsor & Newton 140-lb. hot-pressed paper, collection of Gayle Paulson

Here I used aureolin and cadmium orange, mixed with manganese blue and carmine. When the wash was nearly dry, I lifted some of it with a thirsty brush to create the highlight and accent the form.

Mineral violet was used for highlights. Raw sienna, raw umber, burnt umber, and French ultramarine blue were used in various combinations. Some areas are slightly muddy, and therefore more subdued. This is an appropriate, intentional use for muddy colors; here the muted hues give relief to the stronger color in the hair and face.

Various mixtures of mineral violet and raw sienna, with additions of manganese blue, French ultramarine, and vermilion.

I began the painting with a glaze of aureolin over all areas that would include yellow. This seems to brighten later glazes. Here I placed cadmium red/orange over the initial aureolin glaze, then intensified the aureolin with Winsor yellow.

Aureolin, carmine, burnt umber, and French ultramarine blue were floated in over a thirty-minute period.

Aureolin, vermilion, and cadmium orange with a hint of cobalt blue.

This section is a complex mixture of vermilion, new gamboge, mineral violet, raw umber, Hooker's green, and manganese blue. I floated in the colors, carefully separating them into compatible groups.

Mineral violet, manganese blue, and raw sienna.

Aureolin and vermilion are the highlights, turning to cobalt violet.

Hooker's green and aureolin; shadows include mineral violet and/or burnt umber.

Permanent rose and cobalt blue were used for warmer passages, manganese blue and cobalt violet for cooler ones.

Many combinations here, including Winsor violet with cobalt blue and aureolin. The yellowy green is aureolin or new gamboge plus indigo. The cooler greens and darks are combinations of Winsor green with carmine and new gamboge or olive green. The muted gray is olive green with cobalt violet. My intention was to push and pull the warm/cool combinations. Shadows are warm here. Note the bright touches of unmixed colors.

FULL IN THE MOMENT, 20 x 15" (50.8 x 38.1 cm), Winsor & Newton 140-lb. hot-pressed paper, collection of Mr. and Mrs. Edward Crockett

Along the part in the hair, flesh tones of aureolin, rose madder genuine, and Hooker's green blend into mineral violet and cobalt blue with a little cadmium orange floated in.

To create this section of hair, I used French ultramarine blue, burnt umber, and a little Winsor blue. This is a dull combination that subdues the passage. The Winsor blue grays the more opaque colors, giving the hair a silvery appearance.

The brightest highlights are Winsor yellow. Where the basket rounds, the orange is cadmium lemon yellow floated into cadmium orange. This gives more visual variety than mixing the two colors together on the palette. The darks are glazes of Hooker's green, burnt umber, and Winsor violet.

This section is largely made up of burnt sienna, alizarin crimson, and Hooker's green. The highlights are permanent rose and cobalt blue.

Cool permanent rose is juxtaposed with warm vermilion.

While an initial layer of strong French ultramarine blue was barely damp, I laid in a wash of indigo with a little burnt sienna.

A mixture of burnt sienna, vermilion, and rose madder genuine is woven with permanent rose and French ultramarine. In cases like this, when I need to tone down color intensity, I use a complement, such as olive green to create a warm passage or Hooker's green for a cooler one.

To make this basket recede visually, I added Winsor blue to a mixture of aureolin, raw sienna, and Hooker's green to stain and thus dull the colors. Note the contrast between the basket and the colors used to describe the bag; this shows how when used deliberately, muted colors can be as important as luminous ones.

I created this interesting shadow using cobalt blue and mineral violet, with reflected shadow colors of their complements. The yellows are new gamboge and raw sienna.

TREASURED, 20 x 15" (50.8 x 38.1 cm), Winsor & Newton 140-lb. hot-pressed paper, collection of the artist

Winsor yellow with Hooker's green was floated into spattered water to create a random speckled effect. Some flowers have a thin glaze of warmer cadmium yellow.

Alizarin crimson and French ultramarine blue meld into raw sienna and manganese blue. By mixing on the paper rather than on the palette, the colors find their own boundaries and aren't the muddy brew they might be if combined before application.

Burnt umber and French ultramarine blue combine with rose madder genuine for the darkest passages.

Pure cadmium red. The darks are Hooker's green and burnt umber.

This is Winsor blue and burnt umber. A dull combination such as this can create a sense of distance and receding space because it doesn't demand visual attention.

For flesh tones I generally use a combination of aureolin, rose madder genuine or permanent rose, and cobalt blue or Hooker's green. Here, I also used cobalt violet under the cheekbone and cadmium yellow orange in the warmer sections. I use cadmiums cautiously in mixtures, since they can quickly become muddy when combined with other opaques or staining colors. They are best used alone.

Raw sienna and raw umber with aureolin and rose madder genuine.

Burnt umber, alizarin crimson, and indigo.

The flowers are cobalt violet and manganese blue. The greens are various mixtures of Hooker's green or peach black with aureolin. For the darkest darks I used burnt umber and Hooker's green or Winsor green. To create cool highlights, I used thin glazes of Winsor blue.

Combining alizarin crimson, Winsor blue, and burnt umber produces a slightly dull result, except where the alizarin crimson predominates.

Cadmium red and Winsor blue. This dull combination works to reduce the importance of the area and allows the adjacent reds to appear all the more luminous by contrast.

ARTISTS IN RESIDENCE

When I invited more than a dozen nationally known, award-winning watercolor artists to submit work and comments on their methods of color selection, it came as no surprise that their responses were as varied as their work. Finding the threads that link their diverse color statements proved a complex challenge for me. Some artists' comments contradict others, but all are worth heeding. Be open-minded! Consider what each artist has to say and use their ideas in developing your own color choices.

Each of these painters relies on a stable palette and a modest repertoire of color combinations. Likewise, all are aware of colors or combinations that might cause poor results and avoid them. When asked about experimenting with new colors, one artist admitted, "Even when I try new colors, I mix them to look like my old ones." Some say they never experiment, while the artist Dale Laitinen says, "My palette is evolutionary, not revolutionary. It is like the Grand Canyon, moving slowly through time."

I wasn't astonished to find artists who feel comfortable using transparent staining colors almost exclusively, downplaying or eliminating earth colors or strong opaques from the palette. I was surprised at how many artists use opaques—though often in glazes that are well thinned with water to render the dulling capacity of these colors insignificant. Most artists minimize opacity by skillfully laying down a passage and leaving it alone. Likewise, most paint color into wet color, allowing the paint to mingle directly on the paper. The fresh, clean colors in the works shown on the following pages attest to the fact that all of these artists manage to avoid overworking their paintings.

A few artists who had read my color theory before sending their material were apologetic about having broken what they perceived as rules. However, I'm offering only guidelines, which are meant to steer you in the right direction, not hinder the discovery process. After all, color choice is just one aspect of painting, and experimentation is to be encouraged.

All of these artists express a common reverence for setting complementary colors next to one another, as well as mingling them together in a wash. They nestle analogous colors for visual vibration, and juxtapose warm and cool colors to create spatial push and pull or strengthen a neighboring hue. Contrasts of value, temperature, and paint density are all considered important. In short, these educated, intelligent, very talented painters handle watercolor masterfully. I'm reminded of a quote by Robert Henri that appears in *The Art Spirit*: "Each man must take the material he finds at hand, see that in it there are the big truths of life, the fundamentally big forces, and then express in his art whatever is the cause of his pleasure."

Above and left, detail: REFLECTIVE COLORS, 22 x 30" (55.9 x 76.2 cm), Strathmore Imperial 500 140-lb. hot-pressed paper, collection of Eli Lilly

JEANNE DOBIE

In part, what Jeanne Dobie wrote about color in *Making Color Sing* (Watson-Guptill, 1986) motivated me to begin my research on color analysis, eventually leading to the Transparent Watercolor Wheel and guidelines. As a good book should, hers will appeal to the beginner and professional alike. There's much to be learned from her thoughtful writing.

Dobie's painting *Twilight Zone* is a nostalgic work that exhibits a splendid sense of atmosphere, light, and even temperature. Notice how the fluid reflections of the railing posts melt through values and color to a deeper value, anchoring the painting. The concentration of the deepest values and strongest colors at the center of interest appropriately magnetizes our attention. The complex ironwork of the chairs and table display endless nuances of clean, subtle washes that span from warm to cool, further stimulating the viewer's attention. The painting's success rests largely on the skill of the painter to convey a mood by harmonizing colors and contrasts in a manner that is a vision rather than mere representation. We are convinced and captivated by this moment in time.

Dobie writes that she prefers to keep her palette "reduced to the fewest pure pigments needed." Her colors are aureolin, cadmium orange, cadmium red, alizarin crimson, rose madder genuine, light red, Indian red, cobalt blue, French ultramarine, Winsor blue, viridian, and Winsor green. Dobie treasures aureolin, rose madder genuine, cobalt blue, and viridian for supplying her with glowing, pure colors that are visually substantial. When any of those four colors needs modification to neutralize their power, she will often add some light red. She warns against mixing cerulean blue, yellow ochre, and Indian red, as doing this can result in a combination muddy enough to ensnare a four-wheel-drive.

Jeanne Dobie, TWILIGHT ZONE, 20 x 29" (50.8 x 73.7 cm)

To create a luminous warm setting, Jeanne Dobie chose transparent rose madder genuine, aureolin, and cobalt blue for the sunset afterglow. The mountains were painted transparently over the sky area to allow the atmosphere to permeate through them.

Cobalt blue was muted with Indian red to prevent the color of the water from becoming too dominant.

Establishing an atmosphere is more important than replicating the scene. A misty wash of rose madder genuine and cobalt blue was used in the foreground for a cooler repeat of the sunset afterglow.

Here, Dobie again used Indian red as a glaze to meld the figure into the rosy scene. It added a mellow glow over the mixture of viridian and light red.

As Dobie describes it, the hardest thing to do when painting is to tone down an area that is "singing" with color, because it doesn't contribute to your concept. Here, she found she had to mute the dazzling brilliance of the cadmium yellow jacket with glazes of Indian red, aureolin, and viridian.

FAWN SHILLINGLAW

Fawn Shillinglaw is the perfect example of an artist who paints what she knows, lives with, understands, and touches her soul. She once wrote, "You can paint the Parthenon and sketch the Seine, but often the most inspiring subject matter lies right beyond the door." Wisconsin scenes are a recurring theme in her work, but her paintings are much more than mere representations of these settings. There is a story behind each one that, coupled with her exploration of light and atmosphere, creates an entrancing experience for the viewer.

Throughout her painting *Lunchtime*, there is a prodigious play of reflected light from the sky and all other objects as they influence one another. Shillinglaw writes, "I feel I am painting with reflected color and light."

Observe the contrasts within her painting. Elements such as the white post, the porch edge, and the railings seem to sparkle because they are played against the shadows behind them. Shillinglaw advises being mindful of two basic rules while painting: Work for the effect of light against dark, and of warm against cool.

Where does shadow color come from on white subjects? This is a question novice painters commonly ask her. "That's where beginners make mistakes," says Shillinglaw. "They use black or gray for shadows as if shadow were an absence

Fawn Shillinglaw, Lunchtime, 28 x 20" (71.1 x 50.8 cm), Arches 300-lb. rough paper

of color. But it is quite the opposite. Shadows are full of bright, colorful, luminous, transparent shapes…the sky is reflected, the leaves, the earth tones. All the colors can be found in the shadows [of white objects] for a subtle glow."

Shillinglaw chose her palette of Winsor & Newton colors long ago, based on their permanency. None, except for alizarin crimson, which only recently dropped in rating, is rated below A. Her palette consists of cadmium yellow, yellow ochre, cadmium orange, raw umber,

burnt umber, burnt sienna, alizarin crimson, cerulean blue, French ultramarine blue, Hooker's green dark, olive green, sepia, and Davy's gray. As for her paper preference, she uses Arches 300-lb. rough—"always."

All of these surfaces were rendered with tray mixtures of cadmium orange, burnt sienna, ultramarine blue, and alizarin crimson.

Here, Shillinglaw began with a very light layer of cadmium orange to set off the white post and show the warm glow reflected by the autumn leaves. Over this she painted a cool shadow mix of French ultramarine blue, toning it with alizarin crimson in some areas to reflect the influence of the leaves.

Here, there is a faint cadmium orange glow around the white highlight, which gradually mixes with French ultramarine blue near the peak.

To set the main door back from the screen door, Shillinglaw washed a darker combination of burnt sienna, French ultramarine blue, and alizarin crimson in the corners.

The dark interior under the steps needed to glow. To achieve this, Shillinglaw used sepia, French ultramarine blue, and alizarin crimson for the deepest dark, and while it was still wet, she dropped in cadmium red for a feeling of warmth.

To set off sunlit spots and the bright, colorful leaves on the sidewalk, Shillinglaw combined French ultramarine blue and cerulean blue with burnt sienna, cadmium orange, and a little alizarin crimson. She mixed these colors directly on the paper by keeping the surface wet and dropping in the paint. Later she applied sepia near the steps to add warmth.

Shillinglaw rendered the grass with olive green and a touch of aureolin for a warm, transparent green; over this she laid Hooker's green dark mixed with ultramarine blue or sepia and a hint of alizarin crimson.

JUDI BETTS

I'd seen Judi Betts's work in print but never had the opportunity to view it in person until I was invited to hang one of my paintings at a client's house. I'm not sure what they thought when, instead of proceeding with the task at hand, I walked over to study Betts's painting. She paints with a clear purpose. Her sense of pattern is almost mosaic, yet on a grander scale the design appears abstract. Her color is fresh and fluid, and when she does use an opaque combination, she skillfully knows how much liquefying it requires to remain semi-luminous. Her superb use of light electrifies simple subjects with excitement and character.

Betts often relies on triads. By choosing three primaries, she is able to create, theoretically, nearly any other color. For example, she might use rose madder genuine

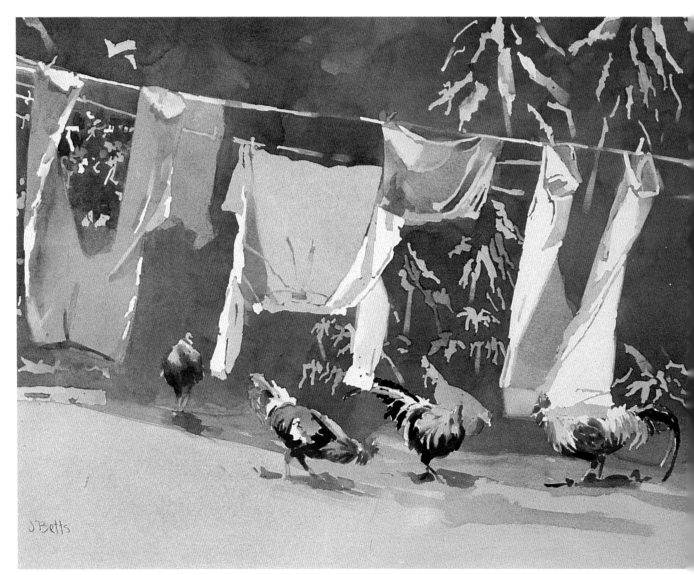

Judi Betts, MONDAY MAMBO, 22 x 30" (55.9 x 76.2 cm)

with aureolin and cobalt blue (a transparent nonstaining set of primary colors). Another possibility is Winsor red, Winsor yellow, and Winsor blue (transparent staining), while a third is yellow ochre, cerulean blue, and Indian red (nonstaining opaques).

She uses sedimentary colors with restraint, and avoids using large amounts of staining colors. I find it interesting that as the body of a painting develops, Betts, like me, saves the whites of the paper, punctuating them with clean, bright colors at the end. Many successful paintings are composed with mostly grays, and *Monday Mambo* is no exception. Betts uses many combinations of colors to blend her grays, mixing cool, neutral, and warm variations. In this particular painting she created a neutral gray glaze using aureolin, cobalt blue, rose madder genuine, and ivory black. The glaze could be warmed or cooled as well as varied in value as needed.

Betts's extended palette includes nearly thirty colors, but she relies primarily on cobalt blue, rose madder genuine, aureolin, cadmium orange, Winsor red, and Winsor blue. Her secondary choices are generally burnt sienna, raw sienna, ivory black, cerulean blue, and warm sepia. She good-naturedly says that she rarely considers adding new colors, since the current ones keep her "VERY busy and intrigued."

Here, several layers of a neutral gray glaze made of aureolin, cobalt blue, rose madder genuine, and ivory black were used.

The gray glaze is warmer here.

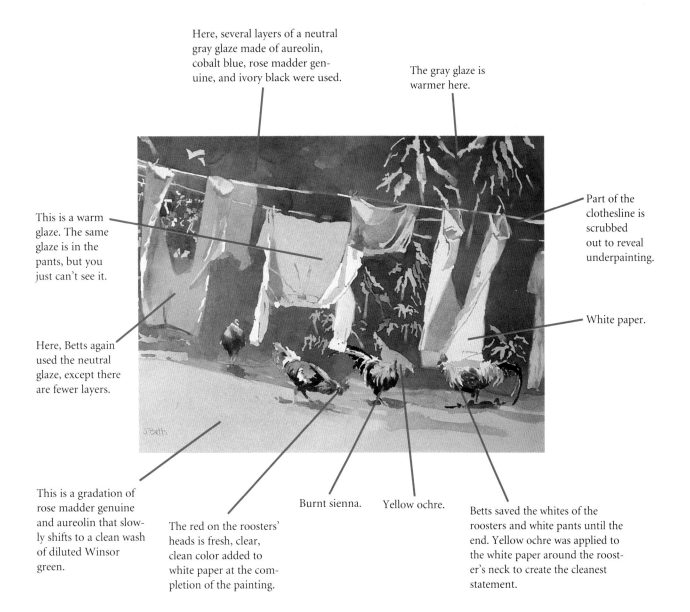

This is a warm glaze. The same glaze is in the pants, but you just can't see it.

Here, Betts again used the neutral glaze, except there are fewer layers.

Part of the clothesline is scrubbed out to reveal underpainting.

White paper.

This is a gradation of rose madder genuine and aureolin that slowly shifts to a clean wash of diluted Winsor green.

The red on the roosters' heads is fresh, clear, clean color added to white paper at the completion of the painting.

Burnt sienna.

Yellow ochre.

Betts saved the whites of the roosters and white pants until the end. Yellow ochre was applied to the white paper around the rooster's neck to create the cleanest statement.

IRVING SHAPIRO

Watching Irving Shapiro paint is like watching a ballet. His hand seems to float from palette to paper, applying strokes as if gravity were nonexistent. In expressing his philosophy about clean color statements, Shapiro says that they "are less the result of particular color combinations, and more the result of decisiveness and purposeful brushwork." He goes on to say that experience teaches the painter how effective a mix may be, as well as how much liquefying is necessary.

I especially appreciate his following comment: "Fussy, aimless painting that lacks the forethought of a plan will make even one color appear to be unclean."

Shapiro's points are well taken. Watercolor is not a medium that caters to a painter who vacillates and noodles until something emerges. He and I do differ slightly

Irving Shapiro, WILDFLOWERS, 24 x 36" (61.0 x 91.4 cm), Crescent cold-pressed watercolor board

in our outlooks, as I believe the habit of selecting a counseled color combination offers the painter the advantage of knowing he or she can achieve a clean statement, tilting the balance toward success.

In studying Shapiro's painting *Wildflowers,* notice the creative use of negative spattering with a spray bottle, as well as textures created by laying tissues selectively on the wet surface and lifting them to reveal sensational patterns. These patterns suggest positive and negative forms and spaces that Shapiro then augments, creating a sense of depth and mystery in the background.

Shapiro finds himself using a set of primary colors that, beginning with red, includes alizarin crimson, brown madder alizarin, or cobalt violet. For yellow, he relies most often on yellow ochre or raw sienna, and cobalt blue or manganese for blue. He points out that using burnt sienna and raw umber will "nicely flavor the degree of gray" by which a color is chromatically reduced.

Shapiro's palette consists of yellow ochre or raw sienna, cadmium yellow light, raw umber, burnt sienna, brown madder alizarin, cadmium red light, alizarin crimson, cobalt violet, cobalt blue, cerulean or manganese blue, ultramarine blue, phthalo blue, and olive green. As optional colors, he uses phthalo green, Payne's gray, bright red, new gamboge, and neutral tint.

The entire surface was wetted, then large, sweeping passages of color were allowed to mingle and run. The colors Shapiro chose for this first step of the painting were raw sienna, cobalt violet, raw umber, and cobalt blue.

Before any paint touched the paper, Shapiro applied frisket to the wildflowers to preserve white paper for later development.

Finally, the frisket was peeled from the flowers, and they were painted with washes of new gamboge and cadmium orange. The subtle mid-values were created using raw umber and cobalt violet.

When the "blocking in" of the first washes had dried, creating the large patterns, Shapiro stated the more delineated, hard-edged, and controlled washes. He used brown madder alizarin, cobalt blue, and some burnt sienna to create the darkest values.

DALE LAITINEN

In appearance, Dale Laitinen has a frontiersman's ruggedness. With acquaintance, though, it becomes evident that his consciousness and sensitivity are well suited to the endeavor of painting. This duality is apparent in his ability to capture the qualities of endurance as well as to express empathy toward his Pacific Northwest subjects.

Note how Laitinen's general comments regarding his painting philosophy are borne out in his painting *The Granite Range*: "Combine good color decisions with the order of a strong composition and the contrast of value, and it all starts to work…A gorgeous luminous wash needs the companionship of opaque or dark areas to give itself life…warm colors need cool, dark areas need light, intensity needs subtlety."

Laitinen observes that the more colors he mixes, the higher the probability of neutralizing fresh color passages—in other words, creating mud. He wisely warns that "overuse of the brush for blending will kill a fresh passage."

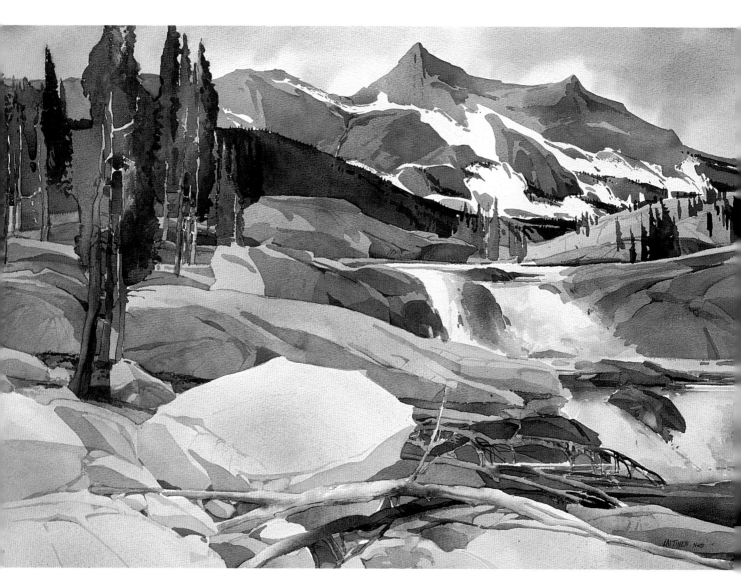

Dale Laitinen, THE GRANITE RANGE, 29 1/4 x 41" (74.3 x 104.1 cm), Arches rough paper

Of yellow ochre Laitinen says that if he lays "it down too heavily, or in too many layers it can look heavy and chalky. The cadmium colors can be too solid and opaque too." French ultramarine blue and burnt sienna are two more important colors on his palette. He loves the granulating effect of French ultramarine blue and finds that it combines beautifully with burnt sienna for making grays. Burnt sienna, he finds, is a transparent red earth color that is frequently used in mixing greens for foliage, and for warming neutral or cool colors. To create darks, he'll often use alizarin crimson with blue.

His palette (for now) consists of cadmium yellow, yellow ochre, Naples yellow, burnt sienna, cadmium red, Winsor red, rose madder genuine, alizarin crimson, cobalt blue, cerulean blue, French ultramarine blue, cobalt turquoise, and Winsor green. The paper he uses is heavyweight Arches rough, a surface that to me seems appropriate for this painter!

The foliage on the nearest trees is moved forward with a mixture of burnt sienna and Winsor green mixed on the paper. The greens in the distance are made to recede by adding French ultramarine blue.

The shadows are darker grayed purples consisting of French ultramarine blue, alizarin crimson, and burnt sienna. While it was still wet, Laitinen charged the wash with cerulean blue for a milky atmospheric effect.

After the first wet-in-wet wash dried, Laitinen introduced a middle value of French ultramarine blue and alizarin crimson, grayed slightly with burnt sienna. The reds are accents of cadmium red.

The snow patterns seem white but are tinted with French ultramarine blue and yellow ochre.

Here, Laitinen used a primary triad of rose madder genuine, cobalt blue, and yellow ochre to create subtle, translucent grays.

The fallen tree trunks vary from burnt sienna to yellow ochre, with accents of cadmium red and Winsor red for the warm tones. French ultramarine blue and alizarin crimson make up the shadows. Laitinen charged the darks with thick amounts of cobalt blue to enrich the shadows. The intensity and warmth of the logs contrast well with the cool, dark water.

The darker water is mostly French ultramarine blue and Winsor green, grayed with burnt sienna. Laitinen deepened the value by glazing additional layers.

CAROL CARTER

The first time I saw Carol Carter's work I was intrigued by her bold, somewhat unconventional, yet very successful usage of color. I was fascinated by the arresting point of view she took of her subjects and by the loose washes, which although dry, seemed so wet they defied gravity by not dripping. Although I wasn't surprised to find she painted flat, considering her large format and the obvious fluidity of the washes, I was surprised to find she usually limits the number of colors per painting to three or four. *Blue Skies* employs six, which although more than normal, is still remarkably few. Her standard palette colors are aureolin, cadmium orange, cadmium scarlet, cadmium red, alizarin crimson, Winsor violet, French ultramarine blue, Prussian blue, cobalt turquoise, Winsor green, and sepia. Carter is presently experimenting with Naples yellow, Indian yellow, Indian red, neutral tint, ivory black, and charcoal gray. She paints exclusively on Arches 300-lb. cold-pressed paper.

Carter's process requires 2- to 6-inch brushes to lay heavy charges of pure pigment in a controlled wet-into-wet technique. Through experience, she understands the viscosity of the medium. Knowing just when to float in pigment or pure water to effectively darken a passage or create blossoming, she can skillfully model form and create visual interest. This talent allows her to control what otherwise might become a madcap puddle painting in the hands of someone with much less skill in brushwork.

Carol Carter, BLUE SKIES, *40 x 30" (101.6 x 76.2 cm), Arches 300-lb. cold-pressed paper*

Carter plays pure colors against surrounding mixed grays, causing them to gain visual importance. She describes painting a block of cobalt blue and surrounding it with a gray made of burnt sienna and ultramarine blue. The cobalt blue thus becomes visually more dominant than if painted alone. Likewise, she deliberately "pushes and pulls" objects by using cool/warm combinations of complementary colors.

Most artists paint the foreground first; Carter, however, paints her backgrounds first, stating that although her traditional training suggests she begin with the foreground, she finds that reversing the procedure helps set the painting's environment. Placed within the environment, the foreground subject becomes a positive element, advancing forward in space.

Laudably, Carter allows wet paint to air dry, never using a hair dryer to speed things along, which can cause colors to dull and drop in value. Like me, she uses no masking fluid, preferring to save her whites spaces by painting around them.

Here, the white of the paper creates the light of the horizon.

The skin is a combination of turquoise blue with burnt sienna, which creates warm or cool flesh tones, depending on which color predominates.

This is Prussian blue.

The bathing suit is Winsor violet with alizarin crimson.

In this passage Carter used French ultramarine blue.

The hair is Winsor violet.

CARLTON PLUMMER

I certainly knew of Carlton Plummer before I revisited Maine some years ago, but after seeing a few of his paintings, I wanted to meet him and chat. His works capture the spirit of the Maine coast in all its force and color. Unfortunately, he was out of the state at the time of my visit, and we never met.

I expected a Maine coastal scene when I invited him to contribute to the book, but was delighted to find *Contemplation*, which captures one of his workshop students pausing in the midst of an outdoor painting session to contemplate the quintessence of her surroundings. This award-winning image is so

well balanced that if you squint at the work from a distance, whether it is sideways, upside down, or right side up, the abstract qualities of composition beam through. The perfect positioning of the light figure against the dark background punctuates the center of interest masterfully.

Carlton Plummer, Contemplation, *21 x 28" (53.3 x 71.1 cm)*

Plummer explains that he worked wet into wet during the initial stages, applying color into color while establishing a mood for the painting. True to the philosophy of the impressionists, he juxtaposes colors, generally keeping them the same value to induce visual stimulation and interest for the viewer.

The violets of Plummer's paintings are particularly arresting, and until now, I could only guess what they were. Now I know: His staple base color is permanent rose, and the blue he most often mixes with it is cobalt blue; at other times, he'll use French ultramarine blue or cerulean. When he requires a dark, he'll often use alizarin crimson with a dark blue. Other mixes he is fond of are sap green with aureolin, permanent rose with new gamboge, and French ultramarine blue with raw sienna. Two colors he finds exasperating are burnt umber and Payne's gray.

Through correspondence, I learned why his color choices were so pleasing. He uses a very sensible palette and prefers whiter papers with good lifting ability. His full palette consists of aureolin, new gamboge, cadmium lemon yellow, alizarin crimson, permanent rose, cadmium red light, cadmium orange, raw sienna, cerulean blue, Prussian blue, sap green, and viridian.

The shadow in the neck area involved many glazes of permanent rose, new gamboge, cerulean blue, and a touch of raw sienna.

The shadowed tree trunk sets off the figure. Since it is influenced by some reflected light, Plummer painted the lighter areas with French ultramarine blue as a base color, adding new gamboge, alizarin crimson, and sap green.

This mid-value dark area forms a large mass to help pull parts together. Working wet into wet, Plummer applied French ultramarine blue mixed with alizarin crimson, sap green, and new gamboge.

Background trees are sap green, cerulean blue, raw sienna, and alizarin crimson.

The bag, although in shade, is affected by filtered light. A mauve wash of permanent rose and cobalt blue over raw sienna here creates the effect of warm to cool mottled light, which remains subdued. The overall value is basically the same, but because of the warm/cool combinations, there is some visual vibration.

The various shades of the long dress are made of permanent rose mixed with cobalt blue, cerulean blue, or French ultramarine blue. Light washes of new gamboge were added in places.

The jacket consists of washes of cerulean blue and cobalt blue, with raw sienna and permanent rose added to mute the color as well as create variety.

DEBRA EDGERTON

The geometric composition of Debra Edgerton's painting *K.C. Market: Radishes* is a well-woven balance of light shapes, mid-value shapes, and darks. She explains that her approach to transparent watercolor "isn't always an exploration into the nuances of color. In the case of this painting, the secret to clean luminous color was to apply thin layers of the same color repeatedly to build up a certain value."

Edgerton uses mainly staining colors, applauding their luminosity and ability to layer through a full value range while maintaining transparency. In working with a system of layering and glazing, she has discovered one problem that is cause for concern. She finds that alizarin crimson and Winsor red, both transparent staining colors, cause underlying layers of paint to lift or mix when later glazes are applied. This problem can be partially alleviated by adding a little

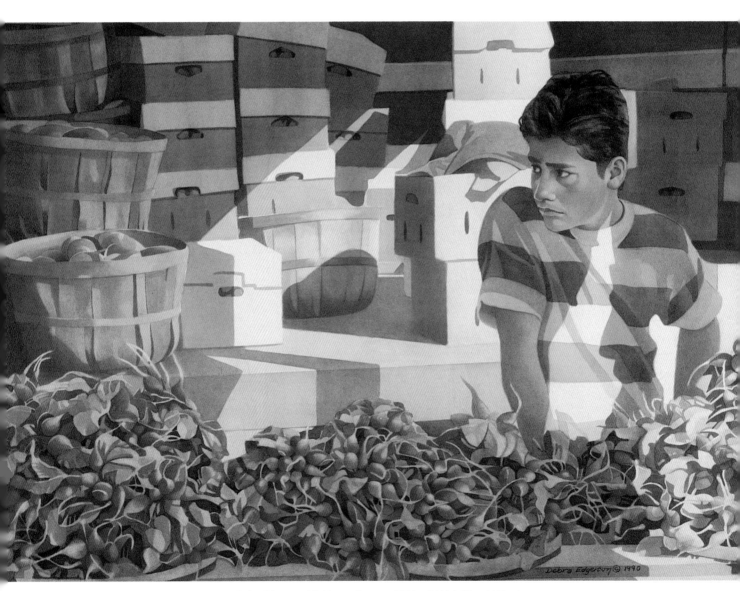

Debra Edgerton, K.C. Market: Radishes, 18 1/8 x 26 1/4" (46 x 66.7 cm)

watercolor medium when preparing a wash of either of these two colors.

This artist maintains a primary and secondary palette of colors. Her core palette consists mainly of staining colors and includes new gamboge, sepia, Winsor red, alizarin crimson, Winsor or Thalo Blue, and mauve. On a second palette she keeps earth-tone sedimentary colors, which she uses less often. These colors are raw sienna, burnt umber, cadmium red, cadmium yellow light, and Hooker's green.

Edgerton steers away from absorbent paper, preferring the characteristics of Winsor & Newton or Strathmore, which allow her to render crisp detail and distinct edges. Since she isn't fond of stretching paper, she either uses watercolor board or Winsor & Newton's 140-lb. paper attached to a backing board with drafting tape. In her experience, she finds that Winsor & Newton doesn't buckle excessively when it is wet, and flattens well when dry.

Here, to create this rich brown, Debra Edgerton used a combination of sepia, new gamboge, and Winsor red.

Because she knew these reds would be in the shadows, Edgerton built up the value slowly so that excess pigment wouldn't be sitting on the surface of the paper. This allowed the mixture of mauve and Winsor blue, applied afterward, to remain clean and still permit the reds to show through.

The skin tone is a mixture of new gamboge, Winsor red, alizarin crimson, and Winsor blue. The shadow, made of Winsor blue and alizarin crimson, was applied after all the details in the face were in place.

For the shadow areas Edgerton worked with complements: Winsor red and a green made by combining Winsor blue with new gamboge.

Although Edgerton rarely works with cadmium colors, here she wanted a cleaner yellow, so she used cadmium yellow light with a little phthalo blue for the leaves in the sunlight.

ROBERT BARNUM

Robert Barnum paints dynamic scenes of rural Midwestern life that look as if they had been visited by a welcomed tornado. The compositional order of the fracas and the jubilant mood of the figures in the paintings, however, attest that the hullabaloo is harmless. Like *Prayer Meeting*, each of his paintings narrates a story about the robust life of the individuals he depicts.

Barnum once told me that he couldn't teach his particular painting method to his students because it was too complicated. After studying it, I see his point. The level of difficulty in handling glazes that sometimes total more than twenty is extraordinary.

Barnum's favorite colors are yellow ochre, burnt sienna, Thalo blue, cerulean blue, alizarin crimson, and vermilion. Additional colors on his palette are cadmium yellow pale, cadmium orange, raw sienna, cadmium red, ultramarine blue, raw umber, Thalo green, Hooker's green dark, Hooker's green light, and cadmium violet. He paints on Arches 300-lb. rough and cold-pressed paper.

Barnum explains how Thalo blue and burnt sienna make a useful "value base." By mixing a warm or cool version, and adding it to any color, this base can create dramatic changes in value without loss of color clarity.

Barnum's glazes are not always a single color; often he will work with several selected hues that allow him to shift the temperature range from warm to cool throughout the process of application.

Without betraying his true feelings, Barnum comments on tube

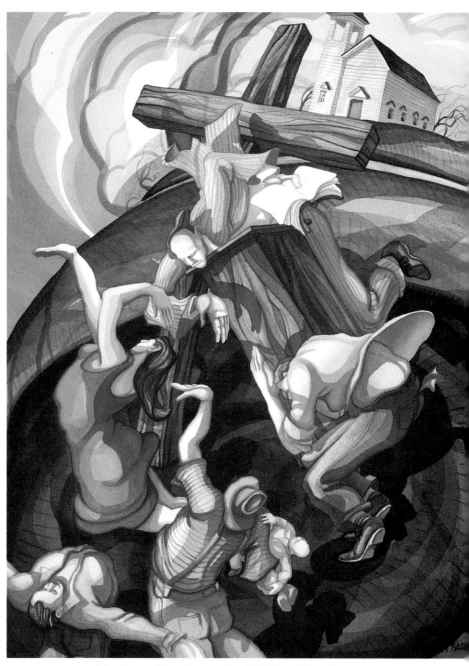

Robert Barnum, PRAYER MEETING, 26 x 19" (66.0 x 48.3 cm)

greens: "If tube greens were people, I would beat them up." He elaborates by explaining that when a tube green is used in a later glaze, perhaps the fifth or sixth layer of paint, "it will virtually eat all colors below it and spit them out as mud."

Although I wouldn't choose or advise the colors Robert Barnum uses for glazing, my respect for him as a gifted and important painter is stalwart. I'm reminded of this quote: "It is the difference of opinion that makes horse races." Thank you, Mark Twain.

Once a passage is nearly complete, Barnum may use two or three additional glazes of his value base of phthalo blue mixed with burnt sienna.

Theses are the glazing layers for the sky:
1) cerulean blue;
2) yellow ochre;
3) burnt sienna;
4) a value-base mixture of burnt sienna and phthalo blue;
5) phthalo blue and ultramarine blue;
6) raw sienna.

Skin tones are composed of these glazes:
1) yellow ochre;
2) vermilion;
3) alizarin crimson;
4) cadmium red light;
5) burnt sienna;
6) cerulean blue;
7) phthalo blue.

Dark earth colors are layers of:
1) raw sienna;
2) burnt sienna;
3) Hooker's green dark and burnt sienna;
4) phthalo blue and raw umber;
5) phthalo blue and ultramarine blue.

The glazes used for the earth colors are:
1) cadmium yellow pale and Hooker's green;
2) cadmium orange;
3) yellow ochre and raw sienna;
4) burnt sienna;
5) phthalo blue.

The glazes used to create the color of the jeans are:
1) raw sienna;
2) cadmium orange;
3) alizarin crimson and burnt sienna;
4) ultramarine blue;
5) ultramarine blue combined with phthalo blue.

PAT DENMAN

Pat Denman's painting *Frozen In* is as imaginative as her floral paintings. This is an interesting work to analyze, since it is more monochromatic than others included in this chapter, yet the variation of color in her composition is as extensive as what you'd find in a painting executed using a full palette. Rather than choose colors from various positions around the color wheel, Denman has used analogous colors—closely related hues that are neighbors on the wheel.

Denman works on 140-lb. Arches cold-pressed paper, which she prepares by first dampening it. When the paper is nearly dry to the touch, she staples it onto 3/4-inch-thick Gator board, a foam-core board coated on both sides with a hard plastic skin. Denman uses one side of the board for about a year, then flips it and uses the other side. Since her painting style doesn't require a taut surface, this seems a sensible method.

After sketching in her composition, she redampens the paper and begins applying initial glazes of transparent and semitransparent nonstaining colors such as aureolin,

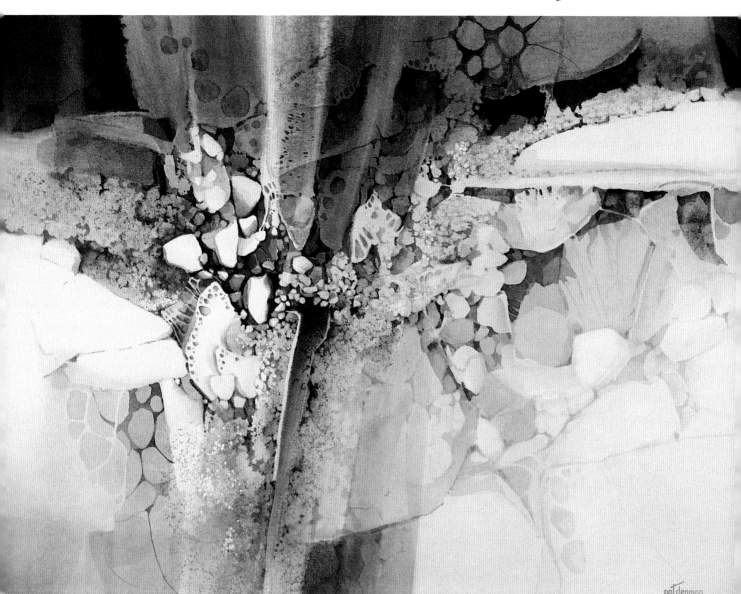

Pat Denman, FROZEN IN, 22 x 30" (55.9 x 76.2 cm), Arches 140-lb. cold-pressed paper

rose madder genuine, cobalt blue, Antwerp blue, and viridian. At this stage her intention is to establish the composition. If it isn't going as planned, the forgiving nature of the Arches paper coupled with the lifting quality of the nonstaining colors, as she puts it, "relieves some of the pressure I sometimes feel when facing a new sheet of paper."

Building the structure of the painting is a rhythmic process; as one passage is strengthened, another may be lightened for balance.

Denman lets the painting take its own direction, paying attention to what is revealed to her as the image develops. She calls this "conscious listening." As a painting progresses, in addition to her mainstays listed above, she uses raw sienna, burnt sienna, cadmium red, cadmium red pale, alizarin crimson, ultramarine blue, cerulean blue, Winsor green, and Payne's gray.

Denman eloquently explains her affinity for watercolors this way: "Watercolor painting affords artists

the highest highs—when a successful painting seems to just roll off the brush—and the lowest lows—when what seemed to be a promising painting slips away, along with the artist's time and spirits. Despite the unpredictability of watercolor, I believe that the love of this challenging but fascinating medium is the bond that unites all who work with it, even though the modes of expression are infinitely varied." I couldn't agree more!

Here, Denman used cerulean blue last for accent.

The middle-tone area began with several light washes of Antwerp blue, followed by a wash of very light rose madder genuine muted with a touch of Payne's gray.

Denman added darks to create a sense of depth by using a mixture of ultramarine blue, rose madder genuine, and Payne's gray.

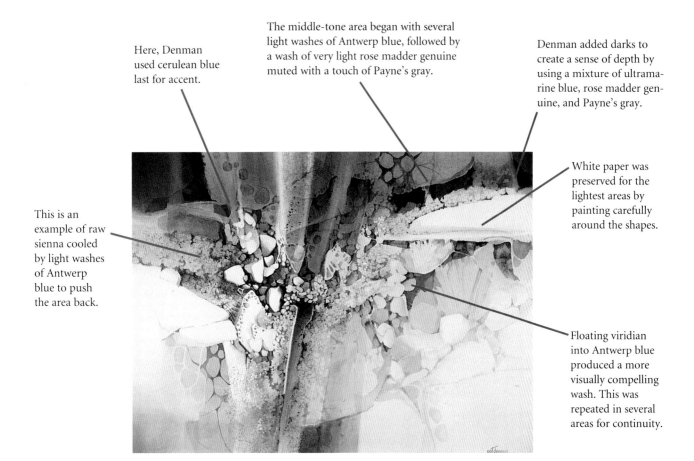

This is an example of raw sienna cooled by light washes of Antwerp blue to push the area back.

White paper was preserved for the lightest areas by painting carefully around the shapes.

Floating viridian into Antwerp blue produced a more visually compelling wash. This was repeated in several areas for continuity.

PATRICIA HANSEN

Patricia Hansen's painting *Quiet Time* displays a clear sense of lighting, capturing a time of day so palpable you could almost set your watch by it. Sunlight is suggested by preserving white paper or barely tinting objects; color is, instead, reserved for shadows. The patterns that emerge from the play of light and colorful shadow are intriguing. Hansen often places complementary colors next to one another. As an example, where modeling shadow is needed in the yellow chairs, she introduces the complement of violet. Note the violets and purples in the chairs' floral design and the repetition of these colors in the rug and flower pot on the right. It's pleasant to see other instances where grays are juxtaposed with clear colors to freshen them.

Hansen generally begins a passage by laying in a combination of transparent and semitransparent colors, which she then glazes over with one or more layers of slightly more opaque color combinations. The colors she favors most are aureolin, new gamboge, rose madder genuine, Winsor red, alizarin crimson, cobalt blue, French ultramarine blue, manganese blue, viridian, and Winsor green. Hansen avoids earth colors, and is a little jittery about combining phthalo blue with other colors.

The support Hansen chooses is Arches 300-lb. cold-pressed paper.

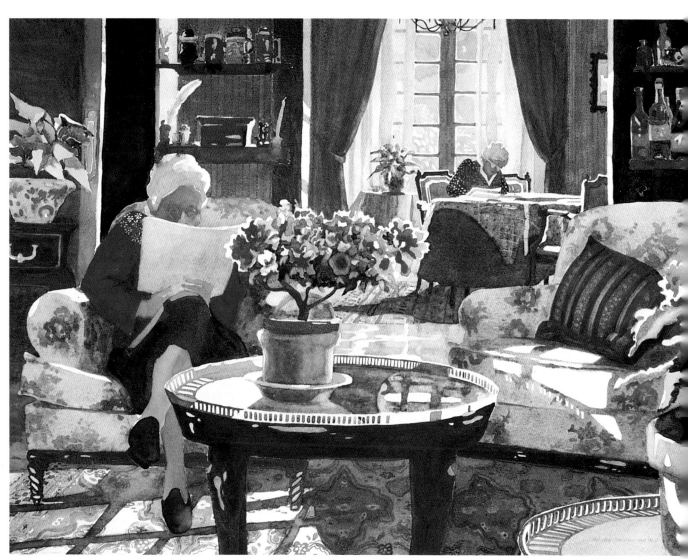

Patricia Hansen, QUIET TIME, 22 x 30" (55.9 x 76.2 cm), Arches 300-lb. cold-pressed paper

This color was underpainted with rose madder genuine, aureolin, and cobalt blue to make an orange. Then a purple mixed from manganese blue and alizarin crimson was glazed over the orange. Hansen wanted a warm purple that would contrast with the yellow chair.

The drapes are rose madder genuine, aureolin, cobalt blue, and cobalt violet. Hansen glazed several layers of this combination to produce a muted orange.

The hair is cobalt blue, burnt sienna, and raw sienna.

The tablecloth was painted in a series of washes using viridian, cobalt violet, and French ultramarine blue.

The flesh tone is rose madder genuine, aureolin, and cobalt blue.

White paper.

The pot is cobalt blue, cobalt violet, aureolin, and viridian. Sometimes the colors are mixed, and other times straight.

To render the chairs, Hansen underpainted a floral pattern using cobalt blue, alizarin crimson, and ultramarine blue for the purple, rose madder genuine and aureolin for orange, and viridian with aureolin for green. Once this was dry, she overpainted using a combination of manganese blue, aureolin, cobalt violet, and rose madder genuine to give the look of old furniture.

Hansen established the wood finish by underpainting with French ultramarine blue, then overpainting with new gamboge and rose madder genuine. She gets some interesting darks when she floats the reds and oranges over the blue.

JUDY D. TREMAN

You can't help but be struck by the contrasts and design of Judy Treman's paintings. Notice how her bold background colors in *Kaleidoscope in Red, White and Blue* contrast with the sensitive and subtle coloration of the flower petals. Yet without thoughtful, restful passages in the background, where complementary colors are glazed or mixed to gray the shadows, the painting might otherwise be overwhelmed and become unbalanced. The petals of the lower flower show how an opaque cadmium is best used: alone or in subtle combination with another color, applied in a diluted wash.

Treman's palette is remarkably similar to mine, and her reasons for using those colors are consistent with my assertions. In her notes, she suggests using aureolin or burnt umber to mute French ultramarine blue, rose madder genuine, or alizarin crimson "when the colors by themselves are too strong or garish." Two colors she avoids in combination are French ultramarine blue and burnt sienna, as she finds they become dark and muddy when mixed. I agree, but find that floating one into the other so they don't fully combine is a successful solution. She also likes to use Winsor red "as it comes from the tube when I want an absolutely vibrant red." Treman makes the observations that burnt sienna, mixed with other colors, especially French ultramarine blue, easily turns to "muck," and that Winsor blue is so intense and staining that can easily overpower other colors.

Judy D. Treman, KALEIDOSCOPE IN RED, WHITE AND BLUE,
38 x 27" (96.5 x 68.6 cm), Arches 300-lb. rough paper

She explains the qualities she likes in several of the colors she finds most useful. It's easy to see how each remark is put to task in *Kaleidoscope in Red, White and Blue.* Aureolin, she says, is a workhorse that mixes with other colors to create clear hues. She also uses either aureolin or burnt umber to mute colors that are too strident. Alizarin crimson is useful for making rich, lustrous darks as well as shadow colors for red hues.

The support she chooses is Arches 300-lb. rough paper, which she describes as "strong enough to withstand many layers of glazing and quite a bit of reworking, does not buckle, and gives a texture that gives a painterly quality to my work."

Pale shadows are ultramarine blue and rose madder genuine, with a touch of burnt umber or aureolin when a grayer tone is required.

Treman's black is composed of Winsor blue, alizarin crimson, and ivory black. This mixture gives a richer color than black alone, especially in areas where the paint's tube strength is diluted with water.

Middle-value shadows are ultramarine blue and alizarin crimson, applied after the drawing is completed. This value is strong enough to hold up when the local color is applied.

The lightest blue is a mixture of cobalt and cerulean. The next darker glaze is Winsor blue mixed with French ultramarine blue. The darkest blue is the last mixture plus alizarin crimson.

Here, the darkest shadows are Winsor blue and alizarin crimson, applied in the earliest stages of the painting.

Glazing Winsor red over dry paper produced this red. Treman uses no more than a single glaze of Winsor red, as otherwise it begins to muddy.

Cadmium yellow pale greatly diluted gives a subtle yet distinctly yellow glow to the interior flower petals.

These greens are mixes of Hooker's green light, Winsor red, and aureolin.

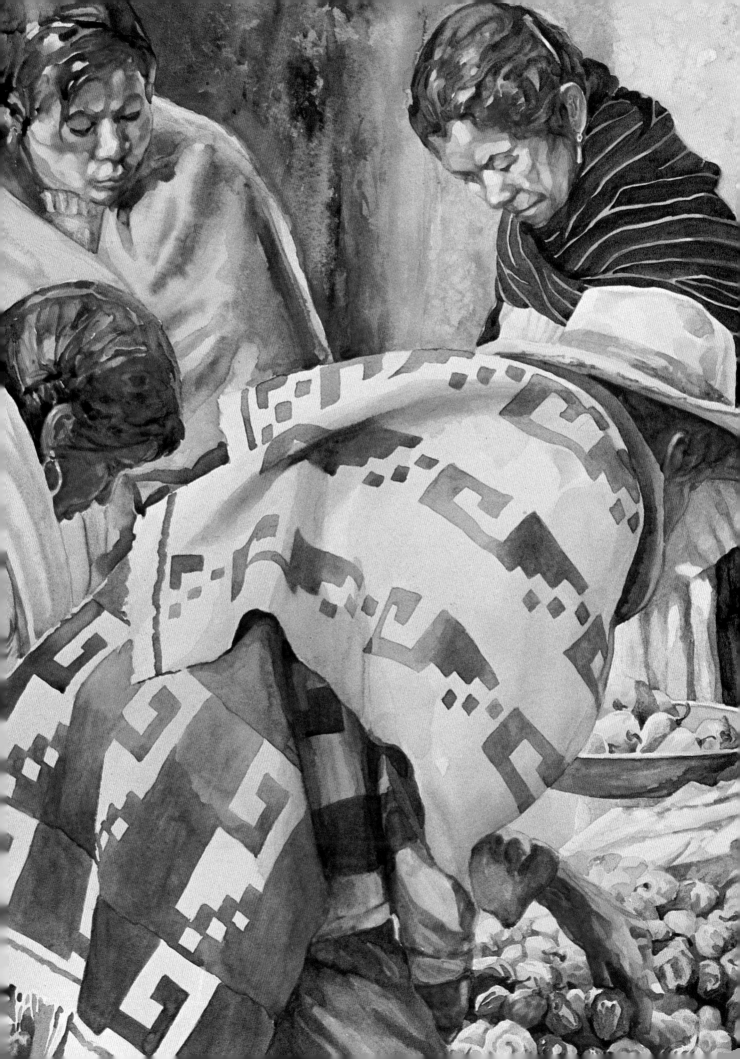

PRACTICAL TIPS FOR HANDLING PAINT

My intent in writing this book is not to tutor you in how to paint. There are many good books that already do that very well. There are, however, certain methods of paint handling that are so salient to achieving luminosity that I feel obliged to include them.

One is that you mix paint and water in the proper ratio. When I first began painting with watercolors I struggled with this concept. More often than not, my washes were pasty when I wanted a dark passage, or were laid down too dry in a light application. To get what I wanted, I had to rework the painting so often that it would become lackluster. Trial and error commanded my days until I found a method for balancing water and paint in a way that let me make a lustrous statement with a single pass rather than five or six.

To help you understand how to correctly mix water and paint to get the most luminous washes, I've outlined some experiments and provided step-by-step photographs as a guide. Next, we'll explore how to properly charge a brush and learn how to judge the intensity of the wash once it's applied to paper. After all, if you can't deliver that sumptuous wash you just learned to mix, you're no further ahead than before.

Some of the most interesting washes are mingled colors. There are several means of achieving this effect, but the most advanced is floating in color. Here, your newly acquired knowledge of how to develop a proper water-to-paint ratio will be invaluable. Once you've practiced, you'll be able to control color to create profoundly luminous passages. Then follows an explanation of the importance of keeping your paint wells, mixing tray, and water reserve clean. This short section on watercolor "housekeeping" will be one more rung on the ladder to achieving luminosity.

Paints can be expensive, but there are ways to reconstitute dried and cracked colors you might otherwise throw away. Even if you don't want to go through the bother, you'll find that using additives such as glycerin, gum arabic, and watercolor medium can both help you maintain the quality of your paints so they'll perform as the manufacturer intended them to and enhance certain of their physical characteristics. I'll give you some simple formulas for keeping your paints healthy. Also, I discuss the pros and cons of using masking fluid, Aquapasto, and ox gall liquid.

Last, I'll show you some tube tricks that make handling and maintenance a little easier, with advice on such matters as how to remove a stuck cap and regenerate paint that has hardened in an old tube.

I believe that if you follow the advice offered here, you'll find life as a watercolorist a bit simpler and will be better able to produce luminous results.

Above and left, detail: PICK A PEPPER, 22 x 29″ (55.9 x 73.7 cm), Lanaquarelle 300-lb. hot-pressed paper, collection of Bernard Fox.

GETTING THE RIGHT WATER-TO-PAINT RATIO

As mentioned previously, watercolor paints are composed of powdered pigments suspended in gum arabic and glycerin. If you can envision how a puddle of water would flatten after dropping in some sawdust, you can understand what happens to our color mixtures when we oversaturate them with paint.

Try this experiment. Place two one-inch puddles of water on your mixing tray a few inches apart. One will be used for mixing, the other for comparison. Look at them with backlight to observe how high above the surface of the tray the water sits. It should rise domelike, about the thickness of a quarter. Now, with a thirsty brush—one that is barely damp—pull some cadmium red from its paint well and discharge the color into one of the puddles of water. After this first drop, the puddle may spread a little but you'll notice very little change in its height. This is surface tension—the phenomenon that allows us to fill a glass above its brim without its overflowing. Similarly, a bead or puddle of water will rise well above a nonabsorbent surface such as a mixing tray or well-sized watercolor paper.

Clearing your brush of excess water each time, continue to drop more and more concentrated color into the puddle. Eventually you'll notice the height fall. As you progressively add more paint to the puddle, the surface tension is lowered as paint particles break the bonds of the water particles.

By adding too much paint, the surface tension collapses, and you

Here, the water's surface tension creates the height of these small pools. Surface tension refers to the upper surface bonding strength of the water molecules to resist collapse. This is the dome effect we look for.

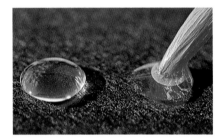

When color is first discharged into water, there is little effect on the surface tension. Although this would be a thin wash, it would be luminous. Another charge of color would probably not lower the height of this dome and would therefore still render a suitable wash.

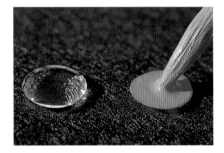

At this point the dome has collapsed and the water-to-paint ratio is unsuitable. Any wash with this mixture will be flat and opaque. By adding a little water to reproduce the dome effect, we would have the most concentrated wash possible that still renders luminosity. In essence, we'd be using the ratio that developed just before the surface tension was broken.

produce a solution that is too saturated with paint. Mixed this way, washes tend to lose their ability to flow out and create sensitive nuances of luminous color. On the other hand, if you add too little paint, you'll have too light a wash. There's a range between the two extremes that's right for our purposes. A good water-to-paint ratio exists just before the puddle begins to recede. The paint is suspended in a grand reservoir of water and charges the brush with such a heavy load that it can then discharge an abundant deposit of color and water to the paper. This is a difficult concept to teach. There is no set formula.

Except when using the drybrush technique, most watercolorists apply paint using either a damp brush or a saturated wet brush. Using a damp brush encourages direct painting or drawing with the brush. Novice watercolor painters often use this method of paint delivery, finding security in not committing to a single large, juicy wash and hesitantly applying small amounts of paint in thin, gutless layers until a patchwork builds, normally resulting in an overworked and chalky painting rather than one that's luminous.

Many artists whose work I respect do use a damp-brush approach with great success. By envisioning the entire painting before beginning, they can proceed with deliberation, achieving distinguished results. Their method of paint application expresses their style, and is not a crutch. However, most transparent watercolors painted solely in this manner are

uninteresting for both the viewer and the painter. Experienced painters more often use the wet-brush style of applying paint because it allows them to render luminous color and unify large sections of a painting, and gives them more time to work form or other colors into the wash. In general, the wet-brush method lets the artist create more visual interest.

DAMP VS. WET BRUSH METHODS

So, how is it done? Let's experiment with two examples that illustrate the differences between damp and wet application of paint.

For the first half of this experiment, let's assume you want to paint a dark passage using a damp-brush application of paint. Begin by squirting out equal, pea-size amounts of burnt sienna and French ultramarine blue next to each other on the mixing tray. With a damp #6 to #8 round brush, thoroughly mix the two together. You've created a dense, sticky mixture containing a high ratio of paint suspended in very little water. Plunk this wash down on your watercolor paper. Inarguably, the color will be dark when it is applied, as well as dark when it dries.

Now for the second half of the experiment. Return to the mire of burnt sienna and French ultramarine and suspend water in the paint mixture. How much water? Do you recall how you added paint to a puddle to see when it would collapse the surface tension? You're doing the same thing here, except you're going about it the logical way, adding water to the paint, rather than paint to the water. It won't take much; one or two brushfuls should do. Once you see the raised puddle, stop adding water or you will dilute the

Colors applied without good suspension can be dense, revealing nothing of their character. Here, the top two squares are quinacridone burnt orange and indan-throne blue. They are so dark, you'd hardly be able to identify them. Below each is a wash using a proper ratio of water to pigment. These washes are more desirable because they reveal the colors' intended identity and character.

The character of a wash can be useless or beautiful depending upon its suspension. On the left, burnt sienna and French ultramarine were mixed in an over-concentrated blend that is far too dark. It's essentially useless as a transparent watercolor statement. In the middle, a properly suspended mixture conveys the individuality of the colors and is luminous. By adding more water to this middle suspension, as shown at right, you get a lighter expression of the mixture that is equally lustrous.

mixture and preclude producing a dark wash. Using your brush, scoop up as much of the mixture as you can and, with the paper flat, apply this wash next to the first. The wash should rise above the surface of the paper, and it's definitely going to take longer to dry than the first. Don't mess around with it. Just let the pigments settle and dry without restating. The difference between this method and the damp-brush method of applying paint should be evident when it dries. If the latter mixture was on target for water suspension, it should be nearly as dark as the former. Regardless, the wet-brush method produces a more luminous result. When you need a lighter

rendition of a darker statement, you simply add more water to your tray mixture. The precaution is not to use the original darker mixture with the intention of spreading it out thinner, which actually will work but produces less interesting, less luminous results.

I should mention that in practice, it is unusual to work with a mixture as dense as our first one. The less dense the examples become, the more subtle the differences, but they exist nonetheless. If you care to experiment further, try matching values of the two methods with additional swatches, only pull fresh paint from the wells. One more point: There are instances where colors that aren't

To fully charge a brush, push it into an adequate supply of paint and water mixture to scoop it up.

A fully saturated 1/2" synthetic flat brush was used to lay down the wash at left; note that it not only painted much less area, it also painted it with less density. At right, the same paint mixture was applied with a fully saturated 1/2" kolinsky sable brush, which covered a much larger area with much more density before running out of paint.

fully mixed can render gorgeous color variation when applied with a damp-brush method, so don't dismiss this as an invalid method of paint application.

CHARGING THE BRUSH

Now, after learning how to mix a juicy wash, your next challenge is to get it into the brush. It isn't difficult to fully saturate the brush as long as there's enough mixture laid out on the tray. You simply push the brush into the liquid as if you were trying to scoop up water in a dustpan. When the brush can't hold any more liquid, it's saturated. To check how well the brush holds the charge, hold it in a downward position for about two seconds. The liquid should run to the point but not drip. If it drips, the brush is not of the highest quality and should be replaced. A fully saturated, high-quality brush will cover an incredibly large area for its size. Our concern is to have enough suspension in the brush to lay down a wet wash without needing to return to the mixing tray every few seconds for recharging. Remember, a well-suspended wash is more luminous than a dry wash. If you spread the wash out too much, the advantage is lost, despite your efforts to properly charge the brush.

ADDING COLOR TO A WASH

Most watercolorists are initially discouraged by their first washes, which seem dark when applied, but dry much lighter—sometimes 40 to 50 percent lighter. Realizing that many artists experience this dilemma, the noted watercolorist Edgar Whitney sagaciously remarked, "If it looks right when it's wet, it's wrong!" Let's examine how to resolve the problem and learn the technique of "floating in" color as well. Since this is going to

be a wet application of paint, it's important to keep the paper nearly flat. If you tilt the paper more than 10 or 15 degrees, the pigment particles are going to run to the lowest point, resulting in a thin wash. If you paint on an upright easel, you'll be cleaning the floor.

Mix a batch of color several times greater than you would for a dry application. Then suspend the mixture in water, looking for the domed surface tension effect. You should have more paint prepared than you think is needed to cover the area. This may seem wasteful, but you'll be surprised how much you'll use. It's also likely that you'll need this supply to restate your first wash. Now charge the brush with the mixture until it is fully saturated—meaning it can't carry any more liquid without dripping. When you apply the paint, you'll feel as if you're dragging a puddle around, which in essence is what you are doing as you extend the boundaries of the surface tension pool. When the thickness of the puddle has evaporated and the wash is still glistening wet, you need to assess the wash for intensity. Remember, it is probably going to be about 25 percent lighter when it dries than it is at this glistening stage. If it needs darkening, as is most often the case, this is the time to add more color.

With a slightly wet brush, regenerate the tray mixture and load the brush. Then, *float* the color in. Don't brush it in! Simply touch the tip of the brush to the glistening wash and allow the tip to discharge the paint like an eyedropper. Obviously this is going to take practice, but once you have the technique down, try floating in different colors for some extraordinary effects. This is when the technique really pays off. The visual variety, color expression, and

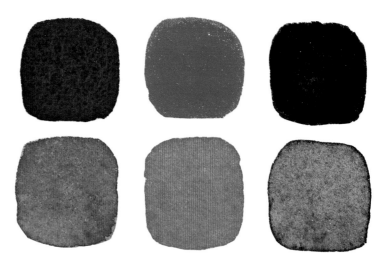

Here are two rows of, from left to right, phthalo blue, Winsor red, and Payne's gray. The swatches in the top row are wet and those below them are dry, illustrating how a wet wash is significantly darker than a dry one. In general, if you like what you see when it's wet, you will be dissatisfied when it dries.

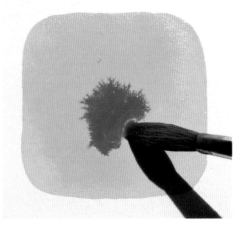

For the sake of demonstration, I've chosen a bold color combination to show you how the eyedropper effect works to "float in" color.

possibilities of creating form by floating in colors is endless. I've kept washes going for nearly an hour, with dazzling results.

While you were waiting for the wash to dry to the glistening stage, the puddle on your mixing tray was also evaporating, ideally at the same rate. Most of the time, if you mixed enough paint to begin with and the reserve is generous, this will be the case. If, however, you need additional water and add

too much, you'll wind up with a mixture that is much wetter than the glistening wash on the paper, and will create what's known as a blossom when you float in the color. The loose paint particles of the damp wash scoot away to the borders ahead of the incoming flood, leaving what looks like a flower in bloom. Some artists call this a happy accident; others call it unfortunate. I prefer to control it to enhance a painting.

When water or a higher concentration of water to pigment is floated into a wet or moist wash, the pigment in the initial wash is pushed aside by the flood. The result is a blossom.

I laid down a wash of French ultramarine and, dividing it with a piece of mat board, dried the right half with a hair dryer. Although the wash didn't dry lighter as most do, it certainly lost much of its character.

There are a few additional things to remember:

Keep your paper nearly flat until the wash dries. Don't move it around. The paint particles need to settle and granulate. Moving the painting disturbs the process, dulling the results.

Don't disturb the drying wash by brushing through it. If you do, the result will be no better than a heavy, dry, single application of paint.

When floating in color, don't wait until the glisten is gone. Timing is important. When to drop in addi-tional color depends on how much you want it to mingle with the wash you've already applied. For instance, if you want an overall darkening, you don't need to wait long. Go ahead and drop in the color at will. On the other hand, if you want to affect only a particular section of the wash without having the dropped-in color spread beyond your intended boundaries, you'll need to wait until the first wash is glistening but not wet.

Don't adjust the paint reserve on your mixing tray until you gain experience and feel confident with your adjustments.

Be patient. Wait for the wash to dry, and don't fuss with it once the glistening stage has passed. The results are worth it.

USING A HAIR DRYER

The desire to hasten the drying time of a wet wash is common. If you ordinarily resort to a hair dryer, you've probably noticed how it dulls the once-radiant wash. What you may not have observed is that some of the paper's charac-teristics change slightly as well. My theory is that when heat is applied to a wet wash, accelerating evapo-ration, steam escapes into the atmosphere as well as into the paper. This causes the paint to mix with the sizing, which is similar to putting cream into tea. It's also sending some of the paint particles down into the paper fibers, where they become ensconced and are troublesome to remove. In essence, the sizing becomes part of the paint application rather than remaining as the barrier between the paint and the paper fibers. Liftability is reduced when the siz-ing is compromised. Once the paint is in the fibers, light has no place to reflect back from.

So, if you must use a hair dryer, at least wait until the sheen has left the paper before turning on the heat. I've found that holding the dryer a foot and a half or two feet away from the paper reduces the amount of heat, causing less dulling and clouding of the paint application. This method doesn't diminish the settling effect of a wash as much as a direct blast of hot air does.

KEEPING COLOR CLEAN

Clean water, a clean mixing tray, and clean colors are essential to transparent watercolor technique.

Change your water often! Thick sediment in the bottom of your water pail is an indication of how muddy some of your mixtures may be. Reduce the sediment and you'll notice an improvement in the clarity and brilliance of your paintings. Test this sometime by painting three layers of transparent colors using the exhausted water. Lay down one glaze and wait for it to dry. Then lay down the next over the first and wait for that one to dry. Do the same for the third. Now repeat the process using moderately clean water rather than dirty water. The results will convince you that the minor inconvenience of changing your water more often will result in cleaner, more luminous color.

While changing your water often is sensible, cleaning your mixing tray is even more so. I am sometimes so involved with my work that I put off this task and find myself using corners or the rim of the tray to mix colors. Of course, this is foolish. Because using the corners means I need to work the mixtures drier to keep them in their restricted space, I lose efficiency and the potential for creating well-suspended mixtures. Another problem is believing I see a mixture on the tray that will work well for my next painting passage, and rather than mix a fresh, well-chosen color combination, I jump into the existing puddle of mud. Don't be so lazy that you overlook the importance of rendering clean colors. You need to stretch your legs anyway, so let the

mixing tray and water pail be your alarm clock. Get up and clean up!

A variety of mixing trays are available for watercolorists. Many have useful features, but all fall short in design. What I use is quite simple. A respected watercolorist once suggested this, and I've never found anything better or easier to keep clean. All you need is one or two plastic slant trays and, for mixing, an enamel butcher's tray. The

If you use exhausted pail water while creating your washes, you'll impart a veil that will dull your subtlest color statements. Here, I overlapped three washes of murky water to demonstrate the effect exceptionally dirty water might have on your colors.

most important aspect of this arrangement is having the paint wells separate from the mixing tray. This way the butcher's tray can be conveniently washed under a spigot—impossible when you use a combination unit. Also, butchers' trays don't stain but plastic ones do, and I find such stains distracting to my color decisions. Though butchers' trays are now hard to

find and are generally flawed, look for shallow ones with a flat bottom, which are far superior to deeper ones with a slightly bowed bottom.

Controlling your craft well enough to allow for options puts you that much closer to creating successful paintings. One particular violation in craftsmanship I've often noticed is the sullying of reservoir colors. Many an artist blithely pollutes the colors in his paint wells by slopping from one to another. Don't let bad habits like this compromise color purity.

If you dip a brush into a paint well to extract one color, then reach back with the same unrinsed brush to grab another color, eventually all your colors will be contaminated. Strong staining colors are the least affected, but lighter-value colors really suffer. If you need convincing, pick up some phthalo green, swish it around on your mixing tray, and then dip that brush into your aureolin. You'll wonder where the yellow went.

The solution is obvious: Acquire the habit of rinsing your brush and mopping it off on a damp sponge to remove excess water before scooping up another color. The colors in your reservoirs should always look clean. If you want to mix them, do it on the mixing tray or the paper!

Incidentally, if mold forms in your paint wells, place a few mothballs around the perimeter of the paint holder and cover it all with an aluminum foil tent when not in use. If it's already growing a thick fur coat, wash out the paint wells thoroughly and start anew. If the problem is only minor, just extricate the trespasser with a utensil.

MAINTAINING PAINT QUALITY

I usually squeeze fresh paint into the wells and slant trays each time I begin a painting session, although this isn't always necessary if you haven't depleted your paint supply.

To keep paints from drying as you work, it is best to drop a little water into the wells. This maintains your colors in a state of readiness. As you continue to paint, you'll be using more of the suspension than the pigment. Eventually the color seems less bold and luminous, and appears flat. You can now dump the paint and start anew, or you can use the following suggestions.

I fill a pint-capacity shampoo bottle (one with a flip-up spout) with water, to which I add around 1/4 teaspoon of glycerin, which you can buy at nearly any drugstore. (You'll recall that glycerin is the ingredient in watercolor paints that retards their drying.) Before leaving the paints overnight, I nearly fill each well with the solution. This small amount of glycerin slows evaporation and keeps the paints from cracking. One word of caution: Don't use too much glycerin. Although it is harmless and certainly compatible, using a high concentration of it will keep your paints from drying on the paper. After the first few days of painting, add this solution only to the colors you have been using. To the unused colors in the wells, which already contain suffcent glycerin, add plain water to keep them from drying out.

As you repeatedly use the water additive method, you leach more of the varnish medium—the gum arabic—from the paint mixture than remove pigment. To rebalance the intended formula, add a few drops of gum arabic to the paint wells as needed. The following symptoms will tell you when this is called for: when paint loses glossiness as the wells are drying (cadmiums, for instance, begin to appear chalky and are the first to need the added medium); when it lacks body and feels like a gritty poster paint as you mix it on your tray; or when a dried wash seems to lack luster and luminosity and appears dull. To remedy matters, add three or four drops of gum arabic to the suspect paint, then spritz in some water to suspend and dilute it. This should cure the problem. If it doesn't, scoop the paint out with a palette knife and squeeze out a fresh batch. If a paint seems "healthy," or if you need to add fresh paint from the tube due to attrition, don't add the medium.

If you find you like using gum arabic to extend the vital condition of your paints, try adding a teaspoon to a pint of water using a bottle like the one I use for my glycerin solution. Add the gum arabic solution when you think you need it, or squirt out a little on your mixing tray when you think a mixture could benefit from the additional transparency gum arabic contributes.

Although it's fine to add gum arabic when it is needed, it is equally important to recognize when your paint is exhausted and requires replacement—for instance, when it doesn't reconstitute and settles in the well like little pebbles at the bottom of a pool, or when you discover a particle of solid color flowing from what was otherwise intended to be an even wash. With any luck you'll have caught the problem before this frustrating point.

RECONSTITUTING DRIED-UP PAINT

Reconstituting paint that has hardened takes just a minute or two and, especially with expensive colors like cobalt violet, is worth the effort. You simply turn the paint well into a mortar and grind the caked mass back to a very fine powder in a suspension of a few drops each of glycerin, gum arabic, and water. The trick is to avoid adding so much liquid that the paint pigment floats off and you need to chase it around. You're seeking a toothpaste consistency. Mix the mass twice as long as you think you should, to be certain all is pulverized and evenly suspended. My last tip is, don't bother with cerulean blue; just when you think it's ready for reuse, it will corrupt the paper with a blue streak that can be distracting and difficult to remove.

DEVOTION, 19 1/2 x 14 1/2" (49.5 x 36.8 cm), Winsor & Newton 140-lb. hot-pressed paper, collection of the artist

To paint the dress of this beautiful elderly woman, I washed in the shadow forms first and then developed the pattern. To allow more "open time" before the dark color dried as I painted around the dots, I mixed a little glycerin with my large reservoir of color. No masking fluid was used.

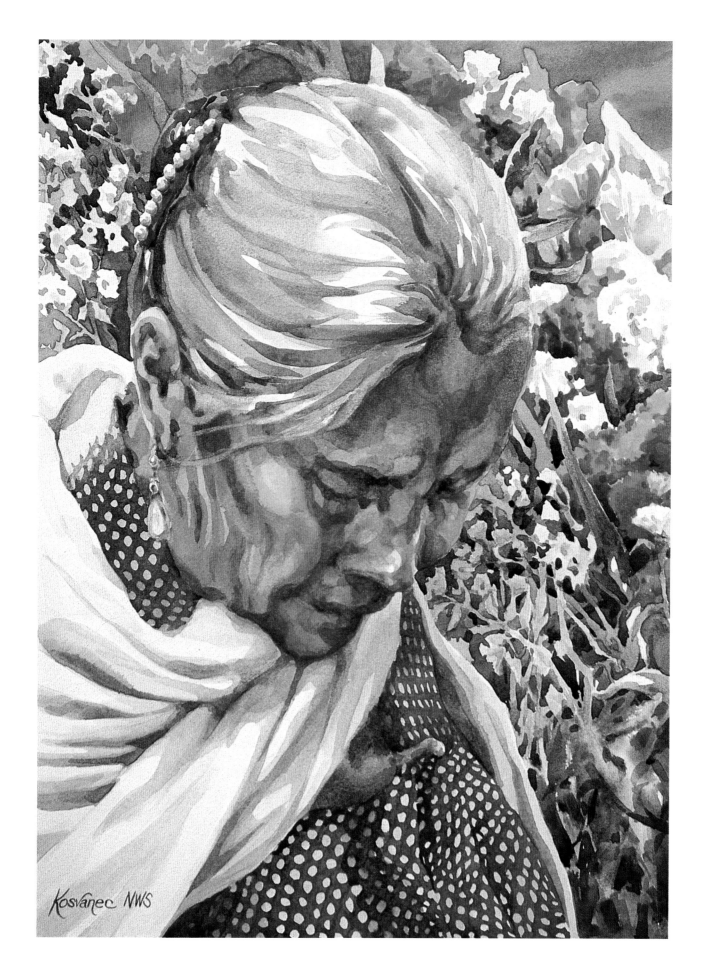

Kosvanec NWS

MEDIUMS AND RELATED PRODUCTS

Available to watercolorists are various mediums and related products that can be added to paints to change the way they perform and widen the range of possible effects. It is unfortunate that so few artists, including professionals, work with these additives, since they offer an extraordinary number of benefits other than the paint-well maintenance program I've outlined. No painter of transparent watercolors should fear using these mediums; with one exception (mentioned below), they are completely compatible with our paints.

GUM ARABIC AND WATERCOLOR MEDIUM

Gum arabic, the binder used in the manufacture of watercolor paints, is, as described earlier, the transparent watercolorist's varnish medium. It's what gives colors their brilliance. Watercolor medium (such as Winsor & Newton's Water Colour Medium) is an alternative product composed of gum arabic, acid, and water. Because watercolor medium contains acid, *it cannot be used with acid-sensitive pigments* such as permanent blue and ultramarine colors.

Gum arabic and watercolor medium are almost, but not quite, interchangeable in use. Winsor & Newton suggests using gum arabic if your washes have an undesirable tendency to flow beyond the brushstrokes. Adding gum arabic to a wash tends to thicken it, making it stay put and not creep away. Another benefit is a slightly longer working time, as the gum arabic keeps the wash from drying as quickly as it ordinarily would. Adding gum arabic to paints also

makes colors richer and more luminous. A dark color will appear darker, and yet its transparency is preserved. Still another, and to my mind, the essential, benefit of using gum arabic in your glazes or washes is that it greatly facilitates lifting color from the paper; with the addition of gum arabic, color doesn't penetrate the paper's surface as much as it would otherwise. So, if your technique calls for lifting color, or if you simply want that option, you'll enjoy using gum arabic.

Watercolor medium, on the other hand, causes glazes to set in a hardened layer on the paper's surface, making them more difficult to lift than glazes containing gum arabic. In that respect, watercolor medium is an ideal additive if you like to apply multiple layers of glazes and want to prevent their tendency to dissolve and muddy the underlying layers. Otherwise, like gum arabic, watercolor medium controls the undesired spreading or "wicking" action of a wash; it, too, slows drying time slightly and increases brilliance and luminosity of colors, adding richness to darks. Finally, both gum arabic and watercolor medium contain a preservative that helps inhibit the growth of mold.

Here are two caveats to heed when you use these additives:

1. To reiterate the point made earlier, don't use watercolor medium with acid-sensitive pigments, notably French ultramarine blue, ultramarine genuine, permanent blue, and ultramarine violet. The acid in the medium will bleach these colors.

2. Don't use a brush to drop in gum arabic or watercolor medium; both additives will cause the bristles to dry to the consistency of a brick. I learned this the hard way, thinking it would be fine as long as I rinsed the brush in water. I was able to revive the brush, but I'll never use one again for that purpose. To drop in gum arabic, which has the consistency of maple syrup, I use a pointed spatula knife, although a dropper would probably be a better choice.

OX GALL LIQUID

Another medium you might appreciate is ox gall liquid, which indeed comes from the gall of an ox! Ox gall is a wetting agent that increases paint flow, encouraging washes to meld and spread out. When planning a large wash in which you hope to show no overlap marks, you'll be more successful if you add ox gall to the wash solution. Also, try adding a little glycerin to slow the drying time. This combination gives you a fighting chance of producing an even wash.

Winsor & Newton suggests adding three to four drops of ox gall liquid to a cup of water and mixing this with your wash. They also recommend that you first lay down a clear wash of the solution over the entire area where you want to produce an even wash of color, then either let it dry before you add color or quickly wash in the color in a wet-in-wet technique. Both methods inhibit the formation of overlap lines, but a method I've been using seems to work best. First, I double the number of drops of ox gall liquid.

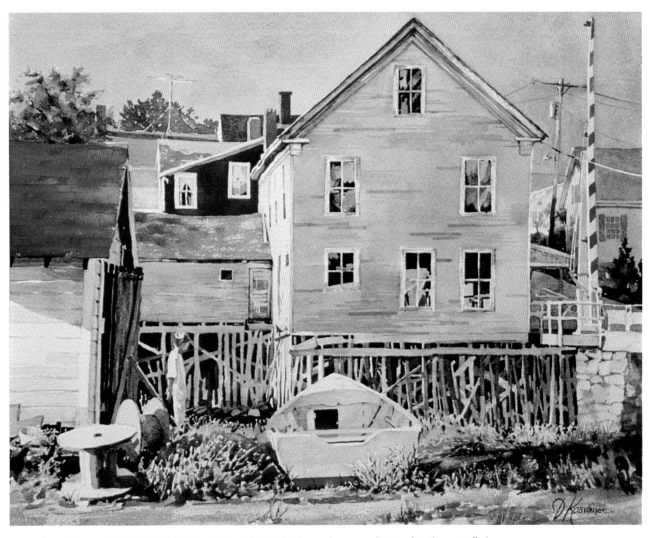

SILENT OBSERVER, 19 1/2 x 24 1/2" (49.5 x 62.2 cm), Arches 300-lb. rough paper, collection of D. Thomas Hoffecker

To evenly cover the various areas of the sky without overlap marks, I moistened the sky sections of the paper with two coats of ox gall liquid suspended in a wash of clear water. Once the paper was no longer glistening, yet still cool to the touch, I began the wash of color. The color flowed predictably and brushstrokes connected perfectly. The young boy's face shows reflected light and is contrasted against a very dark background to dramatize his presence. A light background and less distinct skin color would have been ineffective in drawing attention to the lad.

Then I work wet-into-*damp,* applying the clear solution over the entire area where the wash will be applied. If there are hard edges to be followed, I respect the linear definition and draw it in with my colorless solution. If there are lost edges, I plunge right into the form without concern. Here I part company with the other methods. When the paper is no longer shiny from the wet wash, I start with a second coat of the clear solution and consistently follow the same line and edge concepts, this time to ensure evenly dampened paper that will accept a colored wash uniformly. The paper is ready for the colored wash when it is no longer shiny and feels cool to the touch with the back of your hand. When you apply the clear ox gall solution, keep your paper flat. Raise the angle for the application of paint, and start at the top. Also, mix more than enough base color before you begin! Don't go back into a drying wash with the aim of evening it out. You'll undoubtedly create a mess, most probably a blossom.

AQUAPASTO

Winsor & Newton markets this gel medium, a mixture of gum arabic and silica that is intended to thicken paint for impasto effects. They suggest using several layers of the gel mixed with color, allowing each layer to dry before applying the next. Unfortunately, the silica in the gel dulls the transparency of the colors you mix it with. Despite this, it does have some potential for those who would like to explore textural effects produced by imprinting, coarse brushes, scraping, or lifting.

MASKING FLUID

Used to mask out areas of a painting where you don't want color to go, masking fluid is a compound of latex, ammonia, and water, plus, depending on the brand, a little pigment so you can see where you've applied it to your paper. I've found masking fluid (which is also called liquid frisket) invaluable at times, but my main complaint and caution to those who would like to use it to preserve white areas on the paper is this: When you remove the mask (usually with a rubber cement lifter), you are often left with a slight stain from the color in the fluid. Also, the revealed areas can look as if they've been cut out and pasted on; the edges seem too hard and distinct. Incidentally, Winsor & Newton offers a colorless masking fluid, which won't stain the paper but can be difficult to detect while you're painting.

Masking fluid is tough on brushes. You should apply it with a hard-edged implement, an old synthetic brush, or an inexpensive round used only for that purpose. Before and after using the brush, however, soak it in a solution of soap and water. I keep a small resealable container of soap solution just for this purpose. As you work with masking fluid, be sure to clear the brush of any buildup as it dries. Most of the residue accumulates around the ferrule, but is easy to remove while it is moist. If you don't do this, kiss the brush goodbye: Masking fluid can set the bristles into a rubbery mass—not the kind of spring or snap we desire of a good brush.

Shake the bottle of masking fluid before you use it to suspend the ingredients. Apply the fluid generously, because a thin layer won't block out a wash completely. A thin application may leave pinholes and uneven edges—which aren't necessarily undesirable, if you like the effect. Be patient and let the fluid dry before starting a wash. Finally, be aware that masking fluid can sometimes repel a wash around its boundaries. This is especially frustrating if you are laying in an even wash containing ox gall liquid. As you approach the masking fluid with the colored wash, it is mysteriously pushed away. If a large wash is involved in the same area of the painting, I avoid the situation by painting in the negative spaces instead of depending on masking fluid to preserve the whites.

SUDDEN SPIRAL, 18 1/2 x 13 1/2" (47.0 x 34.3 cm), Crescent 115 board, collection of Barbara Patton

I rarely use masking fluid, but this is an example of where I found it helpful. In the whirlpool, I spattered and painted masking fluid to follow the direction of the water's action. It's important to hydrate your brush in a solution of soap and water before using the masking fluid. As you use the fluid, clear the brush of any buildup around the ferrule by pulling it away with your fingers, and when you finish, wash the brush with soap and water.

PAINT TUBE TRICKS

Let me share a few more paint tips. This one you may already know: When you are confronted with a stuck cap on a tube of paint, grip the cap lightly with a pair of pliers and twist. If the tube material starts to twist, stop and try the next step: Hold a flame under the reluctant cap to heat it slightly—but don't incinerate it! Don't let the flame touch the cap or the tube. Turn the tube continuously to prevent scorching or melting the plastic. Ten seconds or less is usually enough. Then try unscrewing the cap with the pliers again. Don't use your fingers if you care for them.

This next tip will provide you with an amazing amount of extra paint. I squeeze my tubes of paint logically, from the bottom. As the paint is depleted, I use a sturdy brush handle to flatten the vacant lower section and squeeze the remainder higher. Then I roll the tube's lower seal up to the remaining belly. So far, this is fairly stan-

dard stuff. However, when the entire tube is seemingly empty and the roll has reached the tube's shoulder, pick up your pliers and force out more paint. Open the pliers and place the rolled side of the tube against one of the grips, with one of the tube's shoulders against the other grip. Press the roll up into the shoulder. Out pops more paint. Squeeze the other shoulder and roll again—and voilà! If you really want to coerce the last nickel out of the tube, try collapsing the mouth as well.

My guess is that you roll a paint tube toward the title side of the label. If you do, change your habit and roll it the other way—away from the color description. This way you preserve the tube's identity until it's ready for the pliers.

You've probably heard the saying "It's impossible to get toothpaste back into the tube." When I hear this, I chuckle as I recall from my early days of art instruction

seeing a teacher show the class how a quarter inch of excess paint perched at the tube's mouth could be sucked back into the tube. The teacher, or magician as she seemed to me then, simply squeezed the side of the tube gently and evenly. The flat side of the tube (which we ordinarily squeeze) bloated slightly and vacuumed the excess back in. I've found, however, this works better when the tube is more full than empty.

Sometimes you'll encounter paint that is so stiff it won't flow from the tube. Don't throw it away. Remove the cap and force a toothpick—be sure it's a sturdy one—down into the paint as far as is practical. Just watch your aim so you don't punch a hole through the side. Extract the toothpick and fill the cavity with water. Replace the cap and wait a day or so, then work the contents back and forth a few times to more uniformly mix the paint before squirting some out.

Use a brush handle to squeeze more paint to the neck before rolling the tube.

Squeeze the shoulder and roll up the tube with pliers to force out precious paint.

What can you do with a quarter of an inch of surplus paint sticking out of a tube? Ordinarily, you'd probably place it in your paint well even if you didn't need it. After all, how do you get it back into the tube? By gently squeezing the sides of the tube as shown, you can vacuum the extra paint back into the tube.

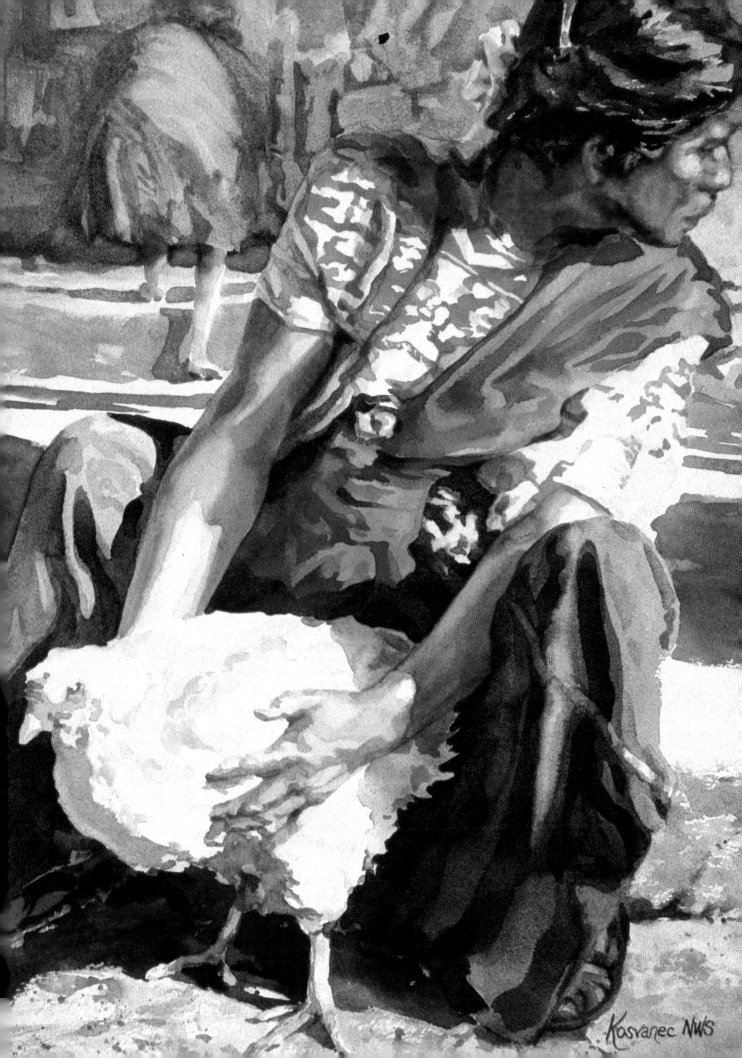

PAPER, BRUSHES, AND LIGHTING

The irrepressible Yogi Berra once quipped, "You got to be very careful if you don't know where you're going because you might not get there." If you can express yourself artistically, you know where you're going, but you still might not get there simply for lack of advice on how to select or handle certain tools of the trade competently. This chapter deals with three important ones: paper, brushes, and lighting. After learning more about each, you'll be better equipped to make educated selections, allowing you to paint with more comfort and confidence.

Few watercolorists understand paper well enough to tailor a selection to their requirements. So, I begin by describing the more common surfaces and what characteristics can help or hinder your work. Beyond the terms that apply to a paper's surface traits and weight, you'll encounter others like "acidity," "pH," and "buffered." You may not feel completely lost amid this jargon, but wouldn't it be comforting to finally understand how it all impacts on your paper choices? I've even included an experiment that reveals the best degree of surface preparation for your painting style. And, my personal recommendations regarding paper manufacturers will help you wade through the admirable and annoying features of their products.

Once you've found a paper you like, you need to stretch it. If you've tried stretching paper before and encountered difficulties, follow my step-by-step instructions to learn an easy method that will offer a solution to your problems. Besides the preferred stapling method, I show you two others—one using paper tape, the other using canvas stretcher bars. I also describe alternatives to stretching your paper.

Next come brushes. Buying them can be overwhelming—how do you know which ones you need, and how do you determine their quality? And when do you stop buying them? With guidance, you'll be surprised at how few brushes you actually need. By buying fewer, you can justify splurging on higher quality. Of course, once you've made the investment you'll want to care for your brushes properly, so I cover the dos and don'ts that will help you preserve them, and also show you some easy repairs.

Last but not least is lighting. Whether you work in natural or artificial light, it's important to gain an understanding of how different light sources can affect the colors you select for your paintings. As you will see, our eyes are not at all the best judges of light quality; in this we need some objective guidance.

Paper, brushes, and light are simple tools in concept, but selecting them thoughtfully with regard to your individual needs can make all the difference in the quality of your artistic expression.

Above: HYPNOTIC RADIANCE, 19 1/2 x 29 1/2" (49.5 x 74.9 cm), Crescent 115 board, collection of Toni Cherry

Left: A SENSE OF URGENCY, 19 1/2 x 14 1/2" (49.5 x 36.8 cm), Winsor & Newton 260-lb. rough paper, collection of John and Sharon Garside

CHOOSING THE RIGHT PAPER

In workshops I constantly observe students struggling against a paper's characteristics. Most often, they've chosen a paper by its reputation or by recommendation rather than considering personal needs. Choosing the right paper to complement your style or technique is very important. Beyond this are other equally important criteria, including factors that can affect luminosity. Painting on too soft a paper, with a paltry amount of sizing, is like painting on a paper towel, while too hard a surface can be uncontrollable and lead to inconsistent results.

SURFACES

The most commonly used paper surface is rough, which has a "pebbled" texture that gives a painter many options. For instance, with a brush held on edge and scraped across the surface, a spotted effect is created. Conversely, you may create pinholes of light by scraping a razor blade deliberately across the bumpy surface of a dry wash. An uncommonly interesting effect is achieved using full wet washes of settling pigments. More pigment settles in the miniature crevices and less on the crests of the paper's surface. These are just a few exam-ples of this versatile and generally forgiving surface.

On the other end of the scale is hot-pressed paper, which is very smooth. With its tightly compacted fibers, this paper has the slick appearance of a stiffly starched shirt collar. Its response and versatility are very appealing. For example, you can create interesting effects by lifting color; negative spattering and other effects are also possible, due to the paper's resistance to absorption. Another advantage to the hot-pressed surface is that it allows you to render sharp lines and crisp color. If you

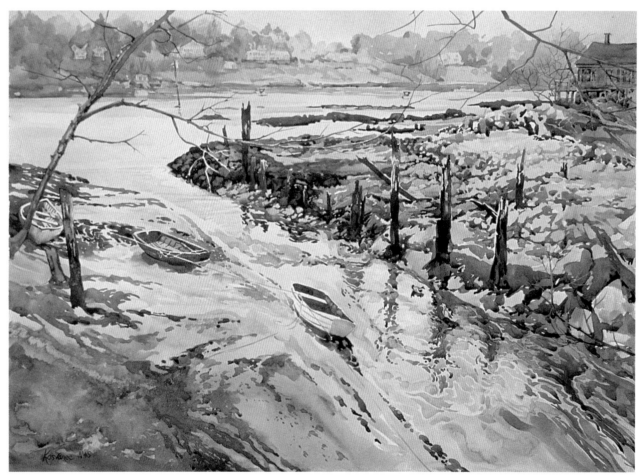

THROUGH THE MIST, 21³/₄ x 29¹/₄" (55.3 x 74.3 cm), Strathmore Imperial 500 140-lb. cold-pressed paper, collection of Fleming Companies

Cold-pressed paper is the most commonly used surface in watercolor painting. It handles predictably, although it lacks a few of the more desirable characteristics of other surfaces.

SPRING SNOW, 18¹/2 x 28¹/2" (47.0 x 72.4 cm), Crescent 115 board, collection of Eldon and Donna L. Balko

This hot-pressed surface allowed general lifting; I was also able to lift color by spattering drops of water on the surface, which loosened paint I then removed with a tissue. Line definition is more pronounced and viable with this smooth surface.

enjoy detail, this choice is better than a rough surface. Hot-pressed papers described as "plated" or "calendered" are burnished under the pressure of two metal plates; the former is handmade, the latter, machine-made.

The hot-pressed surface is my favorite. However, it has drawbacks. One that can be particularly frustrating occurs when you are laying down successive washes. As brushstrokes overlap one another, they sometimes lift previous washes—even ones that are thoroughly dry. Consequently, streaks of light may appear. This surface is not very forgiving. You must paint decisively and directly to get the best results. This may seem contradictory to its lifting ability, but it's not. The lifting of color is useful mainly for effects, and not for

repainting. Imagine our starched shirt collar being soaked in water; once it dries, its slick surface will no longer appear shiny. The same holds true for the once-used surface of hot-pressed paper; a reworked area looks dull and obvious.

Perhaps the most popular surface is cold-pressed paper, which in attributes is somewhere between the extremes of rough and hot-pressed papers. (The British term for this surface is "not," meaning that it is not hot-pressed or rough.) Cold-pressed paper permits you to create some textural effects and yet render detail as well, since its texture isn't overly pronounced. You can scrape and scrub and lift to varying degrees. You may also layer washes without much fear of lifting previous ones. Because its surface

is forgiving and somewhat predictable, allowing for better control, cold-pressed paper may be the best choice for the beginning painter, followed by rough and hot-pressed.

For the adventurous there is illustration board, which is so smooth that working on it is like painting on glass. To control a wash, you need to work flat. If you work wet, you need an optimistic attitude, a direct response to the work and paper, and a willingness to allow the brush to "dance" on the paper. If you work dry, you will find the surface excellent for rendering striking line and color. It is extraordinary for detail work.

Use a "high surface" or "high plate" illustration board that is 100 percent rag, acid free, and the heaviest ply you can find. You need

this thickness because you should not stretch illustration board. To soak it enough to stretch this paper will raise a "tooth" by swelling the very hard surface you've paid dearly for. Tape it to a stretching board just to give it more heft while you're painting.

I think the most interesting characteristic of illustration board is the way it behaves when you use lifting techniques. In this regard hot-pressed paper is similar, but permits fewer extremes. For instance, when you lift a nonstaining wash from illustration board you can nearly return the paper to white. Lifting a wash of a staining color will leave it singing like a piece of stained glass. Keep in mind, though, that this is a difficult surface to master. Wait until you have a secure grasp of the mechanics before trying it.

WEIGHTS AND SIZES

Weight is an important factor in the paper you choose. Do you fear you might tear through the paper with your painting techniques? Stick to heavier papers. Do you enjoy painting on a springy surface? A lighter weight paper is a sound choice.

A standard-size sheet of watercolor paper measures 22 × 30" and is called an imperial. The number used to describe its weight is based on what a ream (500 sheets) weighs—90, 140, or 300 pounds, for example. But what about a 40 × 60" sheet designated as 1114-lb. paper? This is extraordinary—a paper thick enough to use as a room divider! Well, not really; it's actually the same weight as 300-lb. paper, simply because of its larger surface area.

Metric weight measurement makes the paper's dimensions meaningless, because the system assumes a standard and sticks with it: the weight in grams of a square meter (roughly 40 × 40") of paper, notated as gsm or gm/m^2. Thus, a 300-lb. paper is listed as 640 gsm regardless of its size; likewise, 140-lb. paper is 285 gsm, and so on.

Besides imperial sheets, watercolor paper is available in sizes known as single elephant (25^3/$_4$ × 40"), double elephant (29^1/$_2$ × 41"), and triple elephant (40 × 60"). If you paint large or choose to buy your paper more economically, consider rolls of watercolor paper. Arches, Lanaquarelle, Waterford, and Morilla manufacture a variety of papers in rolls measuring 10 or more yards long by 43^1/$_2$" to 60" wide.

FIBER CONTENT AND ACIDITY

First on the list of criteria for choosing watercolor paper is acidity. You may already know that the highest quality paper is made of cotton or linen, not wood pulp. So when you choose a paper designated as 100 percent rag, perhaps you

OUT OF GAS, 20 × 14" (50.8 × 35.6 cm), Arches 300-lb. rough paper, collection of Mary Jo Newburg

Skidding a brush across rough paper to create textural effects is wonderful.

feel secure. In truth, though, this is no guarantee that the paper is also acid-free! If during the papermaking process the manufacturer doesn't eliminate residual bleaches, neutralize acids or render them alkaline, and carefully monitor the quality and pH balance of water and sizing, the paper's permanency is in jeopardy regardless of its fiber content. Later, atmospheric conditions where the painting is hung may exacerbate matters.

Artists require acid-free paper. A pH value of 7 is said to be neutral, and this is sufficient. Lower than 7 (say, 5) is unacceptably acidic, while higher than 7 is better because it's more alkaline. Buffered papers have a pH value of around 7.5 to 8.5. Buffering helps counteract environmental strains on the paper's pH balance. Before selecting a paper, ask for its pH value. A knowledgeable supplier will gladly provide you with this information. Ideally, the paper you paint on should be 100 percent rag, acid-free, and buffered.

SIZING

Sizing is essentially a waterproofing agent made of glue, starch, rosin, synthetic polymers, or gelatin. *Internal* sizing, which is essential, is accomplished by treating the pulp with one of these agents before sheets are formed. *External* sizing, which is optional, involves treating the paper with a coat of gelatin, starch, or PVA (a plastic glue). When external sizing is introduced after the sheets have dried, the paper is described as tub-sized. Doing this "off machine" simply means tub sizing the paper on a machine separate from the one that formed and dried the sheets.

Depending on your needs, choose a paper that is appropriately sized. A moderately or lightly sized paper will give you softer

MAROONED, 17 x 13" (43.2 x 33.0 cm), Strathmore high-plate illustration board, collection of William and Joyce Melvin

High-plate illustration board allows sharp definition and contrast. Wet washes such as those that define the sky in this painting are also possible, though a challenge to control. Another advantage of illustration board is that it lets you remove most color thoroughly.

edges and comparatively muted washes. Papers that are more heavily sized can better withstand surface abuse such as scrubbing, scratching, erasing, and reworking.

Incidentally, one way to partially refurbish a small section of paper that has been abused by too much lifting or scraping is to burnish the damaged area with a burnishing tool or the flat of a fingernail to compact the fibers. This may allow you to repaint the area, but often

results in a shiny spot that draws attention to itself. You also can resize the area with household gelatin mixed with water or with a prepared size such as Winsor & Newton's. Apply a thin solution and wait for it to dry before painting over it. This will merely make the damaged area less noticeable, not invisible.

Paper described as waterleaf contains no sizing. Thus, when you apply paint, the colors quickly

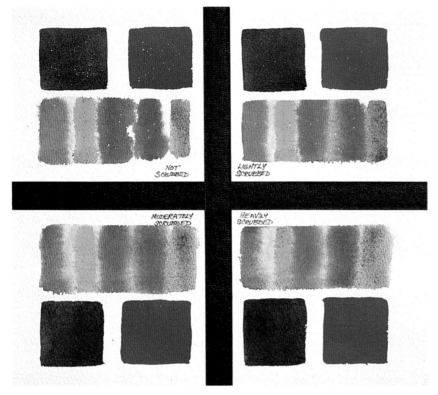

Divide a sheet of paper into separate areas and scrub the surface of each in varying degrees to discover which preparation suits you.

absorb into the paper fibers. Waterleaf is not well suited to traditional watercolor painting techniques.

At this point I'd like to introduce the term *hold out,* which refers to the paper's surface resistance to water and pigment absorption. Let's use Arches 300-lb. rough paper as an example. This paper has internal and external sizing; the latter has the greater effect on hold out, acting like a varnish that resists moisture. I love this quality, but you can modify it to your own liking by scrubbing the surface with a sponge and water. Try the following experiment.

First, stretch a small piece of paper, let it dry, and divide it into quarters with masking tape. Write the words "not scrubbed," "lightly scrubbed," "moderately scrubbed," and "heavily scrubbed" in the divisions so you can later identify the results. Then use a sponge to wash the "scrubbed" panels. For "lightly," imagine you're cleaning a

greasy plate. For "moderately," envision an encrusted broiler pan. For "heavily," have at it; I used a stiff scrub brush.

When the paper is dry, try some concentrated and medium washes with fast and slower brushstrokes. Note the difference in the definition of edges. The scrubbed panels will yield edges that vary in degrees of softness and muted color. Depending on the type of paper, the concentration of pigment in the wash, and the way the wash is applied, there may be little bubbles of air trapped under the pigment in the "not scrubbed" area. These will burst as they dry, leaving pinholes of white paper. Sometimes this is an interesting effect.

Let your eye and taste guide you. In general, too much sizing will cause washes to dry lighter than you expect, yet give you more opportunity to rework the surface. On the other hand, less sizing will give you darker, more predictable

washes, but allow less revising.

Optical brighteners are often added to paper to enhance reflective properties, meaning more light bounces back through the pigments to give a luminous appearance, as though a fluorescent light was burning from inside. Papers treated this way have some undesirable characteristics. Brighteners contain dye additives to absorb light in the ultraviolet range, effectively extending the visible range of light. However, these chemicals are not stable, darkening as they deteriorate in as little as six months.

WATERMARKS, DECKLES, AND SURFACE PATTERNS
A watermark is an identifying symbol or name you can see when you hold a sheet of paper up to the light. It's created by a wire design sewn to the screen on which the sheet of paper is formed. As water is pressed out of the pulp in the mold, the metal design leaves its imprint on the sheet.

Many watercolor papers have ragged edges known as deckles. (A deckle edge doesn't necessarily mean a paper is handmade or high quality.) Deckle edges are lovely, but unless you use them in displaying your work, they're useless. If too exaggerated, they can hinder the matting process, as they tend to lift the mat unevenly and buckle the paper. I cut them off to allow the paper to lie flat under the mat.

Hold a piece of paper up to the light to find the watermark.

Utilizing the potential of illustration board calls for painting techniques that differ from traditional approaches to watercolor. A soft, undersized paper can mute washes far more than expected. A rough surface with appropriate sizing is predictable and responds well to traditional painting techniques.

Similarly, if you use paper tape rather than staples in stretching your watercolor paper, the deckle forms a largely unglueable surface, raising the tape away from the stretching board. Consequently, the paper tape will occasionally let go as the paper shrinks while drying.

As a matter of personal taste, I prefer papers with an irregular surface pattern. Some machine-made papers have a distinct uniform texture running through them, which I find distracting. This might not bother you, but I think you'll find the pebbled and felt textures of handmade and high-quality machine-made papers more exciting.

COMPARING LUMINOSITY

Paper choice can affect luminosity. Using only standard painting techniques, I executed three studies of the same subject (a detail of each is shown above) using the same color mixtures and washes, rendering analogous passages in each example concurrently to duplicate brush control and paint density from one to the next.

The first example (left) was done on illustration board. Notice how the colors are generally luminous, but where they have pooled, they've become too dense. This slick surface has potential in the right hands, but since there's no texture, standard brush techniques

have limited use and produce a rather boring painting. On the other hand, there is a toy box full of techniques designed for high-plate illustration board that makes painting on it as much fun as it can be frustrating. If you think you'd like to try it, read Georg Shook and Gary Witt's book *Sharp Focus Watercolor Painting* (Watson-Guptill, 1993).

The second example (center) was done on soft, undersized watercolor paper, which soaked much of the paint into its fibers, leaving a delicate, understated effect. It is possible to restate colors or begin by applying heavier washes, but doing so makes managing

125

clean colors tedious. Staining colors, which ordinarily make strong, dark statements, sink into the paper quickly and appear muted. Opaques, on the other hand, tend to remain more on the surface of soft paper. Here they are somewhat luminous, though they appear dull by comparison to our first example.

For the third example (preceding page, right) I worked on rough paper made stiff with internal and external sizing. Both qualities help keep the paint from sinking in, allowing the white paper to reflect light back through the pigment particles and illuminate the colors. The rough surface makes an interesting contrast to the illustration board; even though the brushstrokes used in each example are nearly identical, the results are very different. The coarse grain and drag of the brush across the rough surface creates visual textures and nuances of light.

PERSONAL RECOMMENDATIONS

I suggest that you avoid student grades of paper. They are sufficiently inferior to hamper the discovery process and can sap the paint's and painter's potential.

I also recommend that you resist watercolor blocks. They are quite popular and are perceived as pre-stretched paper layered in a stack, each piece easily removed to expose a fresh sheet. This oversimplifies the description, but I have yet to find a block that won't buckle when wet. If you are determined to compromise a little on quality for convenience, use a pad of partially synthetic paper such as Arches Liberté, which buckles less.

Well-known papers to consider are those made by Arches (officially, Moulin à Papier d'Arches, founded in 1492), which produces consistently excellent professional-grade papers in a wide range of sizes. Arches professional watercolor paper is creamy white with four deckle edges and is favored for its ability to take abuse like scratching and scrubbing and still remain a manageable painting surface. As with all machine-made papers, only two of the deckle edges are genuine; the other two are mechanically simulated. My favorite weight and surface is 300-lb. rough. I paint on the side opposite the watermark because I prefer its texture. I advise lightly scrubbing the surface while stretching this paper. Otherwise, the heavy sizing can cause pinholes when you apply paint. The 300-lb. rough has a more pronounced texture than the 140-lb. Many painters don't bother to stretch 300-lb. paper, but in my opinion you must do so to prevent buckling. Arches has a 400-lb. paper that may be sufficiently heavy to obviate stretching.

Arches cold-pressed papers represent a standard by which the most commonly anticipated properties of a watercolor paper can be measured. I'm fond of the mill's 140-lb. cold-pressed paper but seldom use it because it is almost too predictable. I like to live dangerously! But that's where the love affair ends, because I'm disappointed in Arches hot-pressed surfaces. They seem to stain quickly and don't allow the full range of lifting techniques you'd expect. Arches also makes a line of watercolor board, which is watercolor paper—the same professional paper you'd buy in sheets—mounted on a cardboard backing.

Winsor & Newton watercolor paper is a recent addition to this firm's line of quality artists' products, and it is some of the best I've ever painted on. The paper is white with deckle edges. The selection is just large enough to satisfy most needs. The heaviest weight is 260 lbs. and is available only in cold-pressed and rough; the largest sheet size offered is imperial (22 × 30").

If your technique requires lifting color, it's important to choose a sympathetic paper; in my observations Winsor & Newton's papers tolerate a high degree of lifting. Surprisingly, I've found I can lift nearly as much paint from their rough surface as I can from their hot-pressed.

Winsor & Newton's heaviest hot-pressed paper is a mere 140 lbs., but I am very fond of it. It has a hard but not brittle surface with a sensitive random texture and excellent hold out. It also allows you to layer or glaze without disturbing the underlayers as readily as other brands. Yet with lifting techniques it performs as well as any paper I've ever used.

Strathmore produces some excellent papers, including its superior 500 Series Imperial watercolor papers. I occasionally use the hot-pressed surface with sparkling results. Its whiteness makes colors appear crisp and luminous, and its slight texture and affinity for lifting techniques make this one of my favorite papers for figurative work. Unfortunately, it is only produced in the standard 22 × 30" size.

On an adventurous day you might enjoy trying Strathmore's high-plate illustration board, which, thanks to its slick surface, will literally give you a run for your money. It permits some interesting effects with lifting glazes and positive and negative spattering. It also lets you render fine detail using the drybrush technique. Staining colors will not lift, but this can be used to advantage. Buy only the 14-ply board, as anything lighter buckles when wet and won't tolerate stretching.

Lanaquarelle paper is softer than

Arches. A creamy off-white, it has four deckle edges. Washes absorb into this paper comparatively quickly, allowing for subtler color and edge definition. The 300-lb. hot-pressed surface is very manipulable, although I like painting on the side opposite the watermark because to me there seems to be a harder sizing on that side.

Crescent watercolor board is Strathmore's 500 Series-type watercolor paper mounted on backing board. Available sizes range up to 30 × 40". I've noticed that mounting the paper seems to lessen its surface texture and sizing hardness. Crescent offers an acid-free white backing board for artists who are concerned that the standard newsprint backing might "burn" through to their painting surface. The white board does look better, and it probably assures a client that you care about conserving your work, but time tests reveal that even if acids from the backing could migrate through, it might take hundreds of years. White backing board costs about 40 percent more than gray.

Saunders's Waterford series is produced by an English paper company with an excellent reputation and good selection. The paper's color is white. The internal and external sizing produces a hard and durable surface that can be worked repeatedly.

Fabriano's handmade Esportazione paper has a strange texture that some find intriguing and beautiful. Its color is a mellow, creamy white, and each sheet has four true deckle edges. The paper's cost is steep, so undertake a slice when you are painting decisively.

Twinrocker is the only mill in the United States producing handmade papers. Handmade paper such as this company's is dimensionally more stable than machine-

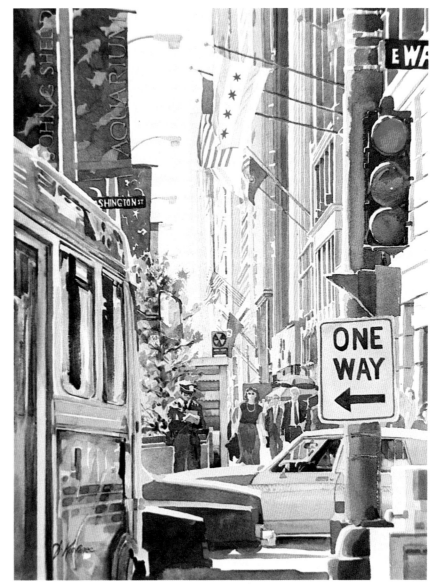

TODDLIN' TOWN, 28¹/₂ × 21¹/₂", (72.4 × 54.6 cm), Arches 300-lb. rough paper, collection of James Holtzman

Arches 300-lb. rough is a wonderfully tactile paper that allows much reworking. I lived and worked in Chicago for many years and always loved the bustle and color of Michigan Avenue, except when I was driving.

made paper, has a naturally pebbled, random texture rather than one that is "embossed" by a screen or felt, and has four true deckle edges. Along with a traditional deckle, Twinrocker has created a unique, exaggerated version called the "feather deckle," which is airy and quite handsome.

When I tested Twinrocker's papers, I found balanced hardness, which in part determines the amount of abuse a paper can take

before it becomes unpaintable. Their watercolor paper holds up exceptionally well. I found Twinrocker's sizing allows exceptional lifting of color (including staining colors) regardless of whether the surface is rough, cold-pressed, or hot-pressed.

This firm offers an incredible assortment of sizes and shapes, including circles, squares, and long rectangles. The largest watercolor sheet currently available is 34 × 48".

STRETCHING PAPER

To many, it seems like a waste of time to stretch a piece of paper and wait for it to dry, but I feel it is essential. First, you won't experience the miserable hills and valleys of buckling paper that tend to dispel or pool what should be an even wash. Second, your finished painting will lie flat when matted; there won't be distracting bumps. Third, you will prepare the surface for the amount of resist, or hold out, you prefer. Finally, you'll enjoy responding to the spring of tensioned paper. There are several ways to stretch paper; I'll describe

the one I feel is foolproof and easy. Needless to say, I arrived at this method by a long trial and many errors.

You'll need a board to attach the paper to. I recommend 1/4" to 3/8" marine or Luan-faced plywood with at least one good side. Exterior door plywood (door skin) is often available at large lumberyards. Compared to the price of marine plywood, this is a much better value. Have the board cut one or two inches larger than the paper size you intend to use. While you're at it, have an assort-

ment cut to accommodate the sizes you normally paint. I always stretch several pieces of paper at a time in order to have a standing supply. That way, I can continue to paint while in the spirit. The boards should be sanded along the edges and rounded slightly to prevent splintering.

The plywood has residual acids that, when wet, could leach into the back of your paper. Although not essential, it is prudent to seal the board with a coat of varnish, enamel, or any waterproof, hard-drying paint. Even acrylic artist's paints will work. Just a light coating is ample.

Many artists use a heavy-duty staple gun to attach paper to the boards, but I prefer the lighter Arrow P-22 (available at most stationery stores), which uses ordinary 1/4" grip staples. These hold well and are easy to remove.

A watermark on a sheet of paper indicates the "right" side for painting. Unless you're stretching a full sheet, make a pencil mark in each corner of the paper before cutting

First, wet the mounting side of your board, then lay the paper face down on it. This means the side you don't paint on is looking up at you.

Next, using a hose, wet the paper (the "wrong" side) for about a minute. Don't blast it; just use a steady stream.

Carefully turn the paper over ("right" side up) and center it on the board. (There should be about 1/2" to 1 1/2" all the way around.) Try not to crimp the paper as you handle it. Positioning the paper is easy, since it floats on a cushion of water.

Once the positioning satisfies you, gently press down on the paper with your hands to expel the cushion of water so the paper won't skid around.

With its check mark skyward, wet the "right" side of your paper with a gentle stream of water. When you've done this, set the board with paper in the shade to let it absorb the water and expand.

it so you can tell one side from the other, because the watermark is usually only in one corner.

WETTING PAPER OUTDOORS
To begin the stretching process, you need to wet the paper and board, which you can do with ease outdoors if you have the space and a garden hose following the simple steps outlined and illustrated on page 128.

WETTING PAPER INDOORS
Indoors, in limited quarters, using a spray bottle to wet the paper gives you the same results. First, spray the mounting side of the board. Second, lay the paper checked face down on the wet board and spray the paper's backside. Be certain it is entirely covered. You will see a uniform gloss across its surface when it's entirely wet. Third, turn the paper to the side you'll be painting on, and center it on the board. Lacking the cushion of water that's possible when you use a hose, you should take extra care not to crimp the paper, since you will probably need to lift and reposition it once or twice. Finally, spray this side as well. When you finish, lay the board and paper flat and wait ten to fifteen minutes. If there are no blisters forming, it's now time to staple.

BUBBLES AND BLISTERS
If blisters form as the paper expands, this is not a calamity. It's caused by not wetting either the board or the underside of the paper long enough. If you lift one end of the paper at a time, you'll notice dry spots on it and on the board under the area of the blisters. Just dampen the dry areas with a little spray and lay the paper down again. In about ten minutes for 140-lb. paper and twenty minutes for 300-lb., the bubbles will

If the paper or the board wasn't doused long enough, you might find blisters and ripples forming as it dries.

To remedy blisters and ripples, lift the paper and lightly spray the dry spots of the paper and the board. One will mirror the other in location.

When stretching lightweight paper, place the staples 1/4" closer together than you would with heavier paper. Grasp the handles of the stapler toward the back to gain the most leverage.

disappear and the paper will have expanded sufficiently. If you need to, reposition the paper. Wet your hands and spritz the surface. From the center, gently smooth the paper to the edges with your palms. Don't be concerned if it is not perfectly flat. After stapling and drying, most full sheets will shrink about 1/8" or more to drum tightness.

If you paint wet-into-wet with large wet washes, and your paper is indignantly buckling even when stretched, try soaking the paper longer—perhaps twice as long, which will make it expand more and stay flatter during the painting process. The only problem you may encounter is that because the paper is apt to shrink more with longer soaking, it may pull past the staples. In that case, try using a combination of staples and brown paper tape to ensure that your efforts aren't wasted. It doesn't matter which you use first to secure the paper.

STAPLING
With thinner, lighter weight papers (140 lbs. and under), you must set the staples closer together than you would for heavier papers, which are thicker and offer more resistance to the staple posts. Thus, when using 140-lb. paper, I set the staples about 2" apart and approximately 3/16" to 1/4" in from the edge of the paper. If as your paper shrinks it rips past staples along one edge, remove the errant staples. Next, rewet the paper—on the board. Then, restaple the misbehaving edge after letting the paper expand for about five minutes. This reduces the reciprocal contraction. You may need to moisten the paper a few times during your wait. The next time you stretch the same type of paper, place staples closer together. With 300-lb. paper, try staples every 2" to 2 1/4". Paper this heavy is unlikely to rip past staples during stretching; if anything, an entire side may pull loose, staples and paper together. Follow the same procedure as for lighter weight paper, but let the sheet expand for ten minutes before restapling. Ignore deckle edges and staple inside them, or cut them off ahead of time.

DRYING

After the paper is stapled to the board, set the board on edge for a few minutes to drain any excess water, then lay it flat, indoors or out, in sun or in shade. Depending on conditions, it can take four to twenty-four hours for the paper to thoroughly dry. Check for dryness by touching the paper with the back of your hand, as you would to check for a fever. If the paper feels cool, it's not dry. Starting a drawing on damp paper will impress the pencil lines into the surface, and could cause some unsightly markings as well. So, be patient!

REMOVING THE STAPLES

Removing the staples needs to be done carefully so you don't tear the paper. An awl is an ideal tool to use for this purpose because it gives you a lot of control. These strong, short spikes mounted to fist-conforming handles are available in any hardware store. There is one very important point to make here: Be sure to slip the awl under a staple *between the paper and the board,* not the paper and the staple! Once the tip is under the staple (with the cushion of paper between), lever the handle downward, and the staple will rise easily. If your paper is lightweight or brittle, don't try to raise the staples clear of the board; it's better to do this with a pair of narrow, needle-nose pliers. Again, use the edge of the board as a lever, and clutch the staple from the top side of the paper to pull it.

To control the awl properly, hold its handle with your writing hand and grip the edge of the board with your other. You don't want the point of the awl entering into the painting area any farther than slightly past the staple; so, use the index finger of the hand holding the awl as a "stop" by resting it

Slip the point of the awl under the paper and staple and lever the shaft downward to raise the staple slightly. Don't try to completely remove the staple during this step, as this might cause the paper to rip.

The safest way to finish extracting staples is to pry them out with a pair of small needle-nose pliers. As with the awl, push down to lever them out.

against the edge of the board. This acts as a control point that limits the awl's entry as you exert pressure on it, preventing you from slicing through part of your painting.

PAPER TAPE METHOD

Many artists use paper tape to attach their paper to a board instead of using staples, although in my experience it is more time consuming. The process of wetting and preparing the paper is exactly the same as in the staple method. The paper can't be too wet where the tape will attach; otherwise the tape lifts as it dries. To avoid this, first blot the edge with paper towel.

With 140-lb. paper I overlap the painting surface about 3/8" to 1/2" to ensure good tape adhesion. The rougher or heavier the paper, the

more overlap you need. It is wise to remove deckle edges, as they tend to form a tent between the attachable surface of the paper and the surface of the board. Also, you may need to overlap two or more layers of tape to ensure adhesion.

If you encounter some problems with tape not sticking or tape breaking, try using reinforced or wider tape, or additional tape layers and more overlaps; alternatively, switch to a lighter weight paper or soak it for a shorter time (this will reduce shrinkage). You might also try using staples in combination with the tape.

Removing the paper from the board is straightforward. Cut

If your paper tape is letting go, try adding staples as soon as the tape is in place.

When cutting a taped painting from the board, always use a substantial straightedge guide and cut to the outside. Never cut along the side toward the painting.

through the tape following the edge of the paper, and then cut off the paper-taped border using a straightedge. A more practical approach is to think of the paper tape as a frame around the painting. The objective is to cut away the frame and lift out the painting. For this you need a straightedge and mat knife. Make your cuts to the outside by placing the straightedge between the painting area and the tape "frame." This way, the straightedge acts as both a cutting guide and a barrier that prevents damage to the painting area. Don't guide the blade along the inside of the straightedge or you run the risk of slicing the picture area. Be sure you put enough pressure on the straightedge guide to prevent it from spinning. Don't try cutting through in one pass; two or three are safer. Please keep your body parts intact by ensuring that nothing is in the path of the blade. Later, rip the remaining "frame" from the board. (If you use a pH-balanced paper tape, you might consider leaving it on the paper, since it shouldn't pose any conservation problems.)

STRETCHER BAR METHOD

Another possibility, if you work on a soft or flexible paper, is to stretch paper on a frame of wooden canvas-stretching bars at least 2" shorter than your paper size. The paper dries faster this way because air reaches both sides. Also, during the painting process, you can accelerate the drying of wet washes by blow-drying the paper from behind, which miraculously leaves colors vibrant when dry. (Remember to wait till the sheen has disappeared before applying heat.) A disadvantage of the stretcher bar method is that it makes paper more susceptible to puncturing and ripping.

Using canvas stretcher bars to stretch your paper works well, although you waste a lot of paper surface. The paper dries to drum tightness. Take care not to crimp the wet paper too much as you handle it; otherwise you might end up with a batik effect.

Fold the corners of the paper as pictured and then drive a staple through the three layers. Quarter-inch staples are more than adequate.

ALTERNATIVES TO STRETCHING

If you don't like to stretch paper, watercolor board is an excellent alternative, although it does have some disadvantages. The mounting process alters the paper's surface, causing it to become smoother than you might want. Also, most mounting boards (Crescent's 5100 series is an exception) are not acid-free and could eventually affect the archival qualities of the paper. And, the board's thickness hinders the matting process, though you can solve this by peeling away some of the plies. Lay the painting face down and carefully peel and curl the backing layers away while hold-

ing the painting layer flat. Practice on scraps before you attempt a painting. You'll notice some darker gray slices of paper mixed in with the predominant lighter gray. Begin delamination at the thin, dark gray layer. Don't go all the way to the watercolor paper; reducing the thickness by two-thirds is sufficient. When you later tear up the peeled layers to toss in the trash, don't inadvertently rip up the painting.

Illustration and bristol boards are fine if they are heavy ply and are taped to a firm surface. However, if they become too wet, they will buckle. This is normally not a problem, because these slick surfaces don't lend themselves to an overly wet style of painting.

Boards with a clamping system surrounding the edge seem appealing, but problems with clamps letting go and the limitations of using

The backing of watercolor board is composed of several layers that make delaminating easy. You'll find the layers are demarcated by a slightly darker gray paper.

While peeling back a layer with one hand, hold the painting flat with the fingertips of your other hand, lifting with the knuckles.

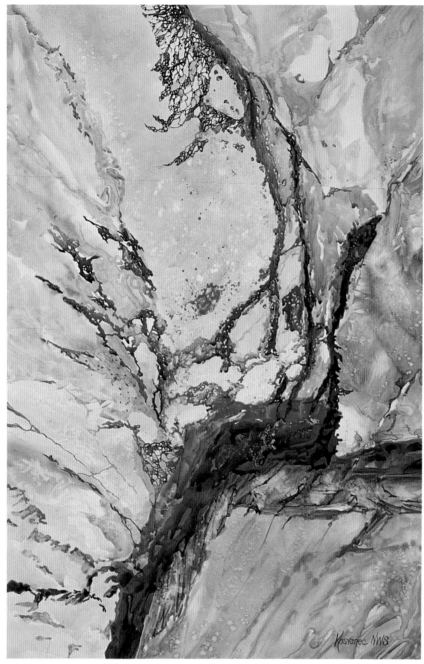

SILENT MIGRATION, 29¹/₂ x 19¹/₂" (74.9 x 49.5 cm), Crescent 115 board,
collection of Jackie Schwegler

Crescent's watercolor board is an excellent choice for a painter who wants the convenience of a prepared surface without the effort of stretching paper. Large panels can be cut to more suitable sizes.

only lighter weight paper of half-sheet sizes lessen their allure.

FLATTENING A PAINTING

Some artists think of flattening a finished painting as an alternative to stretching the paper beforehand, but I can't recommend it as standard procedure, considering that painting on an uneven surface is unpredictable, distracting, and tends to precipitate reworking. Still, sometimes in spite of stretching, flattening is necessary. For instance, in an all but finished painting I might see something that needs more work, and so launch back into the painting process. If the paper is no longer on the stretching board, it's going to buckle as I paint, especially if I work wet. Before framing, it needs to be flattened.

If buckling is minor, place the painting on a smooth, hard surface, then lay a piece of Masonite, particle board, plywood, or Plexiglas over it. Lay books over the sandwich to form a press and wait a day or so.

If your painting looks like a relief map, you'll have to get more serious. You'll need a piece of 1/8" or thicker Plexiglas (or plywood, Masonite, or heavy cardboard covered with plastic wrap), a piece of undyed felt (ironed flat), a piece of 1/2" to 3/4" particle board or plywood, and a sponge with water. The Plexi, felt, and board should be larger than the paper. (In place of the felt, I've used paper towels laid in three or four thicknesses, changing the layers after six hours.)

First, dampen the back of the painting evenly with a moist, but not sopping, sponge. Don't let water creep under the paper to the painted side. Make two or three passes if the paper is lightweight, possibly four if it is heavier. Next, remove any excess water and set the painting aside. Lay the felt (or paper towel) on the particle board or other untreated wood surface (the wood helps wick moisture away from the paper, so don't expect a plastic tabletop to take its place), then place the painting *face up* on the felt. Now place the Plexiglas on top of the painting and weight it down with books or magazines. Be patient. It may take a day or more for the painting to flatten out and dry while the moisture is absorbed into the felt and board. There is no harm in checking and then replacing the layers if the painting doesn't seem completely dry.

BRUSHES

Brushes are a major investment, but if properly selected, they will allow you to express yourself with each stroke. How a brush dances over the paper while in our command articulates our artistic expression. This oneness is a very important part of our art. A great brush will outperform and outlast a lower-quality brush.

SHAPES

The two most common brushes watercolorists use are flats and rounds. You'll probably use a flat to begin a painting. Its chiseled square end permits a wide range of effects, from broad washes to fine lines. Try lightly skidding the broad side of the brush across the paper, and you'll achieve a descriptive irregular effect. Flats come in a wide range of sizes, from 1/4" to 5". The most useful sizes for watercolorists are 1/2", 3/4" or 1", and a 2" wash brush. I'd suggest buying sable for the 1/2" to 1" sizes and synthetic for anything larger.

A brush that's described as an aquarelle or a bright is a flat with a shorter "out," meaning the hairs protrude less than a flat of similar size. The shorter hairs give crisper brush control. Another common feature is a handle with a chiseled end that's handy for scraping damp paint to reveal the paper. The difference between a flat and an aquarelle is subtle, but if you have unlimited funds, you might try a 3/4"-size of both styles.

Rounds are as important to the watercolorist as flats—perhaps more important, since they are capable of delivering a vast range of eloquent strokes. These brushes are usually a round bundle of hairs

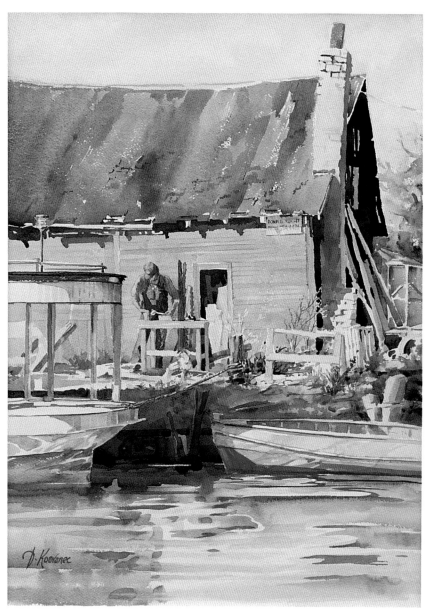

RESTORATION OF HOPE, 29 x 21" (73.7 x 53.3 cm), Arches 300-lb. rough paper, collection of John and Barbara White

I love the textural effects that can be achieved on rough paper using flat brushes. In this painting, I used 1/2" and 3/4" flats three-quarters of the time.

that taper to a fine or sometimes blunt point. The shape allows the painter to develop fine lines that can broaden as more pressure is applied to the brush. Sizes are gauged from #000 to #20 or larger; the most commonly used are #1 through #12. Within that range

you probably don't need more than a #6, #8, and #10, plus a #2 or #3 for signing your name or doing some detail work. A #12 or larger is a luxury brush. Because rounds are the most responsive brushes, artists usually take the plunge and invest in kolinsky sables. If expense is an

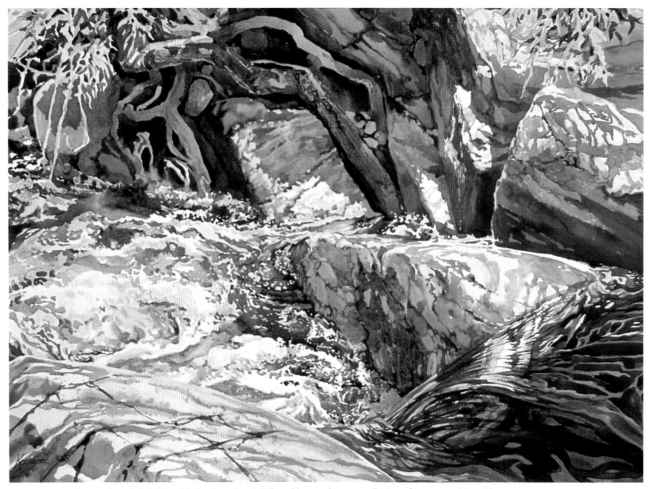

SHADOW DANCE, 25 x 34" (63.5 x 86.4 cm), Arches 140-lb. cold-pressed paper, collection of Jerome and June Shapiro

I painted most of the water in this painting with a #6 rigger. I allowed the brush to flare, repoint, and squiggle, creating the feeling of racing water stopped in action. Bright colors were painted into the preserved whites of the water, while in other cases a bright color was applied first, then the darks were painted over it. These glowing colors in the highlights enliven the surface.

issue, try red sable or a good blend.

A mop looks somewhat like a giant cotton swab and can hold an amazing charge of liquid for painting large, soft-edged washes. With a mop you can gently lay down large washes without disturbing underlayers. Its design seems to distribute stroke pressure evenly throughout all the hairs. You'll find a mop useful, but not essential; if you decide to add one to your collection, consider the 1/2" to 1" size.

Oriental brushes such as hakes and Japanese calligraphy (or sumi) brushes are the first choices of a few traditional watercolorists. I personally find that they have two annoying traits: limp response and low-quality hairs—usually goat,

sheep, or horse—that go astray. These brushes were designed as drawing/painting tools, and respond to a more calligraphic manner.

A few other brushes can render inspiring textural effects. These include hog's bristle brushes in all shapes, chip brushes from hardware stores, parts cleaning brushes from automotive stores, toothbrushes, and typewriter brushes.

Two other interesting brushes are the thin, long-haired liner and the even thinner, needlelike rigger. Both are intended to make straight, uniform lines, but I find them more useful for painting squiggly lines and shapes. Of the two I prefer the liner, which has a firmer feel

and responds beautifully to twists and turns. It also holds a good charge and can paint a continuous even-width line. A #6 to #8 seems a useful size.

The dagger striper and script brush are similar to the liner and rigger, except the dagger striper has a droopy belly that can best be used to create undulating effects. The script brush is not quite as useful as the liner.

Sign painters often use lettering brushes, which have a squared tip and rod shape that facilitate the task of beginning letters with a squared end and continuing the line with a uniform width. Imagine how easy it would be to paint porch railings, posts, or anything

rectangular with this brush. Its chisel-edged tip allows you to begin with a very thin line that can develop into a full-breadth line when you change direction. For example, by holding the brush with its edge horizontal and drawing it to the left or right, you create a very fine line that's the width of the brush's bladelike edge. If you begin the same way but, without twisting the brush, start moving downward in an arch, the width of the fine line gradually broadens. You can see how this tool might be applied in rendering a tall, twisting blade of grass. I suggest you buy a #4 and #8 and experiment.

One method of lifting color from paper requires an oil and acrylic painter's synthetic bright. Buy the least expensive #6 or #8 you can find; cheaper brushes are stiffer, and their sharp edges can be used to accurately wash out lines as well as larger areas. To lift color effectively this way, the paper must be dry and the brush moist but not wet. Loosen the pigment with the bristles and then immediately pat a tissue on the area to absorb the released color. Hog's bristle brights also work, but not with the same control.

HAIRS: SABLE TO SYNTHETICS

When it comes to choosing the finest hairs for a watercolor brush, sable tops any list. The best hairs are kolinsky sable taken from the tips of Siberian minks and Tartar martens, animals that live in Arctic northern Siberia and North Korea. The most desirable hairs come from the male's tail, which grows thick and luxurious as insulation against the fierce cold.

The natural spring, durability, and response of a kolinsky sable brush sets it as the benchmark against which all other hairs and synthetics are measured. Unfortu-

nately, the quality of kolinsky sable has dropped drastically from what it was fifteen to twenty years ago, while prices have escalated. Some brushes now advertised to be kolinsky or the finest pure red sable are substandard. Buy your most relied upon and expensive brushes from well-established, reputable manufacturers.

Manufacturers of watercolor brushes reserve the finest selection

of kolinsky hairs for the larger rounds, since artists require a less exacting response from smaller brushes. Naturally, larger rounds require the less abundant longer hairs, dictating the premium price for brushes size #10 and up.

The next standard for hairs is common red sable, which generally come from another marten and are collected in Russia, China, and Scandinavia. This makes a more

MAYAN CRUCIFIXION, 19¹/₂ x 14¹/₂" (49.5 x 36.8 cm), Crescent 115 board, collection of Patsy and Donald Marquart

I chose a lettering brush to render the strong contrasts in the knotted scarf, with its stylized shadows. The brush let me create a sharp edge and flare calligraphically.

IN PASSING, 19 1/2 x 14 1/2" (49.5 x 36.8 cm), Winsor & Newton 140-lb. hot-pressed paper, collection of Keith and Deborah Robinson

The brush I seem to rely on most to loosen paint for lifting is a 1/2" synthetic bright. Although I used no lifting in the foreground subject, I lifted many soft highlights from the background figures. This short-bristled flat works well held with its bristles on edge.

affordable brush of very high quality, with characteristics similar to the kolinsky. But red sable is also becoming scarce, of lower quality, and more expensive. The lowest standard of hair that could be considered for watercolor brushes is that of the related weasel.

Manufacturers are scrambling to develop alternative brush hair materials that mimic the desirable characteristics of pure sable. Grumbacher's Professional Series brushes, for example, are made with a combination of red sable and kazen squirrel, which has very fine brown hair. The rounds are superb for the money, considering they're about one-fifth the cost of similar-size kolinskies. The flats are not quite as laudable; I would step up a grade or two and invest in a pure red sable or kolinsky. Another natural-hair composite is sabeline, a combination of red sable and dyed ox hair that makes for strong, durable brushes, notably those used by sign painters.

Synthetics seem to possess two demonic characteristics. First, they don't hold a liquid charge as well as natural hair. Second, what water they do hold doesn't discharge in the same predictable manner. These limitations make inexpensive synthetics a poor value. If you have a limited budget, choose one good sable in lieu of five inexpensive synthetics. On the other hand, if you like spring, these have it. When using concentrated, gummy mixtures of color, a synthetic can give tremendous response and control. They are durable and will outlast natural-hair brushes.

One of the newer man-made fibers used in brushes is Taklon, an extruded synthetic that tapers like real hairs. Bundling Taklon fibers of two different diameters together results in a brush that holds water well. Grumbacher's Golden Edge line is made with this fiber. I was impressed with the water-carrying capabilities of these brushes and found that they flowed and reacted without the excessive spring other pure synthetics give.

A step above pure synthetics are those blended with red sable hairs. These have excellent qualities and must be considered if you are price sensitive or are looking for a brush in a size range that you will use infrequently. At the bottom of the quality chain are so-called camel hair brushes, which are actually made of pony, goat, and/or squirrel and will only frustrate you.

For major investments such as brushes, it's best to buy from a trusted local merchant who will

allow you to water-test the brush. To test a sable, dip the brush in some water to release and rinse away the starch or gum added in manufacturing to protect the hairs during shipment. Once you clear the brush of the starch, flick it downward. If it springs back to display a full body and a fine, tapered point, buy it. If not, try another.

CARING FOR BRUSHES

Never leave a resting brush sitting in water. Before you set it down, either flick out the excess water or drag it across a thirsty sponge or towel—one that has been soaked then squeezed of water. Then lay the brush down flat or, ideally, with the tip pointing downward. An extended spring works well as a drying hanger; the brush handles slip between the coils. Or, purchase an oil painter's brush washer, which has a coil stretched across two upright braces and a container at its base. Suspend the points of your brushes above the base.

Brushes are fragile and unresponsive when dry and need to be made thirsty before you paint with them. This is best accomplished by gathering all the brushes you intend to use in your fist and gently evening the points against your tabletop or in the palm of your hand. Then swish them around in your water pail for about twenty seconds. Next, drag the bundle of brushes across your sponge and lay them down. Now you're ready to start painting.

Naturally, you want your precious brushes to look their best, so you might be tempted to form the tip by drawing the hairs past your lips a few times until it's as uniform as a soldier ready for inspection. Considering the toxicity of some colors, I'd suggest you avoid this.

If your skin is oily, you shouldn't touch the hairs of your brushes. Oil

sets an absorption barrier that will reduce the effectiveness of the brush to carry water. If your brushes are already suffering from this condition, try washing them gently in the palm of your hand with mild soap and tepid water.

Through abuse, a sable can lose its shape and spring. To resurrect it, dip it in a fine oil and carefully work the hairs. Reform the shape

and let it stand a few days. Then rinse the hairs in a small container of lighter fluid, changing it several times. Finally, wash the brush with soap and water. If your sable is in good condition but seems a little spiritless, luxuriate it in some cream rinse. Don't blow dry it, however.

Never try to reshape a brush by giving it a haircut. It won't work! If

FERTILE SPIRIT, 19¹/2 x 14¹/2" (49.5 x 36.8 cm), Winsor & Newton
140-lb. hot-pressed paper, collection of Mr. and Mrs. Sherwood Boudeman

For watercolor brushes, there is no hair or synthetic that can compare to kolinsky sable. This entire painting, save the brush I used to sign my name, was done with a wide selection of my cherished kolinskies.

137

A dry brush or sponge is nearly useless for painting. Both must be made "thirsty" before use. To prepare the sponge, dunk it in water and squeeze out all the excess.

To prepare a brush for painting, first swish it in water and then, as is shown here, discharge the excess water into the thirsty sponge.

After several passes over a thirsty sponge, a very thirsty brush will bend like this.

there are a few scraggly hairs, wet the brush and *quickly* run it past a flame. The offenders will be history. *Don't* run the tip through the flame.

Rinsing your brush is almost a ridiculous subject to comment on, except I've seen students haplessly dip their brushes in water to rinse them but not accomplish the task. To prevent the paint from settling up by the throat of the ferrule and stiffening the brush, briskly swish your brush long enough in the water pail to discharge all the color. You'll most likely begin to mix cleaner colors as well.

If mold grows on your brushes, store them with mothballs and increase ventilation.

The best brushes have durable hardwood handles coated with enamel or lacquer. However, when you use brushes daily, water wicks past the hairs, the wood slowly swells, and the protective coat is destroyed from the inside out. The ferrule also expands and shifts as the wood dries and shrinks. If you have a brush with a loose ferrule you can buy ferrule crimpers (sold by most large art stores) and go at it. Another approach, which you can use in conjunction with the crimpers, is to mix up some two-part epoxy and let it run into the cavity between the ferrule and the handle. Apply the glue with a toothpick. Don't let the epoxy run down the ferrule to the hairs. Clean unhardened excess epoxy off with nail polish remover, acetone, or alcohol. Keep the two parts aligned while the glue dries. For chipping paint, sand the area with 180 or 220-grit sandpaper and then brush on a few layers of model airplane paint. As a last resort, just wrap the affected connection with masking tape and replace every few years.

I find gathering all my brushes and dropping them into my palm a convenient way to align the tips before wetting the hairs. If your skin is oily, it would be better to align the tips on a tabletop.

Swishing all the brushes together in the water pail for about twenty seconds saves time. Once the excess water on them is discharged into a sponge and the brushes have been made thirsty, you are assured of having each one conditioned when you need it.

LIGHTING

Painters depend greatly on color sense and color selection in rendering their images, yet few fully appreciate how their light source, indoors or out, affects color perception. I love painting outdoors but find it frustrating because natural lighting is unreliable, its color temperature swinging widely from dusk to dawn, even on the best of days. The inconsistencies of outdoor light—even north light, which is not as dependably constant as we've been led to believe—can bias your color choices as you paint, giving disappointing results when you bring your work indoors and look at it under different lighting conditions.

A studio environment affords me the control I require, but special attention must be paid in choosing an indoor lighting source. In selecting a proper bulb, there are two factors to consider: color temperature, and spectral range.

Depending solely on our eyes to determine the serviceability of a light source's color temperature doesn't work. Our eyes distort judgment by adjusting to different lighting conditions almost instantaneously without our being conscious of any change. One way they adapt is to seek a neutral gray, which in turn establishes a white standard. Imagine two adjoining rooms with no windows, separated by a door. One room is lit with a cool, bluish-white light from a bulb that is meant to approximate north light, and the other is lit with a yellowish-white light from an incandescent bulb. Begin in the "yellow" room and after a moment you'll be convinced that the light is white. Then open the door to the other room, and you'll instantly recognize the light there as cooler, more blue, than the room you're leaving. Move into the "blue" room and close the door. You'll discover your internal calculator changes the blue-white to white. Pass back through to the first room and again you'll reestablish a neutral and a new white standard. Obviously, white is relative; there are warmer and cooler ones, but to make any kind of comparison, we need to establish an accepted standard against which these can be measured.

The "whiteness" of light, determined by its heat, is measured in degrees Kelvin (°K). When selecting a light source to paint by, you merely need to ask its Kelvin rating. A range between 3,000°K to 5,000°K is appropriate for your painting area. Below 3,000°K, the color temperature is too yellow. (Standard incandescent bulbs of 60 to 100 watts are roughly 2,700°K to 2,800°K). Above 5,000°K, the color becomes too blue for my taste.

To attain optimum lighting, you must also consider a bulb's spectral range. As you know, the rainbow is nothing more than white light divided and displayed in visible bands of color—more colors than we can actually see. Bulbs used to light painting areas should cover the spectral range evenly, and shouldn't slight or favor any color.

Light should be brightest in your task area, with the surrounding area just slightly less fully illuminated. The general area should be a level below the zone surrounding the task area, but not dark. The effect is said to cause less eye strain. Also, the more detailed your work, the more intense the light should be.

Standard incandescent bulbs produce yellow light, which isn't the correct color temperature to use for task area lighting. It will cause you to select colors that, when viewed under controlled exhibit conditions, appear biased in color choice. On the other hand, these bulbs can supply a very comfortable general lighting condition for your studio. The warmer light seems to be more soothing than cooler fluorescents.

An economical solution to lighting general and task areas is to use color-corrected fluorescent bulbs for overhead strip lights. Not only do they supply a lot of light for the cost of the units, but they also consume very little electricity for their light output. Beware, however—uncorrected fluorescents are often deficient in part of the spectrum. Choosing one that's designated cool white or warm white isn't good enough; it must be color-corrected.

Halogen bulbs reportedly render a full spectrum and require nothing more than a socket to screw them into. These are the types of bulbs I prefer, and I find them a perfect choice for lighting the task area. Quartz lamps are also a superb choice, but are expensive, use a lot of energy, and become very hot. In my studio, I rely on full-spectrum 3,200°K halogen bulbs to provide a constant light source.

CLOSING

After digesting the Kosvanec Transparent Watercolor Wheel, learning the color guidelines, and the nuances of paint suspension, coupled with everything else that has made up this book, what can we say, apart from creativity, separates the beginner from the accomplished watercolorist? In observing my students, I find they are generally timid. They equivocate and make half statements rather than painting with conviction. I'm hopeful that if you are a novice, you've gained enough information about your materials to have developed the confidence to slap some paint on the paper—and have it come out right. If it doesn't work the first time, load your brush and try again until it feels familiar. Don't hesitate; fire away. Once you do, you'll realize that the slow process of laying down one light wash, followed by another, and yet another, was sapping your potential to render a beautiful, succinct, simply stated wash that looks as if it was born to be there on your painting.

I've been straightforward about many personal choices in this book and realize that by doing so, I'm open to criticism. Once out on the limb, though, you can crawl back down or continue with the quest. I'll continue, remembering the days when I craved information and couldn't find it, acquiring knowledge in bits and pieces from many different sources while always seeking the book I've now written. Certainly my views and opinions are neither unique nor irrefutable; no doubt others have shared the same notions as I or hold positions that differ from mine but are equally valid, prompting debate. What my theories, opinions, and observations collectively form is a cultivable start for sincere painters who are struggling to acquire information. I remember. Keep painting.

WHISPERS ON THE WIND, 19¹/₂ x 14¹/₂" (49.5 x 36.8 cm), Winsor & Newton 140-lb. hot-pressed paper, collection of the artist

INDEX